The Complete Guide to
Calligraphy

The Complete Guide to

Calligraphy

Techniques and Materials

© Quarto Publishing plc 1984
First published in Great Britain in 1984 by
Phaidon Press Limited
140 Kensington Church Street
London W8 4BN

Reprinted (paperback) 1992

ISBN 0 7148 2737 1

This book was designed and produced by
Quarto Publishing plc
The Old Brewery
6 Blundell Street
London N7 9BH

Filmset by Text Filmsetters Limited, Orpington, Kent
Origination by Hong Kong Graphic Arts Service Centre Limited, Hong Kong
Printed by Leefung Asco Printers Limited, Hong Kong

Quarto would like to extend special thanks to Nick Biddulph at the Lettering
Archive of the Central School of Art, Gunnlaugur SE Briem and Heather Child
for their invaluable co-operation and assitance.
Quarto would also like to extend thanks to H. Band & Co; Brighton Polytechnic;
Camberwell School of Arts and Crafts; Falkiner Fine Paper;
Nicolette Gray; Lens Photography; Terry Paul; Alec Peever; Ravensbourne College of Art and Design;
Rexel Cumberland Graphics; Peter Thompson; John Woodcock.

CONTENTS

Introduction

While it is the general function of the craftsman to make a thing legible, it is his particular function as a decorator to make it becoming.

Edward Johnston

In oriental cultures calligraphy is one of the purest and most highly esteemed art forms. It is based on centuries of tradition, demands long and disciplined practice, and is fully integrated both with other artistic skills and with philosophical traditions. In the west, writing by hand has generally occupied a less elevated status and its traditions have been broken and diverted; it has been used, mostly, as a day-to-day convenience, and concern with beauty of form has been sporadic, following curious departures from tradition and frequently divorced from other skills. Schoolchildren are now taught to use computers as soon as they have assimilated the most basic skills of literacy and numeracy. It may seem that the ability to write by hand could soon be a superfluous accomplishment.

Paradoxically, as technology alters the very basis of written communications and although few people can make a living from their skills in beautiful writing, calligraphy is attracting a growing number of devotees and practitioners, both amateur and professional. It is difficult to identify an exact reason for this new surge of popularity. Some are drawn to calligraphy because it is an accessible craft, since so many people can write, but one which also demands discipline and knowledge. As a general reaction to the impersonal qualities of modern living, there has been a widespread interest in returning to traditional crafts, simple materials and manual skills that call upon the ingenuity of the practitioner. And there is considerable appeal in the study of old manuscripts, in the forms and decorations of a long-lost era, whose very richness and complexity make a striking contrast to the austerity of much modern design. Further, calligraphy promotes a particular care and concern for words themselves.

Many modern scribes still use the same natural tools and materials as their medieval counterparts – quill and reed pens, calfskin vellum – with the intention of making their own products as beautiful and long-lasting. Nevertheless, the present-day calligrapher has a far greater range of stable materials to choose from and can exploit the convenience of manufactured pens, inks and paper.

The term calligraphy simply means beautiful writing; this is a broad-ranging definition and the word is interpreted in different ways, while the term calligraphic encompasses any number of items that are written, painted and designed, in two and three dimensions. Calligraphy is discussed here primarily with reference to the western tradition of formal penmanship and the writing of the Roman alphabet and its variant forms. It is explained in terms of the origin and development of that alphabet, the tools and materials available to the calligrapher, the construction of traditional pen-made letterforms using an edged pen, basic ideas of design in dealing with the written word and special applications of calligraphy to particular design purposes and in various media. Essentially calligraphy is defined as written letters, dependent upon the flow and rhythm of the pen or brush, as distinct from drawn

or mechanically designed lettering showing composite forms. However, there are important connections between calligraphy and certain other types of lettering that are included where appropriate.

There is a definite formal basis for modern calligraphy in the traditions of Roman and early Christian letterforms and in the use of particular tools and disciplines for constructing the letters. These structures teach the underlying principles of alphabet forms and are to the calligrapher, to borrow a frequently used analogy, what musical scales are to a pianist. Calligraphy is often compared to music and dancing, as a skill that requires hard work and much practice, but also feeling and spontaneity in every performance. For this reason, the work reproduced for illustration of this book is deliberately chosen to cover a broad range of style, technique and invention.

Below *This is a copy of* Prajna paramita sutra, *a Buddhist scripture, and was written by the Japanese calligrapher Suzuki Seiyo. It has been worked in gold on black, giving it the elevated status an eastern, religious script requires. The form of oriental calligraphy has changed little over the centuries. The original ideograms were engraved on the shoulder bones of animals and on tortoise shell. These symbols have been developed and modified to an extent, but the formalized writing in China today is still in the k'ai-shu style, which was already established by the first century AD.*

fetter grüne, du Laub,
Am Rebengeländer
Hier mein Fenster herauf!
Gedrängter quellet,
Zwillingsbeeren, und reifet
Schneller und glänzend voller!
Euch brütet der Mutter Sonne
Scheideblick, euch umsäuselt
Des holden Himmels fruchtende
Fülle; Euch kühlet des Mondes
freundlicher Zauberhauch.
Und euch betauen, ach!
Aus diesen Augen
Der ewig belebenden Liebe
Vollschwellende Thränen.

The revival of calligraphy

The traditions of western penmanship had virtually disappeared by the end of the nineteenth century and the techniques of calligraphy in current practice, which properly reflect the origins of particular written forms, were only rediscovered within the last 100 years. In Europe and the United States the style of copperplate writing, with its more or less elaborate, cursive scripts written with a pointed pen, was the general standard. In Victorian England there was a revival of interest in Gothic forms of art, particularly architecture, but also the decorated, handwritten books and manuscripts of the monastic scribes. With their pointed pens, the Victorian lettering artists enjoyed drawing and filling in the heavily stroked forms of medieval letters. They must have wondered at the patience of medieval monks to contribute such labour to the copying of an entire book, but no other way of achieving the same kind of letterforms was readily apparent.

The revival of the skills of writing and illumination in the medieval pattern was instigated in the late nineteenth century by the designer William Morris (1834-96). He considered the quality of Victorian design to be generally poor, debased by industrialization and an impersonal attitude to manufacturing. Morris led a renewal of interest in hand-crafted products, taking particular interest in the forms and standards of pre-Renaissance workmanship. His own designs for wallpaper, textiles and furniture influenced public taste and had considerable impact on the aims and methods of contemporary artists and craftsmen. In 1890 Morris founded the Kelmscott Press and began to produce printed books, in which every feature of the design and decoration was informed by much earlier traditions.

Against this background of medieval revivalism, by coincidence and also by sheer hard work, one man became largely responsible for shaping the basic practices of modern calligraphy. Edward Johnston (1872-1944) was originally set on a career as a doctor; his keen interest in lettering and design was initially contained as a private hobby and his artistic skills were self-taught. His own ill-health interrupted his study of medicine in Edinburgh and prompted a visit to London, where he considered a suitable alternative vocation, hoping it would be possible to use his talents as an artist.

His family and friends had encouraged his artistic progress and, through London acquaintances, samples of his work were shown to Harry Cowlishaw, who had some reputation as a scribe and illuminator. Cowlishaw responded favourably, while including some constructive criticism of Johnston's lettering. On the first day of his stay in London Johnston met Cowlishaw and through him was introduced to W. R. Lethaby (1857-1931), principal of the new Central School of Arts and Crafts, who had been a friend and disciple of William Morris. Lethaby strongly recommended that Johnston should pursue his interest in writing and illumination; within a short time of their first

Far left Berthold Wolpe was a student of Rudolf Koch and was originally trained as a silversmith. This piece shows a sample of his interpretation of an italic script. The elegant forms have retained the elliptical o and acute arching strokes in the m and n, which characterize the italic hand. Among his other achievements Wolpe has been influential in the development of typefaces, adapting his calligraphic skills to type design, notably the Albertus typeface.

acquaintance, Lethaby surprisingly showed his confidence in Johnston's future by offering him a post as teacher of these subjects in a new class to be set up at the Central School.

These events occurred in April 1898. During the summer Johnston made a trip to Canada and on returning to London took a studio in Bloomsbury, close to the art school and the British Museum. Lethaby was unable to start the new lettering class until September 1898. In the meantime, Johnston studied at the British Museum, copying old manuscripts, learning the form and technique of medieval scribes and improving his own skills.

It was during these researches that Johnston came to the important realization that the medieval letterforms were not drawn or built up with a pointed tool but were, in fact, natural pen letters formed systematically by a broad, flat-edged nib, which he discovered had been cut from a reed or quill and trimmed horizontally or obliquely across the tip. The shape of the tool itself caused the variation between thick and thin strokes in the writing and also accounted for the basic character and emphasis of particular alphabet forms.

Johnston's early classes were an enormous success; no one else was teaching the craft of pen lettering. Within a year he had started another class at Camberwell School of Art and in 1901, when Lethaby became professor of design at the Royal College of Art, Johnston was also invited to set up a class there. He was still learning his craft as he taught it to others; among his students in those early years were young talents such as Eric Gill (1882-1940) and Noel Rooke (1851-1953), but also more established figures, notably T. J. Cobden Sanderson (1840-1922), a bookbinder and typographer who had worked with William Morris and was starting a private printing press of his own, the Doves Press. The classes flourished in a spirit of mutual exploration and encouragement, made coherent by the profound respect among the students for Johnston's enthusiasm and careful research.

Johnston and his students experimented with every aspect of medieval crafts – mixing ink and colours, cutting quills, preparing vellum, gilding. They re-evaluated the construction of medieval letterforms and the basic form and proportion of the Roman alphabet. Johnston himself developed the Foundational hand, based on tenth-century Winchester script, which he taught as a standard script. Throughout his career as a scribe and teacher he constantly returned to the original forms of old manuscripts and inscriptions and revised the lettering, in a manner which he felt was in keeping with his own time and the contemporary purposes of calligraphy, but with due respect to the traditional tools and materials.

Johnston exercised an extraordinary influence which reverberates to this day, not only in England but also in Europe and the United States. For many years most of the teachers and practising scribes in England were Johnston's own students. In 1906 Johnston published

verfchonet/fondern gegeben/wie follte fdjenken? wer will befchuldigen? Gott

Above *Rudolf Koch was an influential figure in the development of calligraphy and lettering design in Germany in the early part of this century. He was particularly active in adapting calligraphic forms to type design and was responsible for updating forms of Gothic Black Letter, which has always been a standard typeface in Germany.*

Writing & Illuminating & Lettering; this book is still the standard work on formal penmanship and illuminated design, published in many different countries. Johnston was obsessed not only with discovering every detail of his craft, but also with explaining it in precise terms. A book that was intended to follow and expand on the information in his first work, occupied much of his attention during the last several years of his life. It was left unfinished at his death, although the notes have since been edited by the scribe Heather Child and published under the title *Formal Penmanship*. His lecture demonstrations, preserved in a photographic record, also show the immense vigour of his craft.

Although Johnston's influence has been enormous and widespread, there were others, who were also active in revitalizing calligraphic traditions in the early twentieth century. A significant independent movement occurred in northern Europe at about the same time, guided by the work of Rudolf von Larisch (1856-1934) in Vienna and Rudolf Koch (1874-1931) at Offenbach. Von Larisch realized the decline in standards of writing and lettering through his work as an archivist in the Austrian Chancery. This first-hand study of historical documents gave him the opportunity to formulate his thoughts on the quality and purpose of handwriting and lettering. He was also interested in traditional skills and materials and, on his appointment as lecturer in lettering at the Vienna School of Art in 1920, he encouraged his students to experiment with many different media and investigate thoroughly the forms of lettering and different possibilities for their construction.

In the early years of this century von Larisch published two books on decorative writing and lettering. He wrote articles to promote an interest in the subject and arrange publications of specimens of different kinds of written work. He was keen to stress the educational and creative value of writing as a specialized craft. In 1909, on a visit to London, von Larisch met Johnston and they discovered considerable mutual sympathy and pleasure in their shared aims. The Johnstonian tradition of penmanship has, however, invariably remained less broadly based than the wide-ranging interests of the continental calligraphic revival.

A feature of German calligraphy has been its continuing close relationship with printing. Rudolf Koch worked both as a calligrapher and type designer in the Klingspor type foundry; he also taught lettering at the Offenbach School of Arts and Crafts. In 1918 he organized a group known as the Offenbach Penmen, and a workshop was established where high standards of design and execution were applied to printing and textile production. The survival into the modern period of Gothic Black Letter, as a standard typeface used in Germany, has given the northern tradition of calligraphy an unbroken link with its past; elsewhere the development of different lettering arts has been more divergent.

Above *This is a sample of Edward Johnston's early form of signature. Together with the dedication and date, it provides a colophon to a piece of work. The signature itself reads:* In nomine dei; *the* ei *of* Dei *are written as* e.j., *Johnston's initials. This form was abandoned later, as he considered the work immature and believed that the letters lacked the sharpness necessary for good lettering.*

William Addison Dwiggins

TO BE CONCERNED
WITH THE SHAPES OF LETTERS
IS TO WORK
IN AN ANCIENT
AND FUNDAMENTAL
MATERIAL

*The qualities of letterforms at their best
are the qualities of a classic time:*

ORDER, SIMPLICITY, GRACE

*To try to learn and repeat their excellence
is to put oneself under training
in a most simple and severe
school of design*

Modern calligraphy

1 Quotation from W.A. Dwiggins, written by the modern scribe Julian Waters. Dwiggins was a well-known and influential American calligrapher and lettering designer. The two lettering styles are Roman capitals and italic script, arranged in a balanced and considered composition that reflects the subject matter.

2 Quotation from T.E. Hulme, written by Ann Hechle on vellum. The central design incorporates raised and burnished gold leaf stars and watercolour washes.

3, 4 Letter to Sir Stanley Cockerell (SCC) from Edward Johnston (EJ). Johnston was the single most influential figure in the revival of calligraphy in modern times. His letters to friends and family often featured large initials of the sender and recipient offset against the texture of the handwriting. The detail is taken from the left-hand corner.

Above *Quotation from Vasko Popa, written by the Yugoslavian calligrapher Jovica Veljovic in cyrillic script. Cyrillic is the alphabet used by Slavonic peoples.*

Recent practice of calligraphy

Students of these original calligraphy masters have themselves become notable scribes and lettering designers and, in turn, have taught their own pupils particular traditions and new lines of enquiry. A number of calligraphers in Britain, Europe and the United States will admit that their first experience of calligraphy was gained by teaching themselves from Johnston's classic book. In England the Society of Scribes and Illuminators was set up in 1921, with Johnston elected its first honorary member. Similar societies exist in many countries and in recent years have broadened their membership to include the growing numbers of interested amateurs, who both study and practise the principles of fine writing. International exhibitions are organized, which attract entries from all over the world. Although there are language barriers to overcome and different alphabets and characters are used in different parts of the world, there is much exchange of ideas and promotion of common interests.

In England the Johnstonian tradition continues strongly in a second and third generation among scribes such as Irene Wellington, Dorothy Mahoney, John Woodcock, Donald Jackson, Ann Camp and Ann Hechle. These are a few names from a longer list of notable practitioners. In Germany, the influence of Johnston, carried there by his pupil Anna Simons (1871-1931), has continued; there have been many vital contributions to lettering art from pupils of von Larisch and Koch and, in various countries of northern Europe, a broad spread of ideas from designers such as Berthold Wolpe, Friedrich Poppl, Imre Reiner, Jan Tschichold and Herman Zapf. Such influences continue to provide a first-class guide to the work of younger scribes and those who are new recruits to the craft of calligraphy.

The United States has had its own strong tradition of calligraphy and lettering art in the twentieth century, less bound to the influence of medieval penmanship than Europe, but still affected by the principles adhered to by modern European scribes, several of whom have visited and taught in the United States, and a few of whom have settled there. W. A. Dwiggins, Oscar Ogg and Arnold Bank have been important figures in the development of a characteristically American calligraphic tradition and, as in Europe, professional scribes have attracted the interest and support of many amateur calligraphers.

Unfortunately, for a number of reasons, calligraphy has virtually been abandoned as a formal discipline of art school teaching, where the emphasis falls more strongly on printed forms and mechanical lettering in modern design. It has flourished, however, in local societies, workshops, day and evening classes and weekend schools. The future of calligraphy is unsure, yet there is considerable cause for optimism. Today, there are professional and amateur calligraphers in sufficient numbers in many countries throughout the world to maintain the vitality of the tradition.

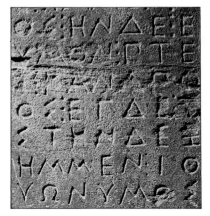
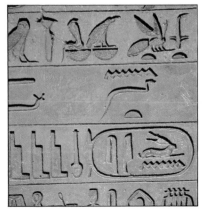

The earliest writing was in pictograms, the best-known example of which is Egyptian hieroglyphics. This example is from a relief found in a tomb at Sakkara, probably dating from the 5th Dynasty (2560-2420BC) (above). The Hittites, who founded a powerful ancient civilization in Asia Minor between three and four thousand years ago, also used a form of hieroglyphics (centre). This Assyrian script, typical of the period between the eighth and ninth centuries BC, was used in many copies of earlier texts made in the seventh century BC for Assurbanipal's Royal Library in Nineveh (right). By the time of the Greeks, a recognizable alphabet had been developed. This writing, relating omens derived from the flight of birds, is from Ephesus and dates from the sixth century BC (above right).

Roman lettering
*The prevalence of Roman lettering on a
wide range of artefacts testifies to a
relatively literate, organized society.
1 Bronze letters, such as this A, were
inlaid in stone-carved inscriptions.
2 Roman coins featured low reliefs of
emperors' heads, symbols of the state and
inscriptions.
3 Stone-carved letters display
characteristics derived both from the chisel
used to cut the forms and the brush used to
paint the preliminary design. Serifs owe
much to the action of the chisel; thick and
thin strokes to the action of the brush.
4 Informal street notices, such as this
first-century graffiti from Pompeii
announcing elections and other public
events, were painted on walls with
brushes.
5 Monumental inscriptions were carefully
planned and executed according to the
importance of the words and available
space, as shown by this example from the
arch of Septimus Severus in Rome.*

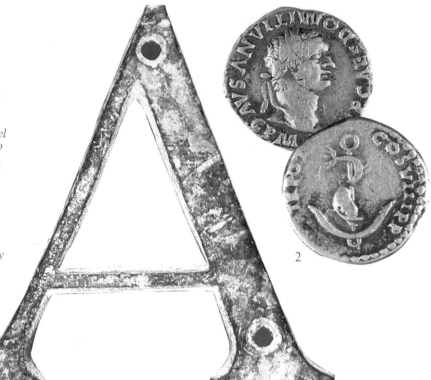

1

2

3

4

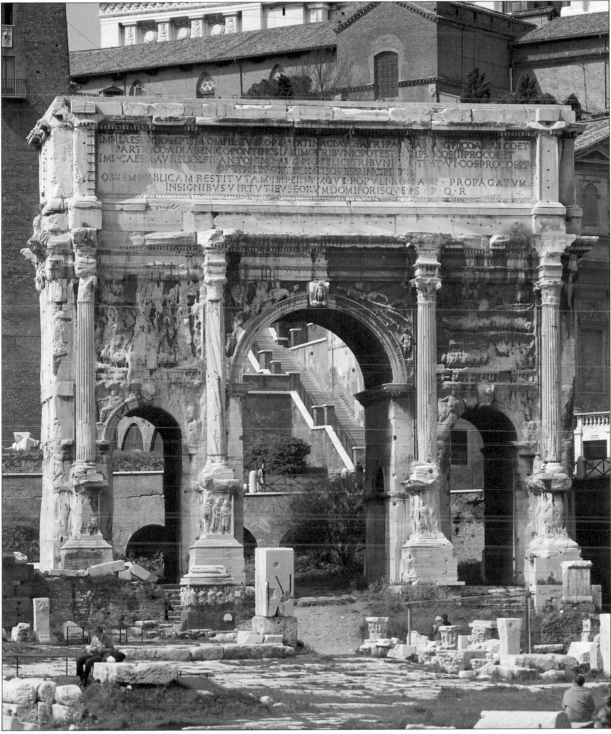

5

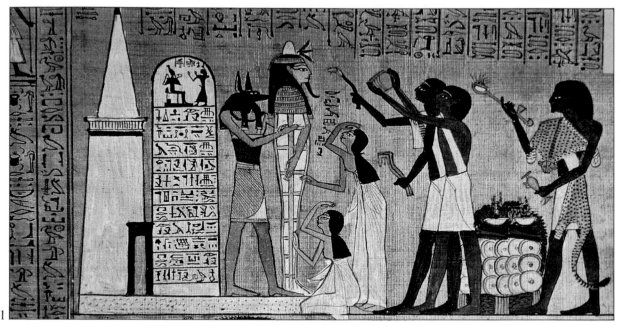

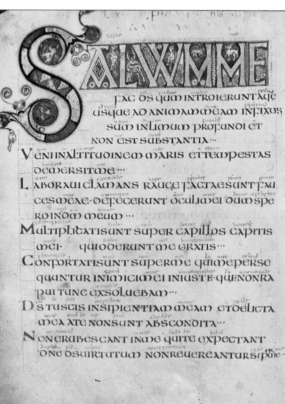

Early manuscripts
1 This Egyptian manuscript decoration is taken from the Book of the Dead, 1300BC. The scene represents the ceremony of 'opening the mouth', and is written on papyrus.
2 The fragment is from an unknown gospel and is also on papyrus. Dating from the first century, it is believed to be the earliest surviving Christian manuscript.
3 These uncials are from a Celtic manuscript of the seventh century.

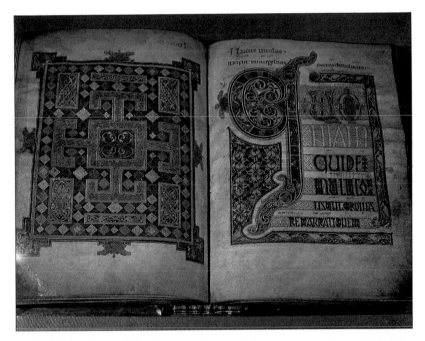

The Lindisfarne Gospels
These gospels were written in the Monastery of Lindisfarne in 698AD, in honour of St Cuthbert, who died in 687. The presentation and illumination are of a particularly high standard. Elaborate animal and bird forms are cleverly integrated in the border. Here a cat peers around the right-hand margin and the complete border is filled with birds; even the ornamental letter contains a number of birds. The intricate patterns that weave throughout the illumination are also typical of these gospels.

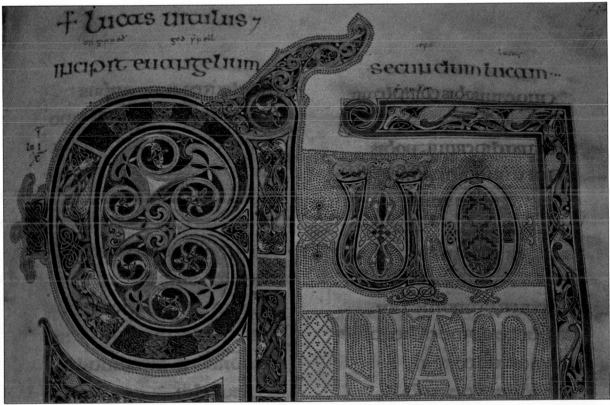

1

3

Medieval manuscripts

1 This is part of an illuminated manuscript containing an Anglo-Saxon translation. It dates from the ninth century and is written in Carolingian minuscule. Charlemagne was ultimately responsible for this script in his desire for the spread of learning. He summoned Alcuin of York to Aachen to direct studies at the Palace school. It seems that Alcuin adapted the half-uncial and cursive script to form the Carolingian minuscule as an easier writing hand; the precise origins of the hand are unknown.
2 Another ninth-century manuscript, this extract combines uncials and Carolingian minuscule. The rounded uncial form has been sharpened up in the lower-case. Notice how the minuscule tends towards the more angular italic hand.
3 This initial is taken from the tenth-century Ramsey Psalter. The intricacy involved in drawing an illuminated letter means that it is necessary first to make a detailed outline. This is gradually built up with gold leaf, then the palest colours are added through to the darkest. Black ink is used to sharpen the outlines and, finally, the fine white hairlines are applied.
4 Sir Geoffrey Luttrell was a patron of the psalter named after him. The Luttrell Psalter was produced in East Anglia between 1335 and 1340, just after the Queen Mary Psalter had been completed. The border pictures depict scenes from everyday life, both indoors and out. The writing is in early Gothic style.

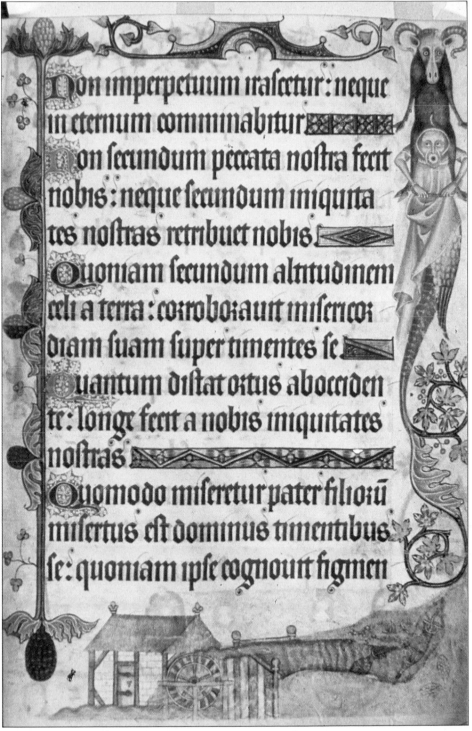

Non imperpetuum irascetur: neque
in eternum comminabitur.

Non secundum peccata nostra fecit
nobis: neque secundum iniquita
tes nostras retribuet nobis.

Quoniam secundum altitudinem
celi a terra: corroborauit misericor
diam suam super timentes se.

Quantum distat ortus abocciden
te: longe fecit a nobis iniquitates
nostras.

Quomodo miseretur pater filiorū
misertus est dominus timentibus
se: quoniam ipse cognouit figmen

4

1

Early Renaissance

1 This antiphon is from a fifteenth-century choir book. It was common practice to rule the staves in red and write the notes and words in black; versal illumination and Rotunda script were also popular.

2 It is quite rare to find such a large script in a thirteenth-century manuscript. There is a tendency toward the Gothic hand with compression of the letters and very regular forms. The piece shows a high standard of gilded work and illumination.

3 This page is taken from the manuscript of the Hours of Jeanne de Savoie by Jean Pucelle. Pucelle was a professional illuminator, active in the second quarter of the fourteenth century. As in so many such decorated books, the scene is taken from the Bible, in this case showing the Annunciation.

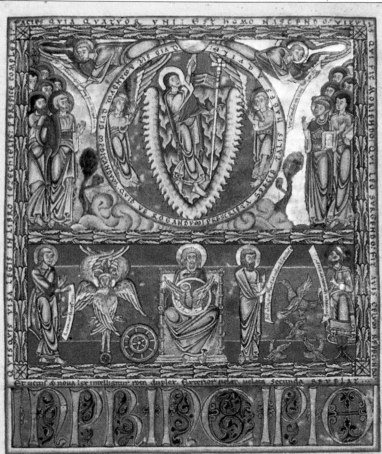

2

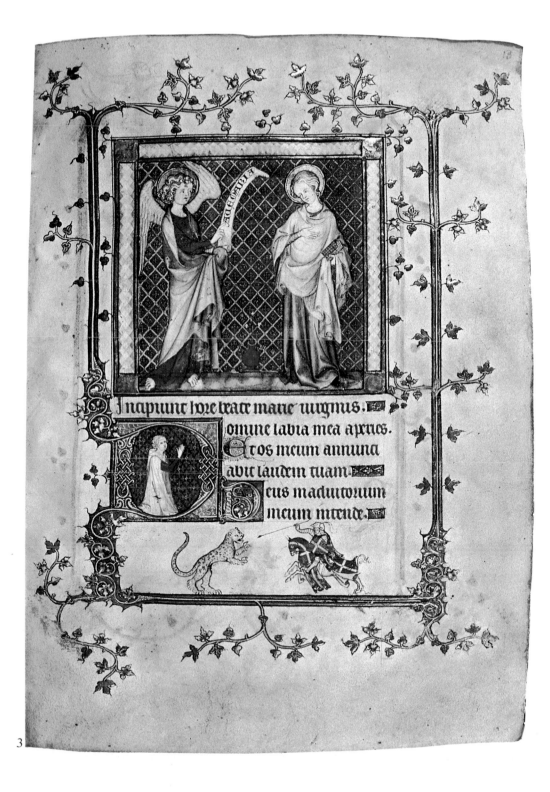

3

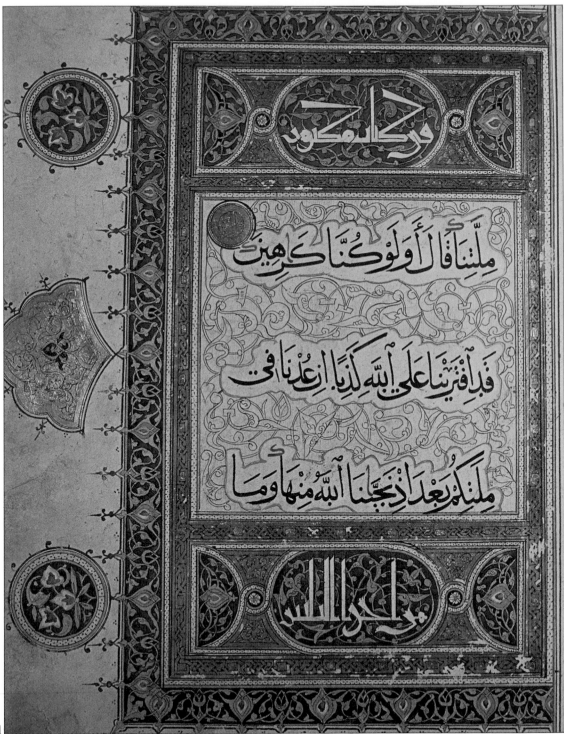

1

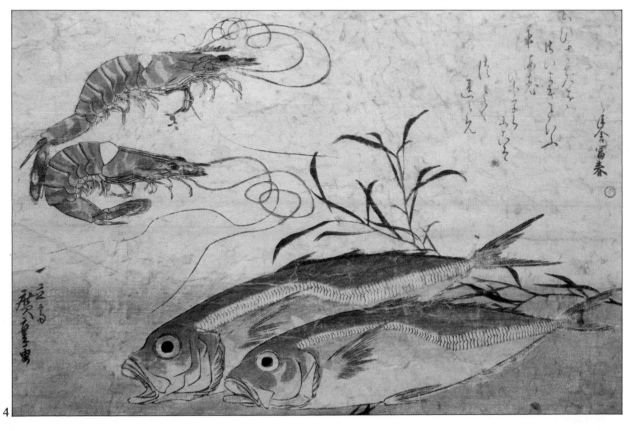

The eastern tradition

Calligraphy plays a vital role in the art and religions of eastern cultures. As Islam prohibits figurative or naturalistic representation, its art is dominated by formal writing and abstract geometrical pattern. In the Far East, calligraphy has always been considered one of the purest of all art forms.

1 This frontispiece of the Koran dates from fourteenth-century Egypt.

2 This Japanese poem in brush-drawn characters, written by the Japanese calligrapher Koyama Tenshu, demonstrates the close link that persists between art and writing.

3 Sacred writings are often subjects for calligraphic interpretation. This is a detail from a copy of a Buddhist scripture, written by the Japanese calligrapher, Suzuki Seiyo.

4 Hiroshige (1797-1858) was the last master of the Japanese popular print, or Ukiyo-e. *This print,* Studies of Fish, *is only one of over 5,000 he produced in his lifetime.*

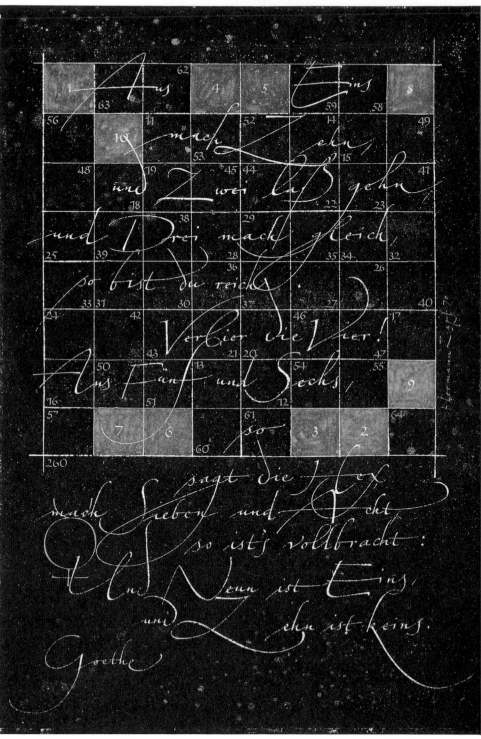

2

GEDICHTE VON HESSE

Modern European calligraphy
*1 The influential German calligrapher
and typographer Herman Zapf is
well-known for the design of typefaces,
notably Melior, Palatino and Optima.
This experimental calligraphy is part of a
series.
2 Executed in brown ink and watercolour
on handmade paper, this book was
produced by the calligrapher Hella Basu.
3 This etching by Karlgeorg Hoefer
demonstrates liveliness in form and design.
Hoefer is also noted for his skill in
brushwork.
4 Capital U in ink and watercolour by
Imre Reiner.*

GOTT
gibt uns die Kraft,
die Lasten des Lebens
zu tragen Wenn wir
in der Dunkelheit stehen,
ist er ein Licht auf unseren
Wegen.

MARTIN LUTHER KING

3

4

ALL
SAINTS'
PARISH CENTRE
WAS OPENED BY
HRH PRINCESS ALEXANDRA
AND DEDICATED BY
THE BISHOP OF
SOUTHWARK
22 JULY
1983

1

2

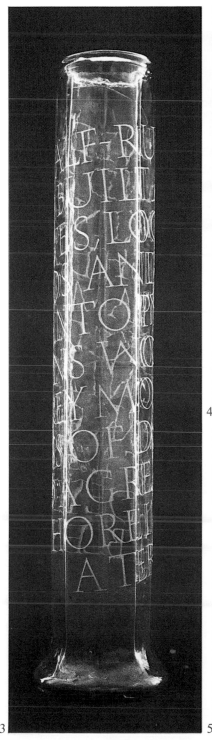

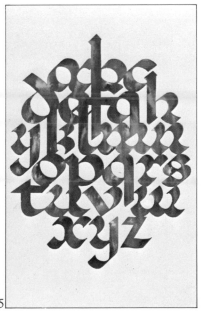

Applications of calligraphy

1 This commemorative plaque by Alec Peever was made by incising letters into Welsh slate. Incising, rather than raising the letters by abrading the surrounding surface, allowed the strokes to be extremely fine.

2 The sequence shows copperplate engraving by John Woodcock. To create the fine lines so distinctive of this printing method, the plate, not the engraving tool, is turned.

3 This glass spaghetti jar was decorated by Gunnlaugur SE Briem. The shapes of the letters were sand-blasted, the surrounding glass masked with adhesive film.

4 This collector's plate was designed by Robert Boyajian for Salem Kirban Inc, and is dedicated to Edward M. Higgins. The plate is porcelain, printed in dark brown, and has a 22K gold rim.

5 This multicoloured alphabet was silkscreened by Peter Thompson. The design is constructed of lower-case letters in a Lombardic style.

3

4

5

These are examples of modern design by Donald Jackson, showing the use of gilding and colour in some calligraphic pieces.

1 These letters were drawn onto vellum with a reed pen. The reed tip had a centre notch removed to give the parallel-line effect. The colour was added separately afterward. The gold leaf is being applied with a haematite burnisher.

2 This gilded piece is taken from the end of a Royal Charter. It is based on the sixteenth-century notarial seals, which were placed at the end of documents to prevent further notes from being added. Here it is used as an end note or finishing piece.

3 The coat of arms of Puerto Rico are part of a presentation panel. Both raised and flat gold have been used in the crown. The raised areas are burnished gold and the flat is powder gold. Platinum has also been used – in the lamb. A quill was the writing tool.

2

1

3

Eastern calligraphy

The traditions of eastern calligraphy are fundamentally bound to religious and philosophical thought; writing has a mystical significance not widely recognized in western cultures and the history of the art of writing is entwined with that of other art forms.

The forms of oriental writing are extremely old and remarkably consistent throughout their long history. Chinese is a monosyllabic language and in the written form each character is a single word. The words are not made up from a basic alphabet combined in different permutations, as they are in European languages. Each Chinese character combines different elements of form to express images, thoughts and the sound of the spoken word.

The brush is the primary instrument of oriental calligraphy. Text is written vertically and from right to left. There are conventions of posture and the method of holding the brush to ensure free rhythm. The movement and disposition of the whole body contribute crucially to the calligrapher's skill. A page of written Chinese or Japanese has a rich and varied texture because of the many hundreds of separate characters that can be used. Each is written as if it were fitted to an imaginary grid, which means that scale and proportion are regulated. There is an important value to the articulation of each brush stroke, the way the character is composed and the fluidity of linear variation.

In China calligraphy is inseparable from painting, but is, if anything, the more important art of the two. Hand-painted characters are used as decoration in every home, with or without accompanying pictures; the streets of towns and villages are covered in notices, banners and hand-painted signs. Handwriting is accepted as a notable form of self-expression and more than this, fine handwriting is appreciated as a mark of respect to those to whom it is addressed.

The alphabet of Arabic languages consists of 29 characters, mainly representing consonantal sounds. It has the same original roots as the Roman alphabet, but over centuries it has evolved quite differently and there are many variations of Islamic scripts. The alphabet consists of groups of characters sharing a basic consonantal symbol, to which diacritical signs are added that express vowel sounds and specifics of pronunciation. A letter may alter slightly in character according to its position in a word, as the first or last letter for example, and whether it is joined or standing alone.

Islamic calligraphy is itself held in very high esteem; the Qur'an explains that writing is a gift bestowed by God. Since an important part of the religious observance involves memorizing the sacred texts, Islamic artists are able to exploit the abstract qualities of writing – the pattern and texture of words – knowing that their readers will still understand the text. Any object or material that can be carved, incised, modelled, painted or drawn has been decorated with writing or constructed in the forms of letters and words.

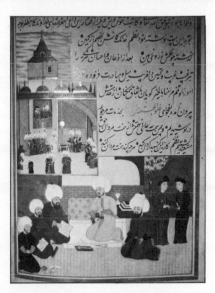

Above *This is a piece taken from the Annals of Selim II, written in 1580. Arabic manuscripts were often highly decorated, where even parts of the writing were highlighted in gold or red. The boxed illustration depicts the court of Selim II; the foreground figures represent the author, scribes and painters of the work.*

The development of writing

Written forms of language evolved slowly over hundreds of years, from pictures, to symbols, to the complex systems whereby abstract signs represent sounds of speech. In the early years of human development, the pictures drawn by the cave painters were expected to perform a sympathetic magic to improve the quality of life. Eventually, words also took on magical significance and were inscribed on ornaments and everyday belongings to protect their owners from malevolent influences. As civilizations have advanced, literacy has always been associated with power; the power of the ruling classes and the church, of philosophers, teachers, politicians and merchants. And still today, the most powerful countries in the world are those with the most highly literate populations and where the education of every citizen is a primary goal.

The development of writing has two distinct stages of interest to calligraphers. Firstly, in the mutation of pictorial symbols toward a standard alphabet form and then, once this basic tool of written communication had been established, the ways in which the alphabet has varied in written form from place to place and under different conditions. In western cultures the division between these two stages is marked by the most powerful period of the Roman Empire, when a standard alphabet had been achieved which was then transmitted to the conquered lands of Europe and, subsequently, developed by the influence of the early Christian church. To the east of Rome, other influences conspired to consolidate different alphabet forms, which also became standard use and are significant symbols of the cultural differences between east and west to this day.

Early writing – signs and symbols

One of the oldest civilizations of which we have evidence was that of the Sumerians, who inhabited the fertile region of Mesopotamia around the rivers Tigris and Euphrates, an area which now falls within the boundaries of modern Iraq. Their agricultural society was highly organized, using irrigation from the rivers and making use of domesticated animals in farming. From the fourth century BC until they were overrun by the Babylonians in 1720BC, the Sumerians established towns and cities, set up a basic system of regional government and were sufficiently prosperous for citizens to perform services beyond the basic requirements of agriculture and trade, such as skilled crafts and medicine.

The earliest evidence of a writing system in Sumer is a limestone tablet from the city of Kish, dating to about 3500BC. This shows several pictograms, including a head, foot and hand. Pictograms are pictorial symbols that directly represent a particular object. Gradually, by association, the symbol could represent a less concrete image – the sun, for example, could also stand for 'day'. A symbol extended in this way is known as an ideogram. The Sumerians at one time had about 2,000

The first basic element of written language was the pictogram (1), a representational symbol. Pictograms developed into ideograms (2) invoking associated images and ideas to construct a narrative. These symbols gradually became stylized (3 and 4) and were related to sounds in speech. As early as 2800BC, cuneiform writing (5) established the principle of using formal, abstract signs that is the basis of modern alphabets.

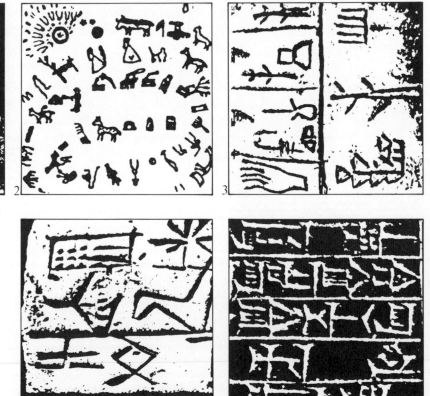

such symbols forming the elements of their written language. A further development occurred when it was realized that a symbol representing one word could also be used for a similar sounding word, and that such symbols could be put together to form composite words, by reference to syllabic sounds. These phonograms, or symbols representing sounds, were freed from the original, illustrative conventions of pictograms. This meant that the number of symbols could be reduced and their forms stylized. The essence of an alphabet system had come into being.

The Sumerians mainly used soft clay as a writing surface, inscribed with a stick or reed stylus. Drawing on clay is difficult because ridges of clay build up in front of the tool; the symbols tend to be more angular because curved shapes are so difficult to form. The Sumerians gradually evolved the method of pressing the stylus into the clay in a series of small marks. The impression of the stylus left wedge-shaped marks; Sumerian writing is known as cuneiform, from the Latin word *cuneus* meaning 'wedge'. Speed in writing also reduced the complexity of individual symbols and increased the tendency to abstraction.

To prevent the clay from hardening before the writing was finished,

Below *The characteristic wedge-shaped marks of cuneiform writing are clearly preserved in this account of the birth of King Sargon of Akkad, dating from the third millenium BC. Akkad, a city on the Euphrates river, was a centre of early Mesopotamian civilization. Much written information has survived from that period; apart from historical records, there are many tablets giving details of day-to-day business.*

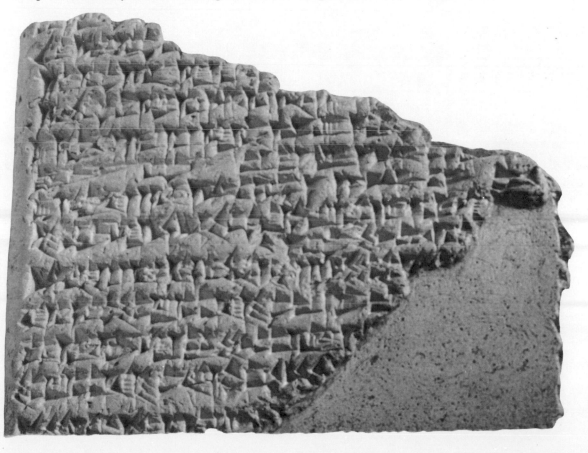

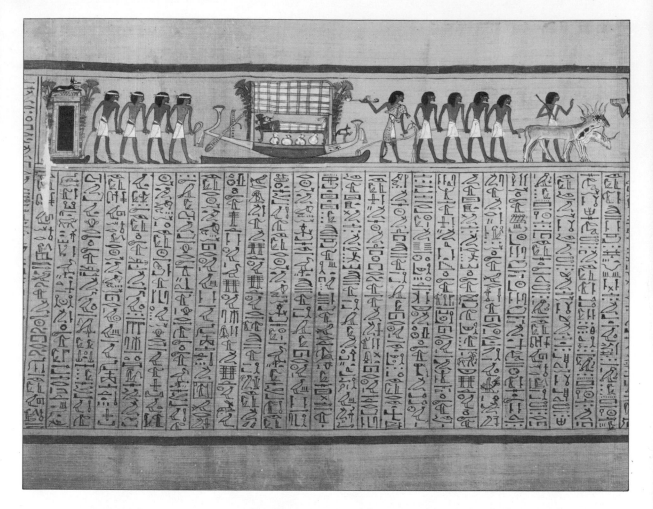

Pictorial hieroglyphs (far right) were retained in ancient Egypt long after a linear script had been developed. Skill and scholarship were needed to master the written language and scribes took pride in the careful design of a wall inscription or long papyrus roll. Each sign represented a word but hieroglyphs also employed what is known as the rebus device; two symbols combined according to the sounds they represent to produce a separate two-syllable word. There were strict conventions governing the form of both painting and writing. Much Egyptian art was concerned with rituals of death and burial, highly significant in their religion and culture. This section of the Papyrus of Ani from the Book of the Dead shows the mummy being escorted to the tomb (above)

small tablets were used for note-taking in business and administrative affairs; important data were then transferred to a more permanent record. The small note-tablets could be held in one hand while written on with the other. This gave a slanted direction to the symbols, towards the left-hand edge of the tablet. This was later incorporated into the formal, conventionalized cuneiform signs, giving them a definite horizontal emphasis. (Most of the evidence of early writing styles also suggests that throughout history the majority of people have been right-handed.)

The development of Egyptian civilization was concurrent with that of the Sumerians; Egypt upheld its cultural traditions through centuries of peace, war and invasion before collapsing under external influences. Egypt was, like Sumer, a well-organized agricultural society with a system of central government, land ownership and taxation that generated much administrative work. From about

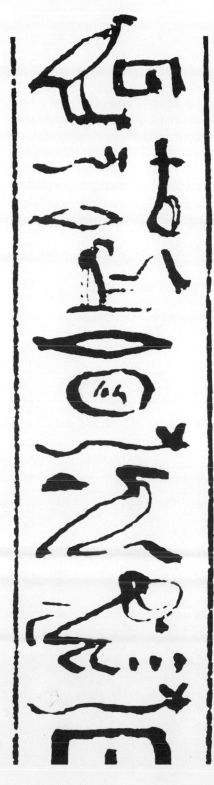

3000BC the Egyptians used a form of picture writing known as hieroglyphics, meaning 'sacred, carved writing'. Within 200 years a script had been developed, known as hieratic script. A thousand years later a less formal script, known as demotic, was also in use. Hieratic evolved as a simplified version of hieroglyphics, whereas demotic was a cursive, practical hand.

The Egyptians, like the Sumerians, had developed their writing through pictograms to ideograms and then phonograms. By 1500BC they had established an alphabet of 24 consonantal symbols, although this was never fully detached from the hieroglyphs and ideograms; the various forms were written together or side by side, as if to ensure that the text could be understood one way or another.

A major influence on the development of form in Egyptian writing was their use of reed brushes with liquid ink to paint the pictograms and signs, instead of relying on inscribed symbols. Further, they wrote on papyrus, a thin, flexible fabric, rather than stone, clay or wood, although those materials were cheaper, everyday alternatives. Prepared animal skins were even more expensive than papyrus and were reserved for documents of outstanding importance. The written papyri were rolled for storage and reading convenience. Until the 12th Dynasty (1991-1786BC) the writing was arranged in vertical lines and the sequence ran from right to left. After this period lines were arranged horizontally in narrow, vertical columns, but still read from right to left.

The Egyptians were the first civilization to have official scribes and a system of education that required the tedious copying of sample writing and admired pieces of literature. Trainee scribes and the sons of noblemen had to spend days memorizing the innumerable signs and the sequence of the writing. Nevertheless, this is indicative of the value Egyptians placed on literacy and the dissemination of knowledge; although many of the scribes were slaves, they were rigorously trained to carry out their particular duties.

In the time of Ptolemy I (323-285BC) the official court language was Greek, and Alexandria became a centre of learning based on Greek scholarship. The Egyptian 24-letter alphabet is thought to have had some bearing on the alphabet of the Semitic tribes of eastern Mediterranean lands. These tribes then passed their own alphabet to the Greeks, where it was gradually adapted to form the basis of the alphabet used today in the western world.

The most influential people among the Semitic tribes were the Phoenicians, who lived on the Levantine coast of the Mediterranean (now Lebanon and Syria). Their civilization was contemporary with the rise of the Egyptian Old Kingdom from 2700BC. The Phoenicians were a skilled and intelligent people, energetic traders, with a merchant fleet that sailed as far as the shores of Britain in the interests of business and commerce.

A stele of the first century BC (below right) is inscribed with demotic script of the Egyptians, which shed all traces of the pictorial symbolism of hieroglyphics. In Phoenician characters (below), which formed the basis of the Greek and Roman alphabets, both the origin and subsequent mutation of the symbol can sometimes be seen. The first letter in this sequence is aleph, *the V-shape representing the head of an ox, the cross-bar its horns. But the basis of the standard form of the Roman capital A is also visible.*

The oldest known alphabetic inscription of the Phoenicians dates from 1000BC. It is not known precisely how their symbols evolved, but there are ancestral links with Sumerian pictography and the cuneiform symbols taken over by the Babylonians. There were a number of different Phoenician settlements and local variations of written forms. However, by 1000BC there was at least one alphabet system in existence with only 30 symbols, each sign representing a single consonantal sound. These symbols were entirely abstract, not suggestive of pictures or associative ideograms. Phoenician culture survived a period under the Assyrians, who conquered and took control of their land from 850 to 722BC. The Phoenician alphabet emerged intact from this experience and was passed onto the Greeks in the form of 24 consonantal signs. It was also influential as the basis of Persian writing and the later development of Arabic scripts.

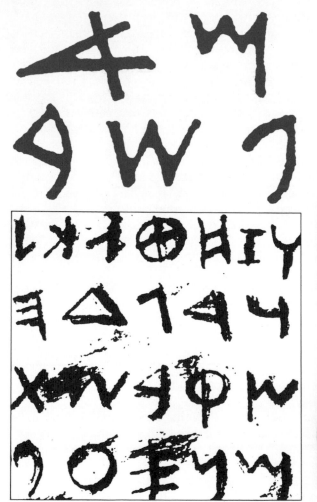

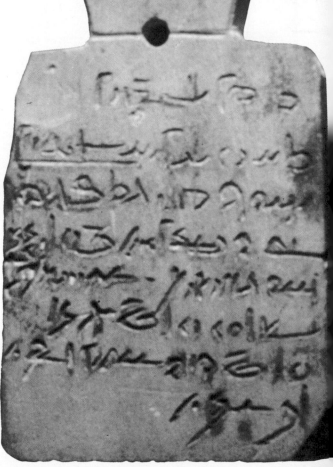

The classical period

The Greeks adopted the Phoenician alphabet some time before 850BC. There had been an earlier form of Greek writing, originating from Cretan scripts of 2500BC and later. This, however, had disappeared by 1200BC as far as can be judged from surviving inscriptions, and it appears that by the time they started developing their own alphabet on the Phoenician model, the Greeks were largely unaware of the earlier writing system. The historian Herodotus (active 484-425BC) describes the Phoenician contribution as follows: 'The Phoenicians . . . introduced into Greece, after their settlement in the country, a number of accomplishments, of which the most important was writing, an art till then, I think, unknown to the Greeks. At first they used the same characters as all the other Phoenicians but as time went on, and they changed their language, they also changed the shape of their letters.'

Letterforms from a Greek inscription of the fourth century BC (below), carved in white marble, show clearly how the forms of individual letters had evolved distinctively. Many of these capitals were taken as direct models for the Roman alphabet, others were slightly modified, such as Mu or M. In Greek lettering this is turned on its side whereas the Roman character is upright.

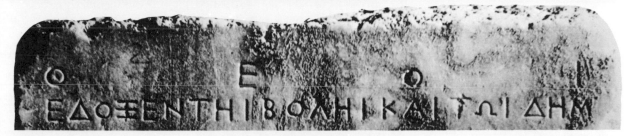

The modifications made to the alphabet by the Greeks were necessary because the Phoenician language was basically consonantal and not all the signs they used were applicable to the spoken form of Greek. The Greeks, therefore, adapted certain symbols to stand for vowel sounds instead of their original consonantal value. *Aleph*, an aspirant H sound in Phoenician, was converted to the vowel sound A and renamed *alpha* by the Greeks. (*Aleph* originally meant 'ox' and its written symbol was based on a simple drawing of an ox's head.) The first two letters of the Greek series, *alpha* and *beta*, have given us the term by which we describe the basic lettering system, the alphabet.

By 400BC a standard Greek script, called Ionic, had been developed to replace all local variations on the Phoenician forms. The Greeks at first used brushes for writing and wrote in horizontal lines from right to left. As they began to use reed pens more frequently, it became conventional to work from left to right, since for a right-handed scribe the pen moves more freely in that direction and the writing hand does not obscure the line of text. Briefly, in between, there was a form known as *boustrophedon*, where the lines ran alternately in opposite directions and the lettering was itself reversed in the reversed lines. *Boustrophedon* means 'following the ox furrow' and referred to the back and forth movement of a plough across a field.

The Greeks used papyrus and skin as writing materials, but wax tablets were also common. Wax enabled swift corrections to be made as

the surface could be rubbed to smooth and melt away the inscription. The forms of Greek writing in early papyri were squared and angular, echoing the carved letters, but they soon gave way to more rounded forms and informal, cursive writing styles also quickly developed.

The Romans had occupied the land around the River Tiber from about 1000BC, but their development as a nation proceeded slowly and was interrupted by Etruscan invasion, followed by an occupation that lasted from the seventh to the third century BC. Regaining control of their land, the Romans progressed rapidly, eventually becoming the most powerful people in the known world.

The Romans adopted certain characters from the Greek alphabet almost without modification (A B E H I K M N O X T Y Z). They remodelled others to suit their own language (C D G L P R S) and revived three symbols discarded by the Greeks (F Q V). By the dawn of the Christian era they had established not only this formal alphabet of a fixed number of signs, but also several different ways of writing it. Roman square capitals, the *quadrata*, are the elegant, formal letters seen on monumental inscriptions in stone; they were also drawn with brush and pen, but the fine, serifed forms of the inscriptional writing

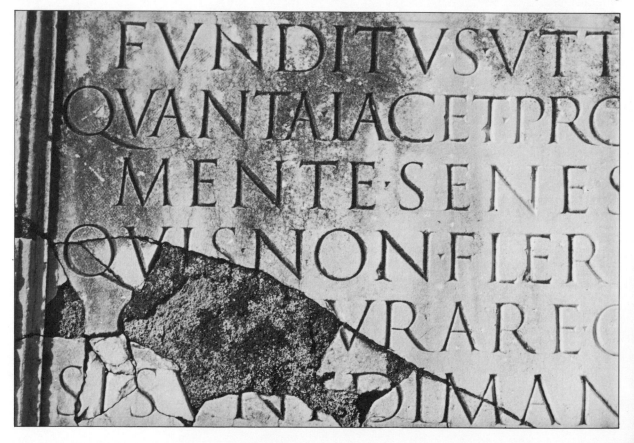

Etruscan letters (above) relate closely to Greek forms. The Etruscans occupied Roman territory for almost four centuries, but development of the formal Roman alphabet occurred after this period. The subsequent might of the Roman Empire was celebrated in many monumental inscriptions carved in stone. The elegant square capitals, or quadrata *(below) are the powerful legacy of a highly organized society.*

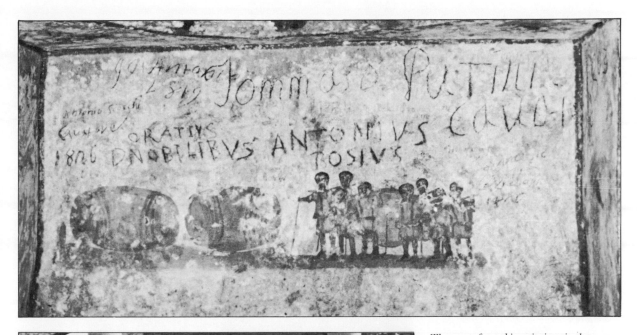

The many formal inscriptions in the Roman Forum (left) are evidence of the public life and government of Rome. But a large proportion of the population was literate and there were informal, cursive styles of writing on vellum and parchment, although of these more perishable materials fewer examples have survived. Graffiti in the catacombs of Priscilla (above) provides a memorial to a less grand personage than the Emperor Augustus. The name of Antonius Tosius was written on the wall of the catacombs in about 79AD and has since been joined by more recent but no more formal signatures.

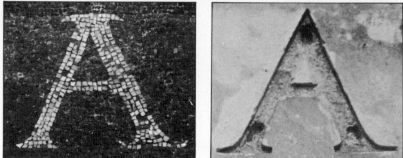

Throughout history the standard shapes of letterforms have been modified by the tools and materials with which they were described. The Romans made metal letters by casting from moulds. The recessed stone forms on a temple facade (above) originally carried metal letters and a closer view (far right) shows the marks where they were bolted in place. In this and the mosaic letter (right) it can be seen that the shapes were squared and coarsened to accommodate the nature of the materials used.

owe much to the action of the chisel. A less formal, more quickly written version was Rustic capitals, compressed, vertically elongated characters with softer lines. This became the main book hand of the Romans and was more economical than the squared, generously spaced *quadrata*. A cursive majuscule script evolved from the formal capitals and several variations of informal cursive script came into being. These were all standard forms within the Roman Empire by the first century AD. Greece had become a province of the Roman Empire by 146BC and Greek was retained as the language of scholarship, and for daily use in the ordinary communications of Greek-speaking settlements.

As the Roman Empire proceeded with its vast business of government and trade, there were many administrative centres employing professional scribes and much demand for the skills of writing and carving letters. A high proportion of the Roman population was literate and writing was an important method of communication at all levels. Papyrus was used everywhere, making its manufacture and distribution crucial to the economy of Rome. The wax tablets used by

the Greeks were also adopted, and public inscriptions of a temporary nature, such as political notices, were painted on walls in Rustics. Examples of these can be found in the ruins of Pompeii.

The Roman alphabet of the first century AD is the basis of the modern western alphabet and has only been altered by the addition of the characters J V and W, which were originally represented by I and U. These were medieval amendments. The most crucial influence upon the further development of writing, but concerned entirely with style and materials, was the rise of Christianity. This became the official religion of the Roman Empire in 313AD. In Egypt, which had become a province of Rome in 30BC, Christian influence closed schools and temples and caused the final demise of the hieroglyphic heritage. While the influence of the Phoenician alphabet elsewhere developed towards modern Hebrew and Islamic script, so the activities of missionaries throughout the Roman Empire spread Christianity across Europe and founded the traditions of western civilization.

Below *These letters are part of an inscription in the catacombs of Rome carved by Filocalus, a craftsman of the fourth century AD. The curling serifs contrast with the usual austerity of Roman capitals and prefigure a favoured motif of Victorian lettering.*

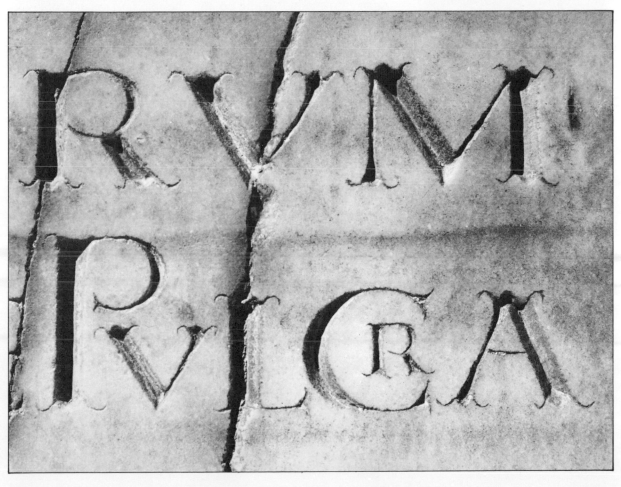

These examples of uncials in the style of fourth-century manuscripts (below) and half-uncials of the seventh century (bottom) show the transition from majuscule to minuscule forms, which was later fully developed in the Carolingian minuscule. The uncials are relatively even in height whereas half-uncials break through the writing lines and begin to form the ascenders and descenders typical of lower-case lettering.

The development of minuscule scripts

Two main developments in writing took place towards the end of the Roman period, one technical, the other formal. The papyrus rolls that had formed the books of Egypt, Greece and Rome were gradually replaced by codex books, which consisted of folded leaves bound together in the form that books take today. These may have derived from the everyday use of wax tablets framed in wood, which were often bound together with leather thongs to produce successive 'pages'. Early codex books put together in this way have been found with a combination of papyrus and parchment leaves. This form was superseded by the use of animal skins for all the pages, because parchment and vellum could be sharply creased, unlike papyrus which cracks when folded. Codex books were far more convenient than the long, rolled papyri, which could only be written on one side, because the outer surface was exposed to continual handling. It was also difficult to find a specific place in a long text while unravelling a continuous sheet.

As parchment and vellum became the standard material of books, the quill pen superseded the heavier reed. Since the animal skin surface could be made smooth and velvety, unlike the fibrous papyrus, the delicate quill suffered no immediate damage and scribes soon learned to shape and trim the quill to a suitable form. Like the reed, the quill was naturally equipped with a hollow barrel that retained a small reservoir of ink. The use of quills became a practical necessity in the further reaches of the Roman Empire, where they were simply more plentiful than the suitable reed. It should be noted, however, that the use of vellum and the quill pen was for a long time reserved for particularly important documents and the use of wax tablets in everyday transactions and records continued over several centuries.

By the fourth century AD the Romans had developed a new script, the uncial, which became the main book hand of Roman and early Christian writings, continuing until the eighth century. The term uncial was first applied to the script in the eighteenth century and derives from *uncia* meaning 'one inch'. The new script was a modification of square capitals, possibly based on cursive majuscule forms used in business records and contracts. The letters were still contained within a fixed height, like the capitals. The characters A D E H and M, however, were rounded, D and H having brief rising strokes like the ascenders of later minuscule forms. The uncial was then followed by the half-uncial. Here for the first time, certain letters broke through the writing lines with noticeable ascenders and descenders. This was a formalization of cursive styles that had developed in day-to-day use and were modified as writing became speedier. Half-uncial script was secondary to uncial and both were later replaced by formal minuscule alphabets. All the Roman letterforms show the influence of the square-edged pen, which may be seen in the characteristic graduation of thick and thin strokes.

Uncials and half-uncials were taken to monastic settlements in the north and west of the Roman Empire by Christian evangelists and missionaries. In Ireland and the north of England they developed into what have become known as the Insular scripts. The tradition evolved of writing the gospels in the form of highly decorated codex books; two of the finest are the Lindisfarne Gospels, written in the northern English monastery of Lindisfarne some time after the death of St Cuthbert in 687AD, and the Irish Book of Kells, probably written by monks on the island of Iona at the end of the eighth century. The Book of Kells, which was never actually completed, also provides much interesting evidence of the writing and decoration techniques employed by the early scribes.

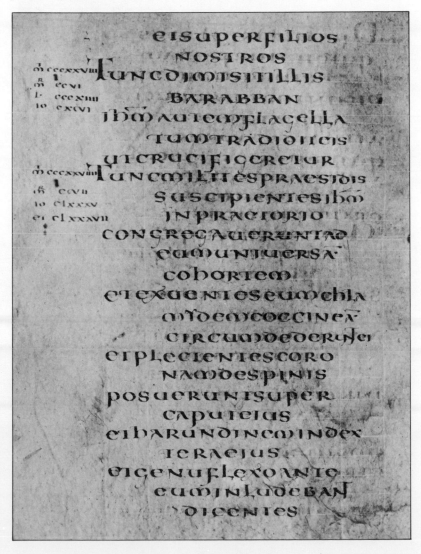

Left Uncials were developed in Roman times and became the standard script of the early Christian church. These Latin Gospels of the sixth century are representative of the style of many such manuscripts – open, even spacing of the lines and no decoration other than a few enlarged capital letters. The lines are carefully arranged against a left-hand margin or secondary alignment indented by four characters. At that time there was no convention of word spacing and punctuation that later became standard form in book design, although some early manuscripts have distinct word spaces.

These English and Irish half-uncials technically remained majuscule scripts; they were preserved concurrently with the development of minuscule, cursive forms of writing. At the same time, such scripts were being developed in other centers of scholarship throughout Europe; at Luxeuil in France, Bobbia in Italy, the Iberian peninsula of Spain and in the area ruled by the Merovingian kings of the Franks in northern Europe. Clearly, although local variations were numerous in the period of confusion following the collapse of the Roman Empire, the missionaries traveling between the many monastic centers provided a link in developing written forms.

1 2 3

Carolingian script was the first systematic development of a true minuscule letterform. It was constructed by reference to forms of writing from Roman times to the ninth century and once standardized was disseminated widely through European countries. In use over two centuries, the basic characteristics of the alphabet changed little (1 and 2). Rustic capitals (3), the informal Roman majuscules, were commonly used for main headings or secondary titles. A manuscript of the early tenth century (right) shows the convention of using majuscule and minuscule forms (capitals and lower-case), clear spaces between words and separation of paragraphs, demonstrating a typical style of book design still in use to this day. Some regional variations of the Carolingian script developed; a page from an English eleventh-century Pentateuch (far right above) with the story of Noah's Ark boldly illustrated, is written in a slightly squared version. Square Roman capitals have been used here. By the twelfth century the beginnings of Gothic lettering are clearly seen in a page from a Flemish Bible, written in Latin (far right below) right. The writing has become compressed, angular and vertically stressed.

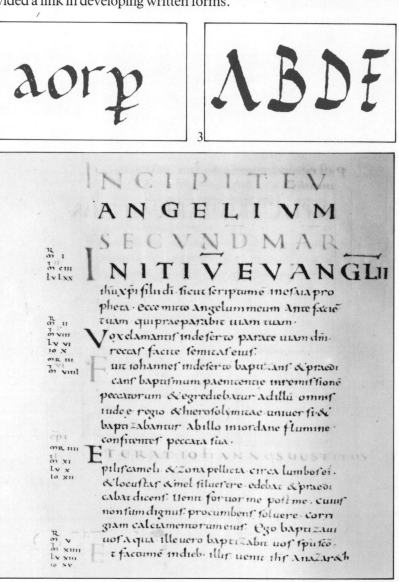

At the end of the eighth century a general renaissance of European scholarship and culture was organized under the patronage of Charlemagne, king of the Franks (768-814) and subsequently Holy Roman Emperor, who governed a vast area of land stretching from Italy and Spain right across northern Europe. Charlemagne appointed Alcuin of York (735-804) master of the court school at Aachen, then, in 782, abbot of the monastery of St Martin at Tours. One of Alcuin's most important commissions was to revise and standardize the variations of minuscule scripts that had appeared. In doing so, he referred back to the original forms of Roman alphabets – square and Rustic capitals, uncials and half-uncials. In addition, he was directed to retrieve the original form of particular texts and eradicate all the corruptions and errors that had naturally arisen during many years of copying and writing from dictation, with all the attendant confusion that had been caused by the interpretations of individual scribes.

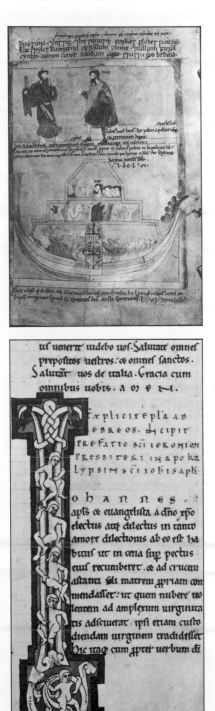

Alcuin's finest achievement was the development of a formal minuscule script for use as a standard book hand. This has become known as the Carolingian minuscule, after its instigator, Charlemagne. It was widely adopted throughout the Holy Roman Empire as the cultural reforms of Charlemagne were carried on by his successors. It also gained influence beyond the borders of that empire; for example, by the tenth century the Carolingian form was in general use in England, where, despite regional variations, the basic, considered form promoted by Alcuin was still preserved.

Another aspect of book production that was standardized during this time was the hierarchy of scripts, which was used to denote the different purpose and importance of information in the text. Major titles, for example, were written in Roman square capitals; the opening lines of text in uncials or a preface in half-uncials; the body of the text was written with the Carolingian minuscule, while amendments and notations might be added in Rustic capitals. The rich decoration of biblical texts, lavishly painted and gilded, also gave rise to elaborate capital and marginal letters and various forms of text ornaments. Monks employed in *scriptoria*, the writing rooms of the monasteries, worked long hours at their highly concentrated tasks. Different aspects of the writing and decoration would be carried out by different hands. The manuscripts sometimes contained colophons mentioning the names of the workers involved. In general, however, the work was undertaken for the glory of God and the dissemination of Christian ideals and any attempts to attract individual credit were not popular and actually discouraged.

The development of Carolingian minuscule was the most important landmark in the history of writing since the standardization of the Roman alphabet. From this point all the elements of modern writing were in place; modifications since that time have been essentially practical or fashionable, not basically structural.

Gothic and Renaissance scripts

The Carolingian minuscule was the standard book hand of Europe in the ninth and tenth centuries and survived through to the twelfth century. In some places, however, definite changes in the style occurred quite early on. Tenth-century manuscripts written at the monastery of St Gall in Switzerland, for instance, began to show compression and angularity in the writing. Then, through the eleventh and twelfth centuries in Germany, France and England the style of minuscule writing became increasingly compressed and fractured; it formed an extremely dense, matted texture on the page. This particular form of Gothic lettering became known as Black Letter, which is a term that immediately suggests its heavyweight appearance and is thus an apt description.

The angularity of the minuscule script was mainly the result of writing quickly, with a slanted pen angle, which tends naturally to eliminate broad curves. The letterforms were compressed in width and became narrow and elongated; this allowed economy in the use of materials – more writing to the page – and, as the writing was more rapid, economy in the time spent by the scribe. There was a great need for this economy as the demand for written texts grew. In the late medieval period manuscripts were no longer just the privilege of the ruling classes and the church; business affairs and secular education had begun to assume greater importance. There were administrative

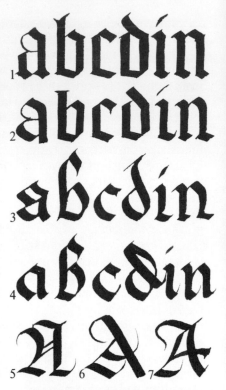

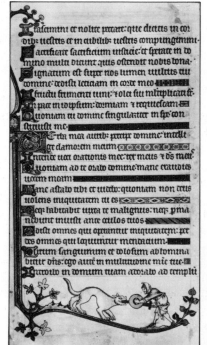

There are several variations on the Gothic hand. Textura quadrata *(1) is recognizable by the diamond-shaped feet and forked ascenders of the letters. In contrast,* textus prescissus *(2) does not have feet or serifs. The Gothic* littera bastarda *(3) and the* bastarda cursive *(4) forms were based on the Textura hand, but were intended to be less formal. The Textura was basically a lower-case script, although the capital form (5) was used if necessary. There were variations on the* bastarda *capital forms (6 and 7). Scribes enjoyed playing with the formal Gothic hand, making sentences using only the letters i m n u v (above). Many documents were written out in the Gothic hand. This twelfth-century manuscript is written in Textura; the patterned line endings are typical of this period. The* Froissart Chronicles *(far right) date from the fifteenth century, and clearly show the French 'lettre bâtarde' style.*

and legal matters to be dealt with, texts for schools and universities; the writings of philosophers and early scientists were in demand; books on subjects such as mathematics, astronomy and music were needed and, in the thirteenth and fourteenth centuries, there was a growing literary tradition of poetry and story-telling. Professional scribes were no longer necessarily court employees or monks and the business of making books flourished.

Northern styles of Gothic Black Letter are known as Textura, in reference to the woven appearance of the page of text. Many different formal and informal styles of Gothic script emerged during the thirteenth and fourteenth centuries. In the later period the writing became mechanically even and rigid; two of the main formal variations were *textus prescissus*, with the vertical stems of the letters standing flat upon the writing line, and *textus quadratus*, which has the characteristic lozenge-shaped feet crossing the base of the stems. The *quadrata* style is particularly familiar because it became the model of printers' types in northern Europe. In this way it gained wider circulation, especially through the Bible, which was the first printed book of the Gutenberg Press, established in 1450. A number of cursive Gothic hands were also developed, characteristically angular and pointed with exaggerated ascenders. This general style was termed *littera bastarda*, to indicate that it was not a true script but a mongrelized version of the formal script.

Gothic was a term applied to the products of the late medieval period by the Renaissance scholars, who thought the cultural style of that period so outrageous that they named it after the barbarian Goths; like several other art historical terms, it was originally intended as an insult. The development of minuscule in Italy during that period also tended towards compression and angular forms, but it never took on the rigid vertical stress typical of northern European forms. In Italy the minuscule retained a more rounded character and was known as Rotunda, also identified as *littera moderna*. This style was used in handwritten and printed works until the late Renaissance period.

In fifteenth-century Italy new styles of writing were developed, which became known as Humanist scripts, because they were associated with scholarship and science. Around 1400 the Florentine scholar and scribe Poggio Bacciolini (1380-1459) returned to the original form of Carolingian minuscule as the source of a new book hand, an alternative to the Rotunda script. This was termed *littera antiqua* in acknowledgement of its origins, which were older than those of the *moderna*. Also in the early fifteenth century, the scribe Niccolo Niccoli (1363-1437) derived an angular, cursive hand from the informal Gothic cursive. This was the basis of italic script. Both men returned to classical Roman forms for their capital letters, and Niccoli's were given a slight slant, in keeping with the tilted stress he also used for his minuscule script.

Above *A stylus, made of metal or bone, was an important item in the scribe's equipment. In early manuscripts the writing-lines were sometimes ruled with a fine sliver of lead, but a commonly preferred method was to prick the measurements on vellum with a sharp point and then score the back of the page between the marks with the rounded points of the stylus. This raised a line faintly on the upper side of the vellum and was not as obtrusive as a drawn rule.*

cancellaresa circonflessa

et ponendo la parte di dentro di detta punta sopra l'unghia del uro dito grosso sinistro ouero sopra uno ditale d'osso nero che ci hauerete come questo la tagliarete uguale in punta senza scarnarla, co si et per chi sà scriuere la scarnarete et fenderete in punta non piu di cosi ouero tagliaretela zoppa nella pu ta destra cosi ouero tonda in detta punta destra cosi ouero tutta tonda cosi che serue ancor à scriuer bene lra mercantile Cò la penna temperata in uno de i modi sopra dissegnati

tenuta cosi

Above *The pages of copy-books often included not only the sample scripts, in this case an elegant* cancellaresca *or chancery script, but also illustrations showing the shape of quills and nibs, correct pen angles and, on many occasions, incorrect pen angles, so the reader copying the style could be in no doubt as to how to achieve the very best technique of writing.*

These revised scripts influenced writing across the whole of Italy and became standard hands for the copying of classical texts. In addition, the papal scribes responsible for issuing the papal bulls and briefs from the Roman Chancery had resisted the peculiarities of Gothic script and developed their own cursive hand with flourished ascenders and descenders – the *cancellaresca* or chancery script.

The Subiaco Press, set up near Rome in 1465, took Humanist scripts as the model for type forms. Printing spread rapidly in Europe in the second half of the fifteenth century, but there remained a demand for handwritten manuscripts. The Chancery scribes were generally involved in producing single or limited numbers of copies so their work was not usurped by printing. Other scribes rose to the challenge of printing and it became a point of pride to produce the finest examples of their scripts, as long as handwritten books retained a certain prestige. Nevertheless, many lesser scribes came to the blunt realization that their days were numbered.

Paradoxically, printing was actually beneficial to various enterprising scribes; the age of the *scriptorium* was past, but people still had to write by hand and still took an interest in the proper forms of scripts. In 1522 the Venetian Ludovico degli'Arrighi published a printed book of writing samples, the *Operina*, for instruction in the *cancellaresca* style. In 1523 he followed this with a manual of several scripts including cursive Black Letter, Roman and italic forms. The printed copy-book became fashionable and several writing masters took up the idea, not only in Italy but in Germany, France, Spain and England. In this way the Humanist scripts spread out across Europe. The chancery hand, for example, was favoured in Tudor England and was actually adopted by Elizabeth I (1558-1603).

Handwriting and printing

As printing replaced the task of copying standard texts, the status and purpose of a scribe's skill declined rapidly. Writing became a day-to-day affair, no longer a specialized art or craft. Scribes turned to teaching the art of writing or copying business documents; in association with the tedium of the schoolroom or the sharp practice of lawyers and moneylenders, they lost all prestige. The writing masters, who published work and tried to attract individual patrons, were conscious of their precarious position and became fierce in their rivalry. They concentrated on developing ever more elaborate and eye-catching forms, as self-advertisement. The pure functionalism of medieval and Renaissance scripts became obscured in the extraordinary flourishings of the copy-book styles.

Arrighi's first book had been cut on wood blocks, which was a rather crude and risky technique for reproducing the fine detail of a script and the essence of pen-made forms. Later in the sixteenth century the

These samples are typical of the elaborate hands developed by the writing masters to show off their virtuosity with the pen. The earliest here is an italic script (below left) from examples published in Italy by Francesco Moro between 1560 and 1570. A fluid copperplate style, with convoluted joining strokes and flourishes (below) is a line engraving from A Tutor to Penmanship *assembled by John Ayres and published in 1698. A style similarly influenced by the technique of engraving is seen in the finely wrought initial letters from* Natural Writing, *produced by George Shelley in 1709 (above). These items span more than a century but in each generation, as copy-books became more and more popular, there was fierce and public competition between contemporary masters.*

propter nomen suum.
Nã & si ambulauero in medio vm-
bræ mortis, non timebo mala quo
niam tu mecum es.
V irga tua & baculus tuus,ipsa me cõ
solata sunt.
P arasti in conspectu meo mensam,
aduersus eos qui tribulant me.
I mpinguasti in oleo caput meum:&
calix meus inebrians quàm præcla-
rus est.
E t misericordia tua subsequetur me,
omnibus diebus vitæ meæ.
E t vt inhabitem in domo domini,in
longitudinem dierum.
R equiem.ãn. In loco pascuæ ibi me
collocauit. ãn. Delicta. Psalmus.
A D te domine leuaui animã me-
am : deus meus in te confido,
non erubescam.
N eque irrideant me inimici mei:et-
enim vniuersi qui sustinent te non
confundentur.
C onfundantur omnes iniqua agen-
tes,superuacuè.
V ias tuas domine demonstra mihi:
& semitas tuas edoce me.

*Above In printed books many of the forms
of design and decoration were adapted
from the conventions applied to
handwritten manuscripts, but text and
decoration were more strictly separated
because of the technical methods of
printing. Metal or wood type was
combined with ornaments cut in wood
blocks, giving an even arrangement as in
this sixteenth-century French psalm book
in which all the margins are filled with
motifs.*

technique of copperplate engraving became available; this was a delicate, linear style that could reproduce the finest flourishes of the pen more efficiently than it could imitate the broad strokes of a flat-edged nib.

One of the first writing masters to take advantage of copperplate engraving was the Milanese scribe Gianfrancesco Cresci. In 1560 he published a book, the *Essemplare*, showing a flourished italic *bastarda* style, originally written with a narrow, round-point pen. This marked a definite break with previous writing traditions. The new styles were developed on the basis of a pointed pen, which was made to produce a variation in stroke by pressure, rather than by the effect of its natural shape. The flowing, looped and elaborated forms of script were written without lifting the pen. The basic form of such writing was, in fact, more speedy and practical, but the ornamentation was soon developed to excess in the search for novelty.

In the seventeenth century these decorative scripts became standard. The slow, intricate process of copperplate engraving, which involved copying a tracing from the original manuscript onto the plates, reduced the individuality of handwritten models. Ironically, the procedure had been reversed, so that those using the engraved copy-books were also forced to use pointed pens to imitate the model alphabets. In Germany the Gothic book script survived in everyday use, but copperplate styles were introduced to northern Europe. In England, France and Italy the italic *bastarda* took root and was propagated by the writing masters' elaborate publications. English penmanship was highly influential. Edward Cocker's *The Pen's Transcendencie*, published in 1657, and George Bickham's *The Universal Penman*, published serially between 1733 and 1741, were the standard works of their time. Bickham's opus contained 212 plates and represented the work of 25 different scribes.

These styles of penmanship continued through the eighteenth century and into the nineteenth. Copperplate hands were also taken to America by colonists and a London writing master, Joseph Carstairs, had considerable success there in 1830, when his handwriting book was published advocating a technique using the whole arm, rather than the hand and fingers, to control the flow of the pen. Carstairs was also influential in England with this style. There were more modest variations of copperplate hands used in everyday business affairs, but in general the fine lines and looping ascenders of the formal scripts set the tone. The spread of literacy also had the effect of disseminating the debased scripts more widely.

During the nineteenth century metal pens came into general use; it is notable from manufacturers' advertisements that pointed nibs were the usual form. The mass production of text – books, broadsheets and pamphlets – was all accomplished by printing from metal typefaces. Another development was the introduction of lithography for colour

printing of ornament and illustration. Highly decorated and illustrated books became popular, reviving interest in the forms of medieval illuminated manuscripts. These were the inspiration for much of the decoration in Victorian books, but when the forms of Gothic letters were revived the pointed pens could not cope naturally with the angular movement that had been characteristic of the square-cut quill. Copyists resorted to outlining the letters with a pen and filling in the strokes with brush and ink.

Essentially, then, the earlier traditions of European penmanship had been lost and the production of books and manuscripts was heavily dependent upon the relatively recent styles of elaborated ornament, many of which were entirely gratuitous and often recognized by some of the writing masters themselves as being of poor taste and construction. In the late nineteenth century the time was ripe for a revival of the pure penmanship of the medieval era and this was instigated in England by the work of William Morris and followed through by Edward Johnston, both of whom took the trouble to study the early manuscripts so that they might rediscover the proper techniques of their design and execution.

Above *Writing manuals contained details of every aspect of posture and technique. This engraving of the correct position for a lady when writing appeared in Diderot's* Encyclopaedia *of 1760. It was a popular image and was repeated, with modifications, in at least one other, later work. The lines drawn vertically through the figure show that the correct posture was supposed to be rigidly upright and symmetrical.*

Media & materials

The essential components of calligraphy are the writing tool, the medium and the surface. In effect, anyone with a pen, a bottle of ink and a sheet of paper can start to practise the craft, without acquiring a wide range of materials straight away. However, there is a large variety of manufactured products and traditional materials that a calligrapher can use. In addition, there are related techniques that require more specialized knowledge. This chapter presents a review of available materials and how they meet the particular requirements in calligraphy. Their value and precise effect in terms of individual style must be judged separately by every user.

Writing tools

Quills

Quills have been in use for hundreds of years. Although they have been superseded by the widespread use of metal pens, quills are still preferred for writing on vellum, because of their particularly sensitive touch and flexibility. The word pen, in fact, derives from the Latin *penna*, meaning 'feather'.

The form of the quill and its handling by the scribe is recorded in many illuminated manuscripts; it was not uncommon to include a small portrait of the scribe at work, presumably as a form of self-acknowledgement for the labour and expertise applied to the task. These tiny 'self-portraits' were placed in Biblical texts, for example, to represent the Evangelist at work on writing the Gospel.

To the casual observer, while it is clear that such pictures show the act of writing, the quill itself may be less recognizable. The popular conception of a curly plume, associated with later, elaborate writing styles, is a more romantic object than the true form of a quill pen. In practice, the quill is cut to a convenient length, about 7-8in (18-20cm) and stripped of its barbs, leaving a plain, streamlined instrument. Too much length can be a hindrance as a long quill tends to twist in the hand and the rising end may also be unintentionally obstructed by the scribe. There is no advantage to keeping the barbs; the stripped quill is cleaner and more easily handled.

Below *This engraving illustrates the nib dimensions used for quills in fine writing. It can be clearly seen that the nib tip is one-quarter the length of the whole nib; the shoulders occupy the remaining three-quarters. It is also interesting to note the different angles of the actual tip. Scribes who cut their own quills have the advantage of being able to choose the particular nib angle they desire. A nib is trimmed obliquely, specifically to give greater comfort to the user. A straight-edged nib has to be held in an unnatural writing poise, whereas an angled nib allows the scribe to maintain a natural position.*

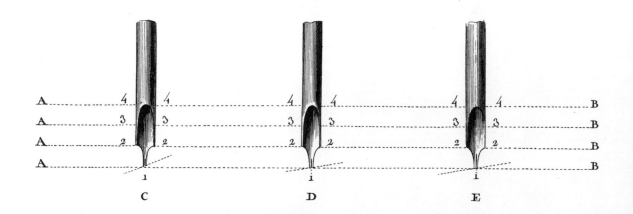

Proportions d'une Plume taillée

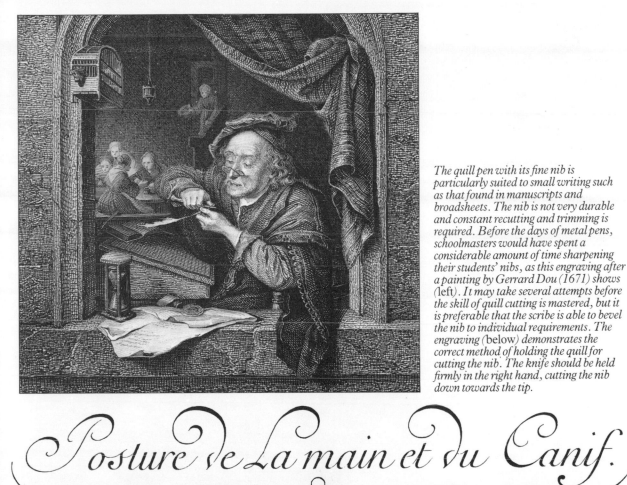

The quill pen with its fine nib is particularly suited to small writing such as that found in manuscripts and broadsheets. The nib is not very durable and constant recutting and trimming is required. Before the days of metal pens, schoolmasters would have spent a considerable amount of time sharpening their students' nibs, as this engraving after a painting by Gerrard Dou (1671) shows (left). It may take several attempts before the skill of quill cutting is mastered, but it is preferable that the scribe is able to bevel the nib to individual requirements. The engraving (below) demonstrates the correct method of holding the quill for cutting the nib. The knife should be held firmly in the right hand, cutting the nib down towards the tip.

Posture de La main et du Canif.

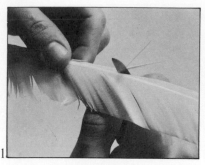

Once a feather has been sufficiently dried, the cutting process may begin. Use a knife to cut away the barbs or filaments from the shaft. The knife should be placed against the stem (1) and the barbs stripped back with the help of the thumb (2). The end of the shaft should then be cut obliquely down towards the tip (3). There is no specific place at which to start this cut, provided enough of the shaft remains for the length of the nib. The pith-like centre should be removed at this stage (4).

In Europe quills have been widely used not only for their fineness, but because they were and are an available material. The primary flight feathers of a swan, turkey or goose make the best quills; they are slightly curved to left or right, depending on whether they come from the right or left wing of the bird. Left-wing feathers make the best pens for right-handed people. Duck and raven feathers have also been commonly used as well as delicate crow quills for fine work. Turkey feathers are now most common; they are essentially harder and less greasy than goose quills.

To render a quill suitable for use as a pen the natural oils must be dried out. This takes from six to twelve months if it is left to dry naturally. Forced drying methods involve cleaning by scraping, soaking or steaming, followed by heat-drying, which makes the quill lose some of its elasticity. In its natural state the shaft of the quill is opaque and relatively soft; it is hardened and clarified by heat. The

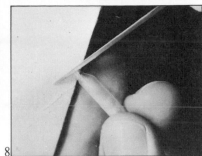

To form the end of the nib make a second cut (5). This is another oblique cut; it forms the stepped arrangement of a nib, with the upper part as the shoulders and the lower as the nib tip. Gently pare the sides of the nib (6) until the nib tip is slightly less than the desired width. This will be rectified when the tip is trimmed. Then, cut a slit up the centre of the nib tip (7). This should be carried out with extreme caution to prevent the slit from becoming too long. The final shaping of the nib is done on a smooth, hard slab, placing the nib with the underside down (8). Use the knife to make a slight slanting cut towards the end of the tip and then cut vertically downward, either at right-angles to the slit or obliquely.

simplest heat treatment is to hold the quill near a fire or put it briefly in a gently heated oven. One traditional method is to soak the quill, dry it and then plunge it into a tray of heated sand. The quill takes on a more brittle texture after heating and needs only brief exposure to heat. Natural drying is a less risky, if lengthy, process. But some scribes prefer the touch of the hardened quill and it is worth trying both drying methods to discover how they suit individual requirements.

The natural size of a quill obviously limits the width of stroke that it can make. The pointed end is fashioned into a nib shape by shaving away the underside, paring down a double shoulder and slicing across the tip to form the writing edge. The end of the nib is bevelled at an angle and then the whole nib is carefully slit up the centre to encourage the flow of ink. Quills are sold cut or uncut. The cut quills may be useful for those learning to handle the tool initially, but most scribes prefer to trim the writing tip to their own specifications. The quill is, in

any case, much more vulnerable than a metal nib and will need frequent recutting when used continually. It is important to remember always to cut back the shoulder of the pen as well as trimming the writing edge, so its flexibility is maintained. Trimming is a delicate business that must be carried out properly, as a ragged quill will pick at the writing surface.

A sharp, sturdy knife is needed for quill cutting. This is the origin of the term penknife, although the present-day penknife is no longer designed for such a purpose. Quill-cutting knives should be available from the suppliers of quills. A tough surgical scalpel or gardener's budding knife are acceptable substitutes. The knife may also be used to scrape ink from vellum when an error is made. Other necessary items of equipment are an oilstone for sharpening the knife, a small slab with a smooth, rigid surface as a base for cutting, and a magnifying glass for checking the nib quality. The fascination with writing accessories long ago produced quill-cutters that trim, shape and slit the nib mechanically. However, hand-cutting is often preferred, as it preserves the particular shape of the pen chosen by individual scribes to complement the touch and movement of their writing.

Below *This engraving clearly illustrates the correct methods of holding a quill pen. Note how the fore and second fingers are extended along the shaft of the quill to give greater fluidity to the writing motion. The length of the quill has been reduced to a manageable size and some of the barbs have been left at the top end, where they will not interfere with the writer's hand. The 'penknife' should have a long, rounded handle, comfortable to hold, and a short, fixed blade. The blade needs sharpening on one edge only and should be tapered to a fine point. It is essential to use a sharp knife for trimming and cutting.*

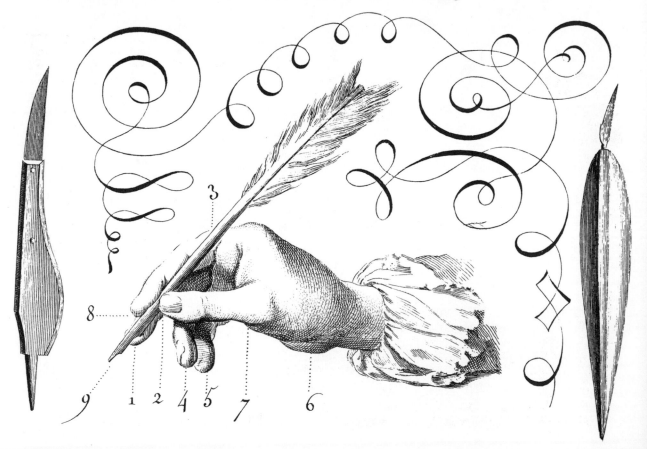

Reed pens

Reed pens date back even further than quills, but they do not play such a large part in European writing traditions. They are particularly associated with the development of writing in areas of the Middle East, where the right type of reed, hollow-centred but sturdy, was readily available. Reed pens are still among the tools of the modern calligrapher for the same reason that the quill is still used; a natural material is often preferred to the manufactured alternatives. If hollow reeds prove difficult to obtain, gardeners' canes are similar and can be used instead.

A reed or cane is larger than a quill, so it can be cut with a much broader nib; a number of reeds can be shaped and trimmed to suit different purposes. A length of about 8in (20cm) is cut from the reed, then one end sliced at an oblique angle. The soft pith around the hollow centre is shaved down until the part forming the nib is fine and hard. The sides of the cut section are trimmed to form the shoulders of the nib and a vertical slit is made up the centre. The tip is then cut cleanly across to form the writing edge, square or angled and at the required width.

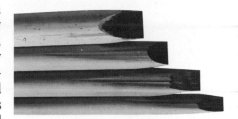

It is possible to cut reed nibs to a thicker width than those of the quill pens. This means that the reed is generally more popular for large writing. Nibs may be cut to varying widths (above) and the nib tip may be straight or angled. This lettering by the scribe E.M. Catich (below) clearly demonstrates the bold strokes typical of the reed pen. The thick and thin contrast is evident, with a smooth graduation between these two strokes occurring on the diagonal. This may vary according to the angle at which the pen is held.

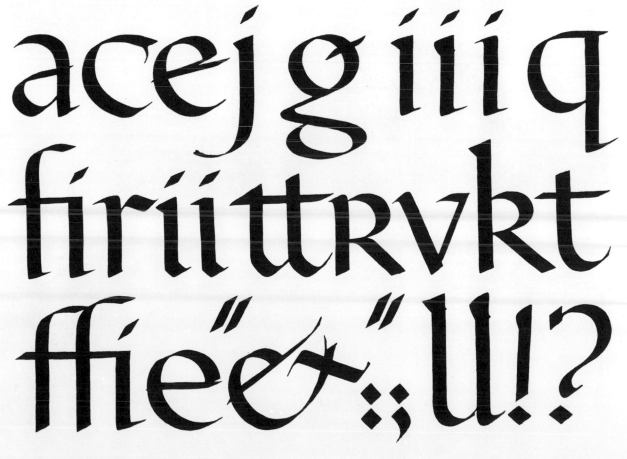

A reed pen is made from a hollow-stemmed reed or cane. Use a knife to make the initial oblique cut at one end of the stem (1). The material is not as flexible as the quill, so that a further trimming cut may be necessary (2). At this stage the central pith should be removed with the point of the knife (3). Then, place the nib on a smooth surface, underside down, and slice off a small piece to bevel the top of the nib (4). Both sides of the nib may then be trimmed to the desired width (5).

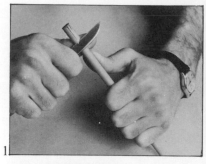

1

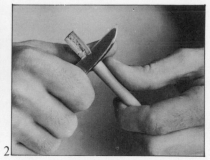

2

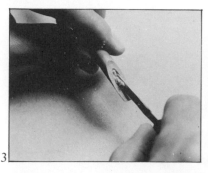

3

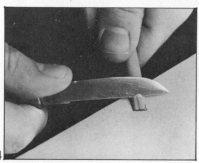

4

5

6

Once the basic shape of the reed tip has been established, the finishing touches can be added. Placing the pen on a flat, hard surface with the underside down, slice vertically through the nib tip to produce an even, flat edge (6). This should be angled at 60° to form a fine point. The slit may then be made in the centre of the tip, taking care not to allow it to continue too far up the tip (7). The slit is essential for consistency in the ink flow.

7

Metal pens

Despite appreciation for the sensitivity of a quill, scribes limited to this type of pen could not fail to be equally aware of its disadvantages – that it wore down quickly, required frequent recharging with ink and soon had to be replaced with a freshly cut tool. The search for an equivalent made of a durable material began early; bronze pen nibs have been found dating back to Roman times and, occasionally, in later centuries a quill sculptured in precious metal was produced as a prestigious, although impractical, gift for a person of importance. The main problems encountered in making metal nibs stemmed from the material, which was not sufficiently flexible and also became corroded by the ink.

Steel pens, first produced in quantity in the early part of the nineteenth century, were at first scratchy and insensitive. As industrial processing improved, however, so did quality and mass-production of metal pens of uniform shape, and flexibility also became possible. These were regarded as disposable items and demand was high, which made them relatively inexpensive.

Modern manufacturing processes allow for precision-made units produced to carefully assessed specifications. Although the basic form of pen nibs has changed little, there is a vast range of shapes and sizes from which to choose. Most commonly, nibs and penholders are still produced as separate units, although pens for special purposes, with extremely broad or unusually shaped nibs, are generally sold in one piece. Detachable nibs are sold singly, in boxed sets according to design or width, or on a display card that includes a penholder. Some types can be fitted with a slip-on reservoir that controls the flow of ink. To avoid any deterioration of the metal before the pen is used, the nibs are coated with a fine lacquer, which must be removed by gentle scraping or by passing the nib briefly through a flame. The ink flow is irregular if the lacquer is not removed.

Square-cut nibs, appropriate for a range of basic letterforms, are available in a number of different widths. For left-handed writers they are made with an oblique edge slanting down from right to left, which can be held at a more comfortable angle than the squared nibs. These are also preferred by some right-handed calligraphers when writing letterforms such as uncials that require a slightly strained position of the hand to achieve thick and thin contrasts in the right relationship. Extremely broad nibs, up to about ½in (1.2cm) wide, are also made as separate units for use in a penholder. Italic nibs with chisel-shaped tips have a narrower, more streamlined shape than the square-cut types.

Wide nibs, permanently fixed onto a wooden shaft by a hollow metal barrel, vary in shape; they may be broad throughout the length or bear a heavy crossbar that forms the writing edge. A variation on the traditional designs are pens consisting of two angled blades aligned at the writing edge, forming a lozenge shape. These are manufactured in

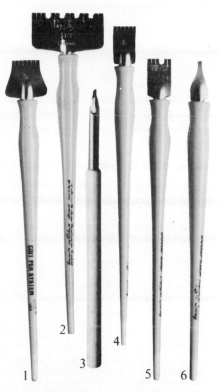

Above *Metal pens have more adaptable nib designs than the reed and quill pens. A range of pens, known as Coit Pens, have toothed nibs. These may consist of several teeth (1), some wider than others (2). The teeth may be spaced more or less widely apart (4), producing parallel strokes, of the same or varying widths (5). They are used for decorative lettering, where a number of elaborate linear strokes are required; a striped effect can be achieved with one stroke instead of several, which would be necessary with a single-stroke pen. Metal pens do have single nibs, which can be removable (6) or fixed onto the penholder (3). These fixed nibs are called witch pens, and have a a tip that turns over at the point. They produce a smooth stroke suitable for any paper surface and particularly for design work.*

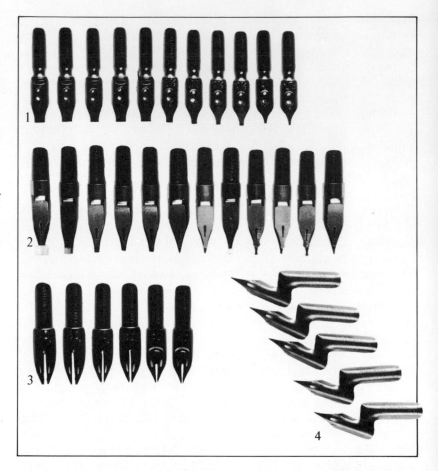

The range of nibs for metal pens is very extensive. Particular types of nibs may be used for specific purposes, but within each category there is still an enormous choice of shapes and sizes, mostly governed by the nib width. Round-hand pens (1) are very versatile writing tools. They are able to produce a great variety of styles from italic to uncials. The nibs may either be square-cut or oblique for left-handed writers. Assorted drawing pens (2) are also available with fine nibs from the flexible to the very rigid. Their various uses include sketching, lettering and cartography. The scroll pens (3) produce very individual writing. The double point on the nib draws two lines to give a shadow effect. The points vary in size and may both be equal or have one thick and one fine. They are particularly useful for text ornamentation. The copperplate nibs have a very distinctive shape (4). The elbow bend is designed for the particular style of copperplate writing and allows for maximum comfort and speed.

a series of widths up to ¾in (1.9cm), which can be used for lettering 5-6in (13-15cm) high.

In addition to these single-stroke pens, there are designs with shaped and multiple-tipped nibs for decorative writing and ornamentation. A single pen may have two or three broad tips or up to five fine points. The five-pointed type is used for ruling music staves, but also gives an interesting effect in calligraphy. For delicate, linear ornaments a crow quill or mapping pen is suitable. Whereas an edged pen can be twisted to form fine hairlines, a pointed nib is easier to use in consistently fine work such as flourished decoration or copperplate hands. The pen designed for copperplate writing has a delicately pointed nib, set at an angle to the shaft.

It is apparent from just looking at pens and nibs what the basic characteristics of the strokes will be in each case. A set of square-cut nibs and one or two broad pens provide the elements of formal penmanship. From there on the choice of pens for experimental or decorative effects is a matter of personal style and preference.

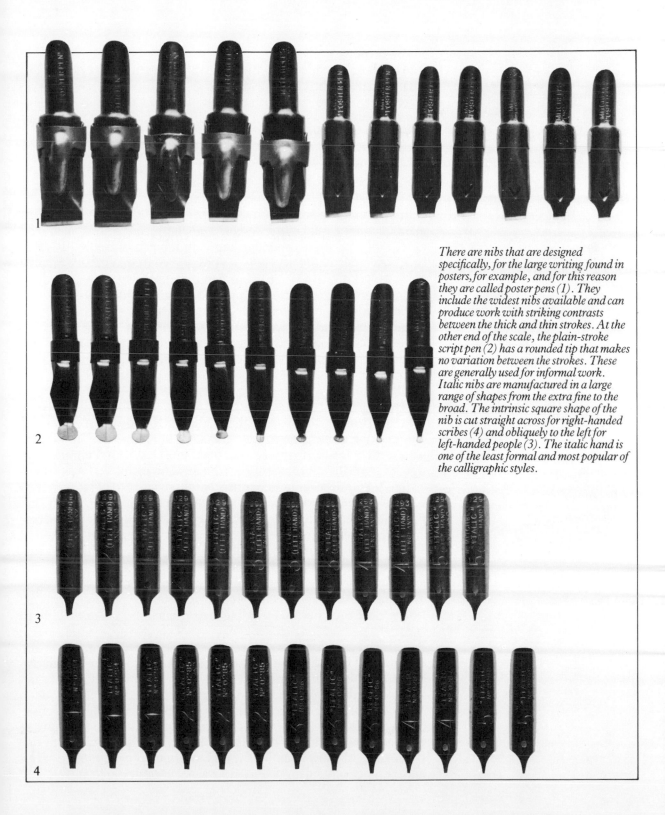

There are nibs that are designed specifically, for the large writing found in posters, for example, and for this reason they are called poster pens (1). They include the widest nibs available and can produce work with striking contrasts between the thick and thin strokes. At the other end of the scale, the plain-stroke script pen (2) has a rounded tip that makes no variation between the strokes. These are generally used for informal work. Italic nibs are manufactured in a large range of shapes from the extra fine to the broad. The intrinsic square shape of the nib is cut straight across for right-handed scribes (4) and obliquely to the left for left-handed people (3). The italic hand is one of the least formal and most popular of the calligraphic styles.

There is a range of different fountain pen nibs, which may be fitted onto detachable pen holders. The very fine nib (1) is suitable for drawing work and building up forms. Where a nib turns to the left at the tip (2), it is designed as an italic nib for left-handed people. It produces the same writing as the straight-cut italic nibs for right-handed scribes (3 and 5). These italic nibs have varying widths for contrast in pen strokes. There is also a selection of calligraphy nibs that are used for all types of lettering. These also vary in width from very fine to broad (4).

Fountain pens

The modern fountain pen is the result of much effort to perfect a pen small enough to be conveniently carried and fitted with a reservoir large enough to provide a continuous supply of ink to the nib. The first description of a fountain pen was included in a French treatise on mathematical instruments of 1723, but a satisfactory design suitable for production in quantity was not achieved until the second half of the nineteenth century. This followed many experiments with methods of filling the pen and controlling ink flow to the nib.

Since that time little has changed in the basic design of the fountain pen. Recent developments include the use of ink cartridges as an alternative to a refillable reservoir and the incorporation of inter-changeable nib units. Fountain pens are more specifically tools for handwriting than for formal calligraphy, suited to small scale, cursive styles of writing. However, most pen manufacturers now include a calligraphy pen in their range of products, usually equipped with units that have edged nibs in small, medium and large sizes. The advantage of these pens in the practice of pen-made letterforms is the continuous flow of ink; the main disadvantage is that even the largest fountain pen nib is relatively small, in comparison with the range of metal pens available.

Fibre-tip pens

Fibre-tip pens are now made with broad, chisel-shaped tips, especially designed for calligraphers. Like fountain pens, they are limited in scale, generally sold singly or as a set including broad, medium and fine tips, and with the advantage of a continuous flow of ink. A fibre-tip pen cannot remain as accurate and consistent as a metal pen, because the tip is more vulnerable to wear and tear; but for practising pen strokes or preparing rough layouts they conveniently fulfil basic requirements and form a useful addition to the calligrapher's collection of tools.

Felt-tip markers are also available with squared or pointed tips, but they are softer and more likely to lose shape than the fibre tips. Some felt-tip pens are filled with a spirit-based ink that spreads on the page. They can be used for practice in drawing out the skeleton forms of letters, since they give a thicker line than a pencil.

Pencils and drawing aids

Pencils used for ruling the writing sheet should be fine and relatively hard. In early vellum manuscripts lines were ruled with a metal or bone stylus, but these were replaced by a sliver of lead, fixed in a holder. Modern pencils are made in a wide range of hard and soft grades. For ruling on paper H or HB pencils are recommended, since these give a sharp line but, used lightly, can be erased with no difficulty. Ruling on vellum should show a minimal mark; a very hard pencil, 6H or 7H, makes a fine, light line.

Double pencils can be used to illustrate more clearly the effect of different nib widths on the pen strokes (below). A broad pen, making exactly the same shape (bottom), does not show this aspect so well. Johnston used the double pencils in this page of writing taken from a demonstration notebook made for Dorothy Bishop (now Mahoney) (left). The pencils have been used to make upper- and lower-case letters in Johnston's Foundational hand. The additional note in the top left-hand corner indicates the ratio of nib widths to letter height. Below this, the three lower-case o's illustrate the space required between lines of writing. The note in the centre relates to the importance of the tail in the capital R.

Double pencils can be a useful tool when learning to draw out the construction of letterforms. Two HB pencils tied or bound together with tape form a twin-point that produces the same effect as a stroke from an edged pen, but in outline form. This demonstrates graphically how thick and thin contrasts are formed naturally by the angle of the writing edge on the paper. It may be found easier to trace the continuity of the strokes if two different coloured pencils are used to make the twin-point. Carpenters' pencils are broad and flat; the lead can be sharpened and honed on fine sandpaper to a clean chisel edge, which imitates the action of a broad, square pen. These pencils are manufactured in hard, medium and soft grades.

An important accessory for the calligrapher is a sturdy and accurate ruler. A wooden rule edged with metal is a good choice, preferably 2ft (60cm) in length. As well as measuring and drawing ruled lines the metal edge of the rule can be used to guide a knife when cutting paper or vellum. A few other drawing aids are essential to the calligrapher, such as a T square and a clean, soft eraser.

Brushes

There are three main purposes for which a calligrapher may need a selection of brushes. One is for feeding ink into the pen. A medium-sized, roundhair sable brush suits this function. The same type of brush can be used for applying size and colour in decoration. It is as well to have at least one fine and one medium for this purpose, and if colour plays an important role in the work, it is advisable to build up a good collection of watercolour brushes. The approach recommended by scribes is to keep a separate brush for each colour. Experience will tell whether this is necessary, but it may be noted that the bright colours favoured in decorative lettering have strong pigments, so it is necessary at least to clean brushes thoroughly when changing from one colour to another.

A brush may replace the pen as the calligrapher's writing tool. This is the basis of eastern calligraphic traditions, but is less common in the west. Early forms of brushes were reeds with the fibres beaten out at one end to separate and make them flexible. This type of brush is still available from some specialist suppliers. More common are Chinese

Below It is actually possible to produce a brush-stroke effect with a very broad-nibbed pen. There is almost as much scope and skill involved with this tool as with the brush. Here Arthur Baker, an American scribe, has produced a free-style, pen-drawn alphabet, where the heavy forms are legible mostly through familiarity. The texture of the writing surface is often visible when using such a broad nib, particularly where letters are formed quickly. The broken strokes on the ascenders and descenders demonstrate this.

bamboo brushes with hair tips. The body of the hairs in these brushes may be more or less thick, but they are brought to a fine point to allow the greatest variation in the brush strokes. There are many different kinds of oriental calligraphy brushes with hair and feather tips, whose uses are generally unfamiliar to those trained in the tradition of the pen. However, it is possible to acquire these brushes and to experiment with brush-drawn lettering. A study of eastern calligraphy will also help to give a greater understanding of their potential.

The nearest equivalent to the shape of an edged pen is the flat-tipped sable brush, sold for use by watercolour artists. Roundhair brushes are also used for lettering. The characteristic changes from thick to thin strokes, natural to the pen, are softened by the flexibility of a brush. It tends to produce more evenly graded forms. A different type of lettering tradition is represented by sign-writers' brushes. These are fashioned with long, narrow, rounded hair tips; the finest are made by fitting the hairs to the shaft of a quill. Brush-writing techniques, like those of the pen, must be learned through experience, based on a good understanding of the character of different alphabet forms.

Alan Wong, an oriental calligrapher, designed this motif for a greeting card (below left). The modern style Chinese characters were written with a brush. Brush lettering may be produced with a variety of tools (below). A bamboo stem makes a good brush, where the fibres at one end are broken up to provide a bristly tip (1). A duckdown feather provides a very soft-tipped brush (2). An alternative feather, which is popular with the oriental calligraphers, is the peacock feather (3). This can be a very striking brush, with the peacock markings showing clearly; on the one pictured, an eye can be seen beside the brush holder. A hair tip is broad and soft, but fashioned into an extremely fine point (4). Such brushes give great variation in the brush strokes.

Surfaces

Vellum

Vellum is the writing surface traditionally preferred by scribes for many centuries. It has a velvety nap and slightly springy surface that is ideal for the sensitivity of a quill. Vellum is prepared from calfskins (and sometimes also from goatskins) in a skilful and lengthy process. The procedure cannot be fully mechanized and has changed little. As each skin is different in texture and weight, the preparation processes and finishing must be tailored to the quality of the skin and the purpose for which the vellum is required.

Fresh skins are first soaked in a lime paddle for 10 to 15 days to clean away salt and break down the fibres. Each skin is then individually passed through a machine with three large rollers, one of which is equipped with blunted knife blades, to scrape off the fur. (Previously this was done by hand using a double-handled knife.) After soaking in lime for another week, a skin is passed through a similar machine, with well-sharpened blades, to scrape off fat and flesh from the underside, then returned to the lime paddle for a further two weeks.

The cleaned skin is stretched on a wooden frame, using string attached to pegs, which can be turned to pull the skin taut. In fine weather it can dry naturally, but heat-drying is usually employed. To prepare the writing surface, a craftsman shaves each skin with a semi-circular blade, taking account of its individual thickness and any weak areas. This removes the grain and smooths the surface, which is finally treated with pumice.

For fine writing, vellum is finished to a light, even tone, which may be brownish or mottled, depending both on the finishing processes used and also on the original fur and skin colour. The calligrapher can choose which type of vellum to use according to personal preferences and the nature of the job in hand. A light variation of warm tones in the vellum can add richness to the finished work. Coloured vellums sprayed with dye are available, as are coarser, more grainy surfaces. The tougher vellums are really intended for bookbinding.

The manufacturer prepares the vellum to a good finish, but practised scribes will prefer to give the surface further preparation before writing. Vellum is sensitive to atmosphere and can absorb too much moisture or dry out if it is kept in the wrong conditions. If stored over a long period, residual grease in the skin will work its way to the surface. Powdered pumice or powdered cuttlefish can be used to rub the skin lightly, but these materials are abrasive and may make the surface more porous. A light dusting of gum sandarac counters this effect, but if it is too liberally applied the surface will resist ink. Gum should not be used before gilding as it may hold the gold leaf where it is not wanted.

The hairside of vellum is tougher than the skinside. Any abrasive treatment should follow the grain of the skin and be applied more

gently to the skinside. If vellum is used in making a book, it is usual to match the pages hairside to hairside and skinside to skinside. For a broadsheet or flat text, the side used is a matter for the scribe's judgement.

Vellum is relatively expensive compared to most papers; the price corresponds to the size required and the maximum size obtained from any one skin is about 30×40in (70×100cm). Suppliers usually sell small offcuts, which can be used for testing the finish and trying out the feel of ink and pen on the surface. Corrections on vellum can be made by scraping the ink with a sharp blade, taking care not to cut into the surface. An eraser and pounce are used to clean up the alteration.

Parchment

Parchment is made from the inner layer of sheepskin by a process similar to vellum preparation. The sheepskin is limed and split. Flesh is removed from the inner layer and the skin is treated again with lime, then stretched, scraped and degreased. The stretched skin is dried, shaved and pounced to create a fine surface finish.

Parchment is different in character from vellum and is an alternative, not a substitute. Sheepskin is naturally oilier than calfskin and parchment has a tough, horny texture. Vellum is generally preferred, although in the past parchment has been used for books, because the split skins were thin and less bulky in quantity than vellum pages.

Paper

The variety of papers available for writing, drawing and printing is a relatively recent development. Early scribes used vellum or parchment not so much from preference as from necessity. Paper manufacture was not fully introduced in western Europe until the fourteenth century. Ironically, in the context of calligraphy, it was printing that stimulated the paper industry, since vellum was not suited to book production by mechanical methods. The disadvantage of paper in those early years, and to some extent still today, was that it was fragile and likely to deteriorate rapidly. This is one reason why the tradition of using vellum for specially prestigious documents still survives.

The word paper derives from papyrus, the plant used by the Egyptians to form a writing surface. A sheet of papyrus was made by hammering together vertically and horizontally positioned strips of the fibrous stem of the plant. Papers are still made from vegetable fibres, which are pulped, poured into flat sheets, drained and pressed. Up to the nineteenth century paper was made by hand, limiting the size of a sheet to the breadth of a paper-making tray that could be handled by one or two men. With the industrial revolution machines were developed that produced paper mechanically, turning it out on long rolls, known as webs. Both these processes are still used, but it is becoming more difficult to obtain handmade papers. The quality and

*Papers are manufactured in a variety of surface grades and textures. A smooth surface is probably more suitable for the beginner than a very rough paper, where the pen may scratch over the fibres and stroke consistency becomes difficult to control. Paper that is graded as hot-pressed has a fine, even quality. The letterforms written on this type of paper will be fluid and complete (*below right*). A slightly rougher paper will begin to produce more ragged edges (*above right*).*

variety of machine-made papers, however, is continually expanding.

The choice of paper is so dependent upon the touch of the calligrapher, the tone and texture required for the work, the size and weight of the lettering and so forth, that it is not possible to list suitable papers by name. There are, however, a few general rules that can be observed as the basis for personal experiment.

Cheaper grade papers are generally made from wood pulp. They are adequate for ordinary purposes, but papers with a rag base, pulped from cotton, linen or hemp, are the most durable and less likely to tear or buckle. The heavier fibres also suffer less where erasures are made. Papers are produced in different weights, with surfaces graded as either hot-pressed, not or cold-pressed, or rough. Hot-pressed papers have smooth, close-grained surfaces and are the most suitable for formal calligraphy. Rough and not papers are somewhat more absorbent and loose-textured. Unsized paper is too porous, allowing ink to spread into the fibres, but a paper too heavily sized will resist the medium. The pen strokes of calligraphy are lightly made; any surface that drags on the pen or is picked by the nib is unsuitable. Highly glazed or coated papers are too smooth and resistant for pen work.

For practice work, a draughtsman's layout pad is convenient, relatively inexpensive and readily available. Such pads are produced in international standard sizes from A1 594 × 841mm (about 23 × 33in) to A5 148 × 210mm (about 5 × 8in). Layout paper is flimsy but stable. As the name suggests, it is also a good surface for sketching out rough designs and layouts in pencil, ink or colour. Bond paper, smooth and white, is sold by stationers in a less varied size range, but A4 or foolscap are adequate for calligraphic practice. Writing pads and papers intended for correspondence are also useful grounds and are available in a wide range of colours and surface finishes, smooth and antiqued. The

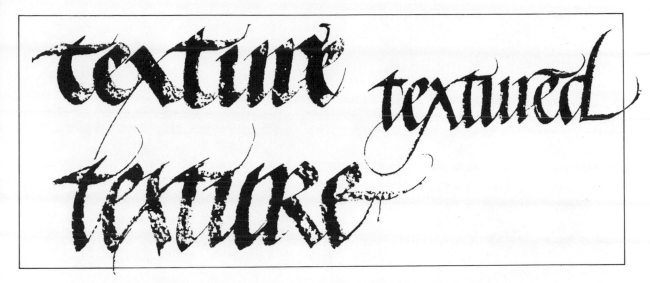

matt side of brown wrapping paper or a roll of unwaxed shelf paper provide quantity and economy for rough work.

For finished work a good quality cartridge paper can be perfectly suitable. Some types have a warm, creamy tone which may be preferred to a stark, cold white. Close-grained hand- or machine-made papers with a hot-pressed surface are heavier and more resistant to damage. As with vellum, it is advisable to obtain offcuts or an extra sheet of a particular type of paper for trial purposes. Handmade papers are generally preferred for important pieces of work, but they are relatively expensive and may be more difficult to obtain. Because of the process of manufacture, they are of limited size and may not be perfectly square at the corners. Allowance should be made for this in ruling the page. They have deckle edges and should be torn rather than cut if the dimensions are altered; sometimes it is preferable to trim all the sides cleanly. Some machine-made rag papers are prepared in imitation of handmade papers, while others have their own distinct character and quality. The tone of paper may vary from one sheet or batch to another. In work requiring matched sheets, it is advisable to buy slightly more than the exact quantity required.

These guidelines are laid down as a basis for buying papers of reliable quality for controlled effects in basic or formal calligraphy. For those wishing to develop a looser style, chance combinations of pen, ink and paper may be a large part of the pleasure. Coarse-grained papers will give a broken effect to the pen strokes; Japanese calligraphy, particularly, exploits the qualities of different paper textures. A surface with a strong or variegated colour will increase the density of a written page. With experience it becomes possible to control such features to some degree, while exploiting their particular contribution to the work as a whole.

Above *The gradual inconsistency of form in these three examples clearly shows the effect of different grades of paper surface. Paper that is only slightly grainy will cause a minimum of broken texture in the strokes themselves. This is not or cold-pressed paper. As the paper becomes coarser the surface absorbs less ink and the writing appears more ragged. The coarsest paper, known simply as rough paper, will cause many breaks and speckling to occur in the strokes. This can be used for special effects, for example where the calligrapher wants to illustrate a word by its appearance: texture.*

Chinese stick ink is popular with scribes because it does not clog the pen. The ink is literally sold in sticks (above right) in varying colours, which have to be rubbed down with distilled water. Ink stones are used for this process. Distilled water is poured into the central well of the rubbing stone and the ink stick pushed back and forth in the water (above) against the abrasive surface of the stone. Stick ink should never be stored when it is still wet as this will cause it to flake. The ink stone should always be washed after use.

Media

Ink

A number of recipes for ink may be found among old treatises on writing and, together with the materials used by earlier scribes, it may be seen how effectively they have stood the test of time. The most common recipes were for carbon inks, using a pigment such as lamp black suspended in a mixture of gum and water. These have retained their blackness over the years. The attractive brown tone of the writing in some manuscripts is not due to original use of sepia ink; it is the result of change in an ink made from iron salt and oak gall, that has worked its way into the surface and lightened with age.

The commercial sale of prepared inks became common in the eighteenth century. As greater efforts were made to perfect metal pens, it was found that inks suitable for quills often had a corrosive effect on metal nibs. Some nineteenth-century pen manufacturers began to produce their own inks to suit their particular pens. The introduction of aniline dyes in 1856, used for colouring paints and inks, to some extent relieved the problems since they were found less corrosive than pigments formerly used.

Modern scribes have a number of high quality brand-name inks to choose from, although experiments based on old-fashioned recipes are still pursued and sometimes result in special qualities that are sympathetic to individual styles. It is also interesting to try out different types of prepared inks, as the best combination of technique and materials is unique to every scribe.

The basic rule for inks is to choose non-waterproof types. These should be checked for all the properties of a good calligrapher's medium – they should flow freely but not spread, be quick drying and

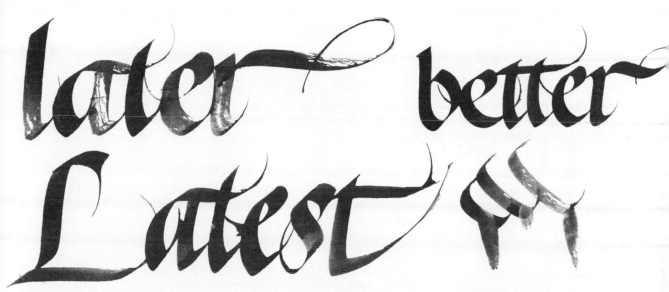

stable when dry, and do no harm to paper surface or writing tool. Waterproof inks are not suitable for writing as they are thick and fibrous, tending to clog the pen.

Art and craft shops usually stock at least one brand of bottled, non-waterproof black ink. Those that are specially developed for use by calligraphers will be marked. Fountain pen inks are widely available. They are economical and quite suitable for rough and finished work, provided the flow and density of colour seem acceptable. One or two types of black writing ink can be diluted with water to produce a variegated effect of warm and cool tones, which can be pleasantly exploited in large lettering. Writing and drawing inks are also available in a range of colours. They are thin and transparent; most scribes prefer to use watercolour paint for decoration in colour, but coloured inks are useful stock items.

The favoured ink of many modern scribes, from Johnston's time to the present day, is Chinese stick ink. Stick ink is rubbed down with water so the scribe can control the density of colour and texture. A small, sloping block with raised sides and a slightly abrasive surface is supplied, which can be used both as a rubbing surface and as a container. The ink is rubbed down in small quantities as needed, and it is important to keep the stick dry when it is not in use. Distilled water produces the purest dilution of ink. If none is available, ordinary tap water may be used as an alternative, provided it is boiled and allowed to cool. The texture of the ink can be varied from one mixing to another. To make it possible to match the consistency, a fixed measure of water and amount of time for rubbing down the stick allows the process to be quite accurately repeated. Johnston also recommended the use of stick ink because small amounts of mixing colour or gum could be added during the process to obtain a precise effect of colour and texture.

Above *The texture of ink can vary considerably. This is particularly true where Chinese stick ink is used. The reason for this lies in the grinding and mixing of the ink where more than one mixing is required. If a consistent texture is desired, then the initial mixing must be carefully monitored. The time spent on rubbing down the stick and the amount of distilled water used should be accurately noted and repeated. For a consistent ink flow non-waterproof bottled inks are preferable, because they are thinner and therefore more fluid than the waterproof types. Ink that does not flow smoothly will cause broken strokes.*

Above *Mixing the gesso for gilding and the process itself require a number of specialized tools. Once the piece of gesso (1) has been reconstituted, it is used to draw the letter, laid with a quill pen (7). An agate (2) or haematite burnisher (3) is used to rub the gold onto the raised letter through the silk. This presses the gold over the general shape of the letter, firming it down, and may be used for burnishing the gold leaf later on in the process. A hooked agate burnisher (4) is needed to mould the gold into the edges and corners of the letter. A pointed agate burnisher (5) will smooth out the final details. A fine blade (6) can be used to scrape down the size before the gold is laid or delicately trim the gold once the burnishing has been completed. This will neaten up any ragged edges, giving the finishing touches to a letterform.*

Paints and pigments

The colours of illuminated manuscripts were applied using pigments bound in gum or egg. Modern scribes will find artists' watercolours the most suitable medium for writing in colour and for painted decoration. Watercolours are pigments bound in gum arabic, with one or two additives to maintain flow and texture. They have a luminosity that other paints do not. They are available in tubes or pans and, for pen work, should be diluted to a milky consistency with high colour saturation so that the hues are not devalued. When watercolour is used for painting with a brush, it should be of a stiffer consistency because washes are difficult to control, especially on vellum. Designers' gouache can be used in the same way, but it is intended as body colour and contains a filler to make it completely opaque. Watercolour is the most fluid and translucent medium and has colours that maintain their brilliance as they dry out.

Manufacturers are careful to develop as much permanence in their products as possible, but some pigments are naturally fugitive and will fade more or less quickly under long exposure to light. Artists' materials are marked with the degree of permanence, so it is possible to choose the most reliable colours. In the same way, some pigments cannot be ground as finely as others; a slight difference in texture may be noticed as the colour flows through the pen. Any variation of quality should be minimal, however, if the paints are chosen from the ranges produced by the well-known artists' colourmen.

Calligraphers who are interested in following traditional techniques can still mix their own colours, using gum arabic, egg yolk or glue size as a binder for powder pigments. Pure, finely ground pigments must be used and the richest hues can be extremely expensive, even when bought in minimum quantity. The pigment and medium can be mixed together in a small jar or ceramic palette with mixing wells. Distilled water should be used as the diluent to maintain the purity of the colours. Egg tempera, the medium of medieval painters, has a brilliance achieved by overlaying thin layers of colour. It dries to a tough, waterproof finish. Once mixed, tempera cannot be stored long as the egg goes off quite quickly, so only small quantities should be prepared at any one time.

Gilding

The quantity and richness of gold decoration is an astonishing feature of many of the finest medieval manuscripts. The full brilliance of the effect, which is described by the term illumination, comes from gold leaf laid and burnished on the page. A less reflective form of gold is often seen as background to ornamental letters and in painted ornamentation; this is applied with powder gold dispersed in a gum binder. The most complex manuscripts were the work of several hands and the gilding was not necessarily carried out by the scribe responsible for the

text. Details of writing and decoration were usually separated and assigned to craftsmen, expert in their respective tasks. Nowadays, some scribes specialize in gilding as well as penmanship, but the tasks are kept separate as before; the body of the text in the manuscript is written first, with spaces left for the gold decoration.

The long preparation and delicate process of laying gold leaf has not been alleviated by any modern invention. The current practice of gilding derives largely from the researches made by Graily Hewitt in the first half of this century. There are instructions for gilding in some medieval works, but Hewitt's procedure was based on the treatise written by the craftsman Cennino Cennini (c 1370-1440). His *Craftsman's Handbook (Il Libro dell'Arte)* was translated into English during the nineteenth century and formed the basis of much experimentation with art and craft materials. Hewitt's attempts to substitute modern materials or find shortcuts in the preparation of gilding proved fruitless. A close interpretation of Cennini's instructions, with very minor modifications, was found to be the only reliable method and remains the basis of the gilder's art to this day.

The finest traditional method of gilding is raised gold – gold leaf applied to a cushion of gesso. The cushion is just plump enough to give the impression of substance without casting shadow or making an unbalanced weight on a book page. It is the preparation of gesso that forms the lengthy part of the gilding process; it is important to obtain exactly the right texture so the gesso will not crack under the burnisher or when a book page is turned. The laying of gold leaf is an extremely delicate skill. Gold can also be applied to a size preparation, drawn or painted on the surface of a page; this has no body and the decoration is completely flat.

The descriptions of laying gold that follow are only indicative of the basic methods. Minor adjustments to recipes and procedures can be made with experience, but, like all other aspects of the calligrapher's craft, individual standards are only acquired through a sustained effort of trial and error.

Above *Gesso must be reconstituted in preparation for laying gold leaf. Take one of the sections of the gesso and, using a sharp knife, scrape pieces from it into a small container (1). This may be a ceramic palette or egg-cup. Squeeze one drop of distilled water from a pipette on the gesso (2). This should be allowed to stand for 15 minutes before proceeding. Then, mix the gesso into a paste-like substance and add a few drops of water to make it liquid. A quill is used to apply the gesso to the letterform; the tip is filled with the aid of a paint brush (3).*

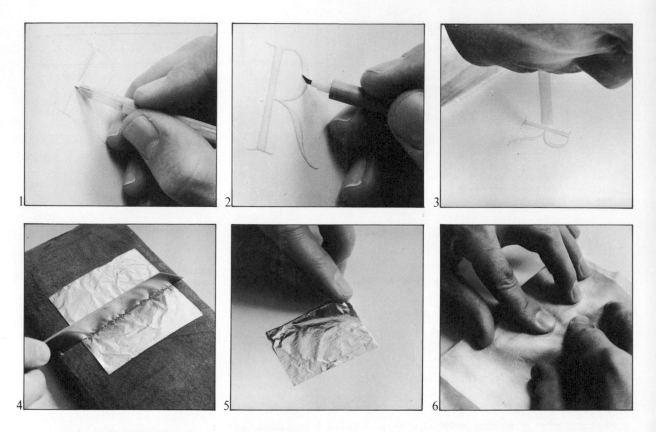

Above *As soon as the gesso has been reconstituted and the writing surface is smoothed over, the pre-drawn letterform may be filled. Use the loaded quill to draw in the stroke (1). It is important to fill the whole stroke and to keep within the form. When the gesso has dried smooth the surface with a fine blade (2); it should have a slightly rounded surface and not a flat, plateau-like top. Blow on the gessoed letter through a tube (3) to moisten the gesso. This prepares it for receiving the gold leaf. Lay the gold leaf on a cushion and, with a sharp knife, cut a piece just larger than the letterform (4). The gold must be placed swiftly and smoothly over the letterform (5), otherwise it may curl or fold up and become unusable. A piece of silk must then be laid over the gold and firmly pressed down (6).*

Raised gold

Assembling the materials The gesso base for raised gold is prepared to the following recipe: 16 parts slaked plaster of Paris, 6 parts white lead, 2 parts sugar and 1 part glue. Cennini's original recipe recommends use of centrifugal sugar. This is no longer available but sugar crystals are an appropriate substitute. The glue was originally fish glue, now also rarely attainable. There are modern equivalents, and a supplier of gilding materials will be able to advise.

Slaking plaster is a lengthy but necessary process. When mixed with water, plaster gives off a certain degree of heat and the slaking exhausts this fiery quality and its 'setting' properties. The plaster is distributed evenly in a bucket or bowl of water – the proportion is 1lb (2.2 kg) of plaster to 1½ gal (6 l) of water. It must be stirred continuously for about an hour, eliminating any lumps; these are most easily found and dispersed with the fingers. Allow the mixture to stand overnight, when the plaster will sink to the bottom of the bucket and the water can be poured off. Refill the bucket and stir the plaster for 10 minutes. This process must be repeated every day for a week, then every other day for four weeks.

At the end of this time, pour off excess water and squeeze out the

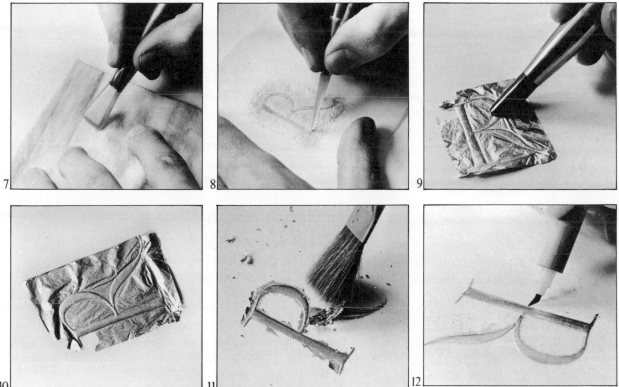

plaster in a linen cloth until it forms a damp but substantial mass. It can then be shaped into blocks and allowed to dry out for several days in a dust-free atmosphere.

Mixing the gesso All this effort has simply gone into preparing the main ingredient of the gesso. Fortunately the second stage is rather less laborious. A quantity of slaked plaster is scraped from the block to be mixed with the other ingredients. It is never necessary to have a very large quantity of gesso and it is best prepared fresh in strictly limited measures of each ingredient. A tiny salt spoon with a semi-spherical bowl is the ideal measuring implement; a teaspoon is too large.

Measure the ingredients onto a glass slab or similar clean, non-porous surface. Scrape down enough slaked plaster to provide 16 spoonfuls; to this add 6 parts of white lead. Crush the sugar to powder and measure out 2 parts. The glue can be scooped up on a knife and poured into the bowl of the spoon, filling it level with the edges. Turn out the glue onto the glass and heap the powdered materials over it. Add 8 parts of distilled water and grind the mixture to a paste using a muller. Since the gesso is light-coloured, a pinch of Armenian bole can be added at this stage to give a pink tinge to the mixture, which will then

Above *Using a broad burnisher, rub down the shape of the letter through the layers of silk (7). Remove the silk and place a piece of crystal parchment over the gold. Rub down the letterform again and then use a fine pointed burnisher to push the gold into the edges of the raised letter (8). Then take off the parchment and burnish directly on the gold with an agate or haematite burnisher (9). When the gold is firmly adhered to the gesso (10) continue burnishing to bring up the shine of the gold. Flick away the loose gold surrounding the form with a soft brush (11) and, if necessary, trim the edges of the strokes with a fine, sharp blade (12).*

Above *This detail, taken from a fourteenth-century manuscript, illustrates the effect of raised gold very clearly. The light reflects off the surface and gives the border an elaborate decoration. This piece is typical of this period when gold leaf was widely used. The straight, formal lines of a border were often intertwined with gilded flowery patterns.*

show up against vellum. Bole should be used sparingly as it has a drying effect and is only needed here as a colouring agent.

When the mixture is well ground, shape it into a flat, circular cake and leave it to dry on a piece of tinfoil. The gesso dries out unevenly as the glue tends to go to the edges and the white lead to the centre. After two or three days, cut the gesso cake and tinfoil into eight sectors, with the cuts radiating from the centre so that each slice has a balanced amount of each ingredient. Leave the pieces until they have been drying for seven days in all. A dust-free atmosphere is essential; the gesso can be dried out in suitable conditions such as a drawer, clean cardboard box or similar place.

A modification of this recipe, which is reliable but forms a smaller quantity of gesso, is 7 parts slaked plaster, 3 parts white lead, 1 part crystal or granulated sugar, 1¼ parts glue. The ingredients are measured out in the same way and ground to a smooth paste. The small cake of gesso can be stored in tinfoil. The extra quantity of glue in this recipe acts as a firm binder and the gesso should be reconstituted with water only.

Applying the gesso A ceramic well-palette or a small, china egg-cup are the best receptacles for reconstituting the gesso. The gesso mixture is specially formulated so that it remains sensitive to moisture and can be given a tacky surface, to which the gold will adhere. The glue and sugar perform this function and the gesso can be made liquid with the addition of distilled water alone. Otherwise, some scribes prefer to use glair, a solution of egg-white, as an extra binder for the gesso.

To prepare glair, separate the white of an egg and drop it into a bowl. Whisk it up until it is very frothy. Measure a tablespoonful into a glass and add an equal amount of water. Mix the liquids and leave the solution to stand overnight. The glair clarifies during this period.

Crumble a sector of gesso into the egg-cup and add one drop of distilled water or two drops of glair. Leave this for 15 minutes and then work the gesso into a paste. Press it down firmly and add a further six to eight drops of glair or water, whichever was used in the first place. Mix the gesso slowly to a creamy consistency; avoid raising bubbles, pricking any that do appear with a needle.

Before gesso is applied to vellum the surface should be treated with pumice to remove any grease or tackiness. The liquid gesso can be applied with a quill or brush. If a brush is used, dip it first in distilled water and squeeze out the hairs.

The vellum is laid flat on a rigid surface, so the gesso will settle evenly. Charge the quill or brush with gesso and apply the letterform or decoration. When using a quill, retouch the thickest strokes to ensure a good raised effect when dry, but the quill must be turned at an angle of 90° to the original stroke to do this, so that clean outlines are preserved. Wipe the pen and draw the wet gesso evenly along the thin strokes.

Laying the gold leaf Gesso prepared with water remains responsive if it is left for a few days before gilding. Egg-white binder dries to a tougher finish, so gesso mixed with glair should be gilded on the following day, but not later. In either case, several hours drying time is needed before gold leaf is applied.

Gold leaf is extremely fine and sensitive to the slightest motion. It can also stick to itself if lifted hastily. It is supplied in book form, interleaved with paper. The gold is more easily handled if the leaf at the back of the book is used first, working forward thereafter.

The gilder makes the gesso ready to receive the leaf by breathing on it. This lays down enough moisture to encourage adhesion of the gold. Although laying the leaf must be done delicately, it must also be done swiftly once the process has begun.

Cover the gesso with a piece of silk, folded to three or four thicknesses. Cut through the gold leaf and its paper backing to extract a piece slightly larger than the gessoed letterform. The action of the scissors presses the gold and paper together at one edge so it can be lifted from there with finger and thumb. A practised gilder lays the gold leaf on a gilder's cushion, cuts it with a long-bladed knife and lifts it with a tip, which is a soft brush of sable or badger hair.

Lift the silk and breathe on the gesso very hard, about a dozen times, from a short distance. Place the gold on the gesso and flick away the backing paper. Press the silk firmly over the gold. This process must be rapidly performed, the gilder using one hand to raise the silk while the other lays the gold.

Using an agate or haematite burnisher, rub firmly on the silk above the raised letter. Remove the silk and place a piece of crystal parchment over the gold Burnish again, lifting the parchment frequently to ensure it does not stick to the leaf.

Make sure the burnisher is clean by rubbing it over the silk and then proceed to burnish the gold directly. Pay particular attention to the angle between gesso and vellum. As burnishing continues, the gold becomes more brilliant and shiny.

When the first layer of gold is smooth and bright, a second layer can be laid. It is placed directly over the first, without repetition of the breathing or rubbing silk with the burnisher. Simply, burnish the top layer using increasing pressure. The surface is slightly resistant at first, but the burnisher will soon move quite smoothly. When the gold has full brilliance, use a soft, dry brush to remove loose gold leaf from around the form.

If any part of the gesso is not fully covered in laying the gold, quickly apply another small piece. There is inevitably some wastage in laying gold leaf, but it is impossible to cut an exact shape. If the gold is lifted or damaged in any way during burnishing, start the process all over again. Any gold that adheres to the surface of the vellum can be scraped away lightly with a knife.

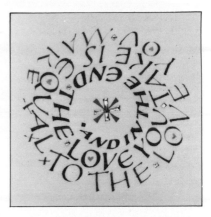

Above *Gilding is still used in modern work, although generally in a less intricate fashion than in the medieval manuscripts. This is a quotation taken from a Beatles' song, produced by the scribe Anne Hechle. The black and red lettering on vellum is punctuated by the small dots and crosses of gold leaf. Gilding has been used in conjunction with coloured lettering and unusual form to produce a more dramatic and decorative effect than plain writing.*

The gold is burnished two more times: half an hour after it is laid and then a few hours later. If other work is done on the same page in the meantime, protect the burnished letter with a piece of silk.

Flat gold decoration

Gold leaf can also be applied to a flat letter which is first written with a gum size. The following is a recipe for size, successfully used as a base for flat gold.

Break up lumps of gum ammoniac into a fine, gravel-like texture, until there is enough to stand ½ in (1.2 cm) deep in a small glass. Cover the gum with distilled water and let it stand overnight, or for at least 12 hours. Stir up the gum and stand the glass in a basin of hot water to warm it through. Stir again and strain the mixture through a piece of nylon fabric cut from an old stocking.

Drop in a small quantity of caster or granulated sugar (the sugar must be a fine, crystalline form, not powdery) and add a few drops of gum arabic, which can be bought in liquid form from most art shops. Add a pinch of Armenian bole as colouring. As before, leave the mixture overnight, then stir, warm and strain it. The size can be stored for some time if sealed in a small bottle or jar.

The size is applied with pen or brush and, like gesso, is made tacky when breathed upon. It is important to use gold transfer leaf, rather than standard gold leaf. After laying the gold, leave it to dry out for two hours before burnishing, and use crystal parchment under the burnisher throughout the process.

Powder gold

Powder gold is sold loose or in tablet form and can be used like paint or ink when dispersed in distilled water. It may be mixed with gum arabic as a binder. Coloured versals are sometimes placed on a gold ground; fine ornamentation is sometimes filled with gold. Using powder gold, ornamentation can be done quite simply with a quill, pen or brush. Although powder gold cannot match gold leaf illumination, it is a simpler way of enriching the effect of a piece of lettering.

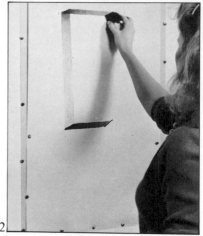

Working methods

It is generally agreed that the most comfortable and convenient method of practising calligraphy is to work on a surface sloped at an angle of 45° to the flat worktop. This recommendation may be varied according to preference in a range of about 40° to 60°. A slanted support is better than a flat one for two reasons: the scribe can sit upright while working and not suffer the strain of bending over the work and, on a technical point, the pen is held at a shallow angle and so the ink is less likely to flood onto the paper.

The angled surface can be achieved by hinging a drawing board to the edge of a table and providing secure props at the back. A designer's

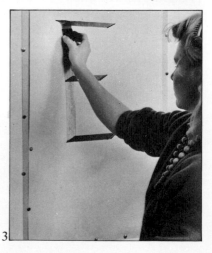

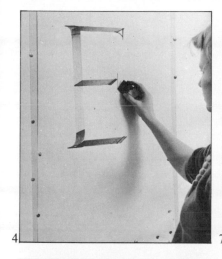

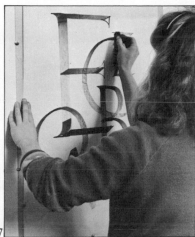

4

7

Left *It is not generally advisable to work on this type of upright surface, not only because it is tiring, but also because ink flow may be affected. Balsa wood dipped in ink is used here, so does not encounter this particular problem of angle. There is a variation in the texture of the stroke (1), however, because the ink tends to dry on the stick very quickly. There are some interesting letterform constructions to note: the centre cross-stroke of the E is drawn after the others (2); the serifs are added last (3 and 4); the C is drawn over the E (5) and gradually further letters are added, which appear to weave under and over each other (6 and 7). This vertical position simulates the stance of a stonemason drawing letters onto a monumental slab before carving them.*

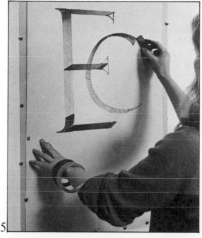

5

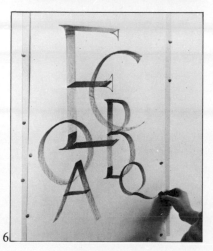

6

board is ideal, but is a relatively expensive item of studio equipment. It is mounted on a sturdy metal base and has adjustable fixings for altering the angle of the work surface. A table easel with ratchet props can be used to bear a drawing board, but may need to be anchored to the table as such easels are lightweight and may slide if pressured.

The drawing board should be covered with a light layer of padding; a couple of sheets of newspaper or blotting paper are adequate, covered with a piece of clean, white cartridge paper. This provides a springy surface, which is better suited to rhythmical pen movements than the rigidity of the board directly underneath the writing paper. A length of cloth tape is pinned tautly across the upper section of the board, to keep the top of the writing paper flat.

The writing level is kept constant; the paper is moved rather than the hand or pen. When a comfortable position has been established, the lower part of the writing sheet is protected by a paper guard. This consists of a clean sheet of paper folded lengthwise and placed, with the fold at the top, across the writing paper about 1in (2.5cm) below the writing line. The corners of the guard are extended at each side and pinned securely to the board. The guard both holds the paper flat and protects it from being marked. If, at the start of work, the lower edge of the writing paper falls below the level of the table top, a curved sheet of card can be slipped underneath and taped in place to prevent the paper from creasing against right-angled edges on the board or table.

Working by the window in clear daylight is ideal, but not always practical. An angle-poise lamp is the best source of artificial light, as it can be adjusted to throw a strong beam directly onto the work. The light should fall across the left shoulder of a right-handed writer and vice versa, at an angle where cast shadows are thrown away from the writing hand, not across the pen and writing line. Common sense will suggest the best arrangement of tools and materials.

Basic letterforms

The written forms of most languages in the western world are constructed from the 26-letter alphabet based on letterforms perfected by the Romans. These letters can be written in many different ways – in capitals or script, for example, in hands that are characteristically rounded, slanted or angular. There are innumerable variations of both handwritten and printed forms, but the letterforms familiar to modern eyes stem from the Roman model and whatever the developments of style, it has been a convention that every letter has an essential form of its own, distinct from other letters and expressed in a particular shape or combination of parts that makes it readily recognizable. This basic structure of a letterform must exist whether it is written, carved, painted or modelled and in however plain or elaborate a form, for the letter to function effectively as a component of language.

The special interest of formal penmanship, the primary discipline of western calligraphic traditions, is the tool that puts flesh on the bones of the alphabet in a consistent and characteristic manner that is natural to that tool's own construction. The edged pen automatically produces thick, thin and graduated strokes that can be organized in a fixed relation to every letter of the alphabet. This is achieved through regulation of the angle and direction of the pen strokes used in constructing the forms. The pleasure of the craft is that the action of the pen provides a logical structure to the rhythm of writing, but does not restrict the forms that can be made, since there are a number of ways of manipulating the pen to alter the character of letters.

Alfred Fairbank (1895-1982) described writing as 'a system of movements involving touch'. Calligraphy is a disciplined craft and there are systems of letter construction that must be practised quite laboriously before a reliable competence is achieved. However, it is important not to turn discipline into tedium, to remember that rhythm and movement are the essence of any handwritten form and it is not the aim of calligraphy to encourage the mechanical uniformity typical of printed lettering. At the same time, the skills involved in formal penmanship are quite different from those of ordinary handwriting. Cursive writing styles develop to promote speed of writing while retaining relative legibility; handwriting may be elegant, but it is not primarily aiming for a consistent structural beauty.

In rapid writing the pen stays on the paper and is pulled and pushed in any way that quickly describes the necessary features of letters and words. The calligrapher's edged pen naturally favours particular types of movement and one of the basic precepts of calligraphy is that the pen is always pulled or drawn across the surface, not pushed or driven against the grain. This rule establishes the requirement that the pen is frequently lifted from the surface, necessarily slowing the rate of progress. It is most simply illustrated by a comparison of different ways of forming the letter O. In handwriting, a pointed tool such as a fibre-tip pen or pencil quickly forms an O by drawing a circle in a single fluid stroke, starting at the top, following around the curve and closing up with the starting point. If an edged pen is used, this action means that in the second portion of the circle the pen is travelling up the paper and must be pushed. This problem is eliminated by forming the O with two strokes, both semi-circular but moving in opposite directions from the starting point and closing at the base of the letter.

Fairbank's emphasis on movement and touch suggests that an actual physical sensitivity is required of the calligrapher and this is quickly understood while practising even the most simple forms of pen lettering. In addition to feeling the proper direction of pen movement, the calligrapher must also learn that variations between thick and thin strokes are formed entirely by the angle and direction of the stroke, not by pressure on the pen.

Above *Letterforms perfected by the Romans are the basis of the modern letterforms of most western alphabets. This carved capital R, from a second-century inscription on the Via Appia, shows how little these forms have altered. The flourished tail of the R reflects the development of the left-to-right movement in writing; in Roman capitals, this tail drops down slightly below the line. The junction of the loop and tail is almost a right-angle.*

GALLVS · ECLOGA DECIMA

EXTREMVM HVNC, ARETHVSA, MIHI CON=
CEDE LABOREM: PAVCA MEO
GALLO, SED QVAE LEGAT IPSA
LYCORIS, CARMINA SVNT DI=
CENDA: NEGET QVIS CARMINA
GALLO? SIC TIBI, CVM FLV=
CTVS SVBTERLABERE SICANOS

D oris amara suam non intermisceat undam,

I ncipe'; sollicitos Galli dicamus amores,

D um tenera attondent simae virgulta capellae.

N on canimus surdis, respondent omnia silvae.

QVAE nemora aut qui vos saltus habuere, puellae
Naïdes, indigno cum Gallus amore peribat ?

N am neq; Parnasi vobis iuga, nam neq; Pindi

V lla moram fecere, neque Aonie Aganippe.

I llum etiam lauri, etiam flevere myricae,

P inifer illum etiam sola sub rupe iacentem

Left *This excerpt from Virgil's* Eclogues and Georgics *(writing and gilding by Alfred Fairbank; illuminating by Louise Powell; 1932-9) shows the traditional use of Roman capitals in manuscripts. They were used for headings, initial letters at the beginning of paragraphs and to highlight other key points in the text. Here they are offset against a modified form of an old minuscule script.*

The character of any calligraphic alphabet is determined by three major elements. In the first place there are characteristics intrinsic to the basic letterforms themselves. Added to this are the particular influences of the pen on the weight of the letters, as heavy or fine, massed or open forms, and on the individual strokes used to construct the letterforms, according to the angle at which the pen is held in making the strokes. This last factor produces consistent stresses in the writing – vertical, horizontal or oblique – and it is applied quite systematically within each alphabet form. This chapter discusses in detail these separate elements of the craft of calligraphy so the beginner can approach the sample alphabets equipped with a knowledge of basic principles that explain why and how the techniques of formal pen-manship produce particular results.

The letter O is the basic form of the alphabet. Its shape sets the pattern for all other curved strokes. These illustrations (left to right) show characteristic shapes: the circular form of the Roman alphabet (pen angle 30°); a compressed vertical form (pen angle 60°); and the horizontal form of the uncial (straight pen).

Variations in the form of the O include (left to right): the oval, italic form (pen angle 30°); the flat-sided Gothic form (pen angle 30°); a pointed form (pen angle 30°); and the ogee form (pen angle 45°).

The structure of letters

Any alphabet form, even if highly elaborated, can be reduced to a simple skeleton framework, showing the basic construction of each letter, the proper proportion in the component parts of each letter and the proportions of letters in relation to each other, in terms of height and width. The distinctive character of a letter depends upon whether it is described with straight or curving strokes, which of the straight strokes are vertical, oblique or horizontal and whether curved parts are open or closed. These elements constitute what Johnston described as the 'essential form' of alphabets; he stressed that each letter must be distinct from any other by virtue of its basic construction, that it should be simple with no unnecessary parts, and that it should be properly proportioned, with no one part exaggerated or dwarfed. In addition, it is important that the letters of an alphabet demonstrate family characteristics, consistency in the angles of joined strokes and the sharpness or shallowness of curved forms, for example. The skeleton of an alphabet can be discovered by using a pointed tool, a fibre tip or pencil, to write out the letters, aiming to produce only the most basic elements that describe the forms.

An alphabet may consist of capital letters, which are all based firmly on the writing line and rise to an even height above it, or lower-case lettering in which there is a basic body height for the letters and rising strokes, called ascenders, complemented by tails of letters dropping below the line, called descenders. (Lower-case is a typographic term here preferred to the common phrase 'small letters' to avoid any confusion when mentioning the relative size of a letterform.) In typography alphabets are generally paired in corresponding sets of capital and lower-case forms. In calligraphy this is not always true, particularly in the formal scripts up to medieval times, which show more complex developments in the structure of written forms that were only later standardized. The uncial alphabet form clearly shows how a mixture of lettering principles can be represented and form a cohesive style. Classical Roman capitals, however, have no directly related lower-case forms, although there were styles of cursive writing widely used in Roman times. There are many derivations of the original capitals that are each equipped with a lower-case alphabet and the two versions are quite logically connected in shape and proportion.

Lower-case alphabets generally show more variation between the skeleton forms of letters, since there are fewer letters that have constructions using only straight strokes. Compare, for example, A E F H M T with a e f h m t. There is more variety of texture and pattern in lower-case, because of the secondary pattern of ascenders and descenders and the rounding of letters such as e and h.

The internal space of a letter is very important to its distinctiveness and also to the aesthetic consideration of its overall shape and proportions. A curve which encloses space within a letter is called a bowl; the

enclosed space is known as the counter. These internal spaces make a definite contribution to the character of individual forms making them more than linear silhouettes. It would be impossible to distinguish c and e, for example, from an outline shape only. The cross-stroke and counter of e are its essential distinguishing marks. The contribution of internal space to pleasing proportions can be seen very clearly in capital A, where the cross-stroke is fixed at a point where it will balance the internal triangle with the space at the base of the letter. In letterforms that contain acute angles, such as A K N and V, the oblique strokes must be carefully angled to give a crisp, open form, not one that appears to be compressed or exaggeratedly flared in any way.

The most basic and vital characteristic of an alphabet is the skeleton form of the O. Broadly speaking, this may be circular as in the classical Roman alphabet, or elliptical as in italic forms. The rounded or elliptical curve of the O sets the pattern for all curved strokes in other letters. It is directly transferred to C D G and Q. It governs the shape of the bowl in B R and P, the lower curve of U and the looping of S. It also dictates the arching of h m and n. In Roman forms based on a rounded O, the curved letters are characteristically rounded, open and upright with stately arches formed of relatively shallow curves, which turn at a broad angle from the stem of the letter. In italic forms, the elliptical O sets a pattern of oval, compressed letters with sharper curves branching vigorously from the stem. There are elaborations and modifications caused by the action of the pen in calligraphy, but even highly stylized forms, such as the squat uncials and angular Gothic Black Letter, are basically related to circular or elliptical forms.

Principles of proportion

It is an essential quality of formal calligraphy, and all good lettering design, that the proportions of letters should be visually pleasing in themselves and that all the letters of a particular alphabet should conform to a logical proportional system. Roman capitals are based on a simple geometric system, which sets the standard for relationships within the framework of the skeleton form, although there are certain optical effects that must be adjusted slightly when actually writing out the letters to create a visual balance. In structural terms, however, the proportions of each letter within the Roman alphabet spring from fixed relationships of height and width, governed by the central fact of the circular O.

A perfect circle can be inscribed within a square, touching on all four sides, which can be divided into four perfectly symmetrical quarters. It is the square that forms the basic unit of proportional measurement, which can be applied to those letters that are not primarily circular. The curving letters are formed by relating the arch or bowl to a section of the basic circle; or to a smaller circle in correct ratio to the full size O.

The fixed measurement of Roman capitals is the height. The wide

These two modern uses of old forms illustrate variations in proportion and visual effect. The rounded, open form of the uncials (top) contrasts with the compressed, angular form of the Gothic Black Letter (above). Although both of these alphabets are highly stylized, they are both essentially derived from circular or elliptical forms.

WIR KÖNNEN
UNSEREN GESCHMACK
NICHT AM MITTELGUT
BILDEN / JOH. WOLFG. VON GOETHE
SONDERN NUR AM
ALLERVORZÜGLICHSTEN

Above *This quotation from Goethe, written by Werner Schneider, illustrates the use of modern Roman capitals. The spare elegance of this form is particularly suited to inscriptions of this type, and works well in this example reversed out of a dark background.*

letters M and W and those having mainly circular form, O Q C D G, are based on the full square. C D and G, since they do not follow right around the circle, are actually nine-tenths of the square. Medium width letters H U N T A V Z conform to a measurement of eight-tenths of the width of the square. Narrow letters B E F I J K L P R S X Y fit within a rectangle, which represents half the area of the square as it is divided vertically through the centre. Although I and J are in the category of the narrow letters, as each is essentially a single vertical stroke, they are obviously exceptional.

It is often helpful to think of the letters as divided into basic categories of wide, medium and narrow by the simple ratios described above. When this is applied to the elliptical O alphabet, however, there is a more complex problem. Primarily this is because, whereas a circle is a fixed, absolutely symmetrical form, ellipses vary in width. To create an italic alphabet with correct proportional relationships between letters it is therefore necessary firstly to establish a well-proportioned ellipse, neither too wide nor too narrow, to act as the

standard O. This is then the guide to the width of other letters and the character of curving shapes. However, as a result of narrowing the O, there is then less variation between the widths of individual letter-forms. The concept of wide, medium and narrow letters can still be applied, but it may be necessary to make more radical adjustments in the basic frameworks than in the Roman alphabet, in the interests of providing a good visual balance.

Lower-case forms, when ascenders and descenders are taken into account, are varied in height and it is necessary to fix a measurement for the body height of the letters and a relative proportion for rising and falling strokes. The body height in typography is known as the 'x-height', which helpfully defines how it can be established. In the relative proportions of capitals and lower-case, the full height of the capital is matched by the body height and ascender of the lower-case letter. Descenders then fall below the writing line to the same measurement by which ascenders rise above the body height. A good, simple system is that the body height should be three-fifths of a capital letter, ascenders and descenders each two-fifths of the height. This gives a proportional ratio within the lower-case letter of 2:3:2. For italics, which are elongated forms, this ratio may be slightly extended to 3:4:3.

The proportions described here represent standard letterforms and those which are good models for a beginner to use. Naturally, as a calligrapher becomes proficient in handling the pen, it may be tempting to develop modifications to the basic alphabets, corresponding to personal preferences for certain styles. In that case, the proportional system can still be used to provide certain fixed points of reference, and should be applied if an alphabet is to remain consistent, legible and visually pleasing. These need not be restrictive, but they will ensure that no letter looks incongruous or draws attention to itself at the expense of continuity in a text. As a final note on proportion, it must also be emphasized that the intention here is to illustrate the governing principles of good lettering, but is not meant to imply that calligraphy requires complicated geometrical calculations. The next essential is to understand precisely how the action of the edged pen affects the appearance of the basic letterforms and, thus, the importance of paying careful attention to the proper techniques of using the pen to enliven the lettering.

Above *The diagram illustrates the construction of the letter O in the Roman alphabet as seen in the Trajan column inscription. There is a slight tilt in the main curves, the overall form being aligned on an angle of 82° from the centre point A. The width of the letter is slightly less than that of a perfect circle. The thin curves of the letter are slightly less than half the width of the thick curves and the transition between the two is very gradual. The inside curves are tilted; the outsides are symmetrical on a perpendicular axis.*

The weight of letterforms

The broad-nibbed pen controls every aspect of the construction and appearance of calligraphic letterforms. The character of the writing depends not only upon the possible variation of thick and thin strokes, but also upon the general weight and texture of the forms. This is dictated by the width of the nib used and the angle at which it is held.

The weight of a letter is described in terms of the number of nib widths that fit into its height. This is established in graphic terms by

Right *'Grow old along with me' shows a mixture of italic and Foundational hands although the capital R in 'Grow' is a reference to uncials. Italic features, such as sharp branching, show up particularly in the half-size lettering.*
Below *This embroidered T shows the use of hairline flourishes. The difference in the weight of these flourishes and the main strokes ensures that the letterform retains its clarity.*

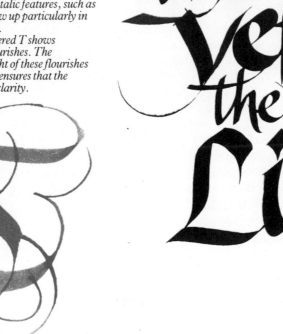

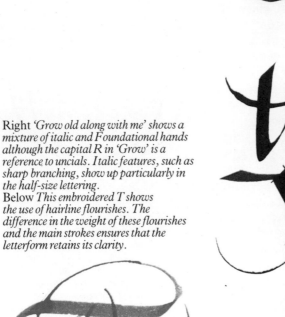

turning the nib to a horizontal position parallel to the writing line and marking the nib widths in a stepped arrangement from the baseline. The measurement demonstrates how letters of the same height can be heavy if drawn with a thick nib or light if drawn with a relatively fine nib, as this is determined by how much of the available space is occupied by a single pen stroke. In general terms, a letter of fewer than four nib widths to height is relatively heavy, while letters of more than five nib widths incline to be light.

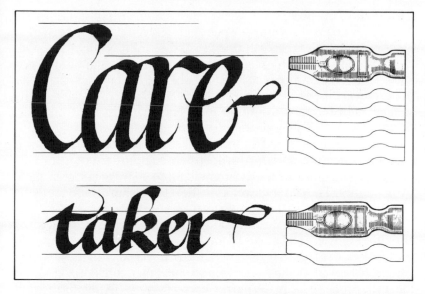

The number of nib widths to the body height of the letter is an important relationship in calligraphy. Letters of the same height can be light if drawn with a fine nib or heavy if drawn with a thick nib as shown (above). Differences in the weight of the letters can be achieved by increasing or decreasing the number of nib widths to height instead of changing nibs; in this example, letters seven nib widths high are fairly open; those that are three nib widths high are more dense (left). The balance of thick and thin strokes overall is also an important consideration (below). Thin strokes serve usefully as connections between letters.

Curving strokes of an edged pen construct the inner spaces of letters as well as the letterforms themselves. Counters which are fully enclosed, as within the circle of O or the bowl of lower-case a d and p, or those which are partially described, as in the loops of s and g, must be carefully preserved. Oblique strokes dictate the internal character of triangular forms such as A K V and so on. The broader the pen, the more these internal spaces are reduced. Also, a broad pen creates more exaggerated and abrupt variations between thick and thin than does a relatively fine nib. The heavier a letterform becomes, the more it tends to demonstrate the essential qualities of its pen-made construction.

As in a heavy letterform it is necessary to preserve a clean shape and good proportion of white space within the letter, so in a fine letterform it becomes more difficult to control the internal form because of an excessive amount of white space. It may be noted that a slight decrease of weight, for example half a nib width, makes considerable alteration to the appearance of the letter. The recommended minimum weight is seven nib widths to height; in any measurement greater than seven, as the strokes are more narrow and elongated, it is extremely difficult to describe a clean curve or a steady vertical stroke.

At this point it can also be mentioned that there is a difference between the actual weight of a letterform and its apparent weight. This is the difference between a simple measurable quantity used in the letter construction – the number of nib widths to height – and the visual qualities of the lettering as seen on the page, its optical effect of massing or linear sequence. Rounded lettering with gently curved bowls and loops will appear less heavy than a compressed or angular hand with narrow inner spaces, although the same pen is used and the two lines of writing are of the same height.

Above *Any alphabet can be written with consistency of form and texture if the principle of a constant pen angle is used. While most calligraphers' letterforms are made with the pen at a slanted angle, including Roman capitals, medieval book hands and italics, a notable exception is the uncial form, for which the pen is held straight. This gives rise to a high degree of contrast between thick and thin strokes.*

The angle of the pen

The simple factor governing the pen angle and its relation to particular letterforms is that the pen's thinnest stroke necessarily falls in line with the nib edge and the thickest stroke in line with the shaft of the pen itself. (This relationship is altered if an oblique-cut nib is used, but for the moment discussion of pen angles can be taken to refer to the squared nib, the most common form and that best used until the beginner fully understands the effect of angling the pen strokes.) This means that the thickest and thinnest strokes are always at right-angles to each other and if the pen is held at a constant angle to the writing line, its every movement forms a logical graduation of stroke between these two extremes. The pen angle refers to the relationship of the edge of the nib, the thin stroke, to the writing line.

The angle of the pen deals not only with the graduation of stroke, it also directs the general stress of the lettering as it falls on the line. In straight pen writing, as it is known, the pen is held with the nib edge parallel to the writing line. The thin stroke is therefore horizontal and the thick stroke vertical; the narrowest points on a circular form are at top and bottom, the broadest in the centre of each side. The forms of straight pen lettering are generally upright, rounded and formal with a strong vertical stress. The alternative to this is slanted open writing, with the nib placed at an angle to the writing line, in which both the thickest and thinnest strokes are oblique, although running in opposite directions; the vertical stroke is narrowed by the angle of the pen. Slanted pen writing is comparatively angular and may be compressed. It can be written more rapidly because the hand holding the pen is in a natural position for writing, whereas in straight pen forms it is somewhat strained. The basic stress of the lettering is oblique, as demonstrated by the tilting of a round O, when the narrowest section of the curve is turned anti-clockwise from the vertical axis. In simple terms, the directional emphasis of the writing reflects the direction of the thickest stroke.

A fixed angle of 30° from the writing line is often recommended for slanted pen writing. This is calculated to give a properly proportioned effect with attention to the letter construction and balance of internal spacing. There is a range of possible variation, for example from 30° to 60°, where the hand can comfortably direct the pen. The italic alphabet, for example, is written at an angle of 45°, which suits its characteristics of compression and speed. It must be realized, however, that any increase in the angle of the nib against the writing line alters the relationship of thick and thin contrasts and how they fall within the natural shapes of the letterforms.

To illustrate the effect of pen angle, Edward Johnston devised the idea of relating it to a clock face with the writing line running horizontally through the centre. When the pen is held in the position for straight pen writing, the thickest stroke runs from 12 to 6, the

thinnest from 9 to 3. It can then be simply compared with slanted pen writing at an angle of 30°, when the thickest stroke follows a line through 11 and 5, the thin stroke lies between 8 and 2.

Continuing the image of the clock face, it is further seen that a line can be drawn between 10 and 4, but with the pen kept flat with the horizontal or at an angle of 30°. In the straight pen form, the stroke between 10 and 4 is relatively thin, since it falls closer to the thin stroke at 9 than the thick at 12. In the slanted pen writing, however, the line from 10 is closer to the thick stroke, so it remains relatively thick. Since it is initially quite difficult to maintain a constant pen angle whatever the direction of the stroke, experiment with the clock face construction is useful in demonstrating the basic principles of how the width of the strokes will change. When the contrasts between the effects of a flat pen and a 30° angle are understood, it is then only a logical extension of that principle to realize how a precisely similar shift of emphasis occurs at a 45° angle, or, in fact, at any point between 0° and 90°.

For a left-handed person, the natural position of the writing hand reverses all these directions and effectively operates from the other side of the clock face. The tilt of a round O is turned clockwise from the vertical if written from this position. To counter this reversing effect, an oblique-cut nib can be used, trimmed to a sharp angle downwards from the right-hand corner. This enables the left-handed calligrapher to achieve the conventional pen angles more comfortably, because the shaft of the pen and the nib's thickest stroke are no longer in alignment. A similar adjustment can be made by right-handed calligraphers. A nib trimmed obliquely downward from left to right keeps the shaft of the pen in an angled position, natural for writing, while the edge of the nib is still kept parallel to the writing line.

Above *This example of modern free pen lettering uses contrasting thick and thin strokes and variations in weight and texture to capture the vitality and rhythm implicit in the words.*

Practical penmanship

The physical activity involved in formal calligraphy is minimal, but concentration and a steady hand are absolute requirements. The first essential, then, is simply to ensure that the working position is comfortable. It has already been explained that there are good reasons for working against a slanted rather than a flat support. To this can be added that the calligrapher's posture should be erect rather than stooped, so a chair with a firm back support is important and the feet should also be well supported, either on the floor or on a sturdy bar of the chair.

The pen should not be under pressure; calligraphy requires a light touch but, at the same time, sufficient firmness to ensure fluid evenness in the strokes. Johnston explained that ideally the pen should 'glide' on the surface. The pen grip for calligraphy is not as tense as that used in handwriting, when speed and pressure are less controlled. In essence, the best way to hold the pen is in the most natural and comfortable position, usually supported by thumb and forefinger and with the shaft of the pen lying in the curve of the hand between them. To release tension and discourage the temptation to apply too much pressure, the fingers are more extended than in the grip used for handwriting; there is no need to clutch the pen. The pen is held at a shallow angle to the paper; the heel of the hand rests lightly on the paper guard. Very slight variations of pressure can assist in describing a pen letter – for example, an increase of pressure moving into a curved stroke can be gradually decreased on coming out of the curve. However, a single pen stroke is a

Right *and* far right *Blackboard exercises provide an excellent opportunity to practise rhythm in writing. Using special chalk, square in section, to imitate the action of a pen nib, experiments can be made on a large scale, as these uncials show.*

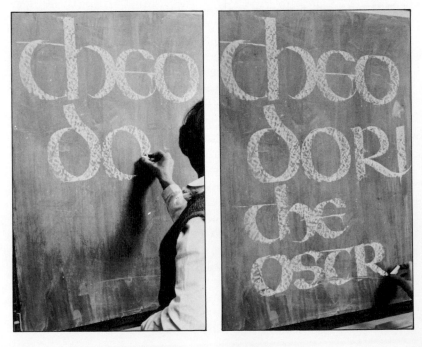

Aimez Vous la perfection, ensuivez bien ce Paragon,
Imitez la main et Ses traits, entierement parfaits.

delicate movement and the increase of weight or tension is extremely subtle in such cases.

If the calligrapher fills the pen by simply dipping it into the ink bottle, it is difficult to control the amount of ink in the reservoir and the fluid may drip or flood onto the paper. The recommended method for charging the pen or quill with ink, and this must be done frequently, is to hold the pen in one hand with a brush in the other, and use the brush to feed ink directly into the reservoir of the pen. The pen should always be moved into contact with the brush for filling, and not vice versa. It is also important to prevent the ink from touching the upper surface of the nib. This method of using the brush may seem distracting to a beginner who is trying to concentrate on the letterforms, but it soon becomes second nature. If the dipping method is found much easier, however, it can be used, but it is wise always to test the flow of ink on a piece of scrap paper before starting to write, to draw off any excess ink clinging to the nib. This should also be done when fine or lightweight lettering is being written, even if the pen is brush-filled, as an overloaded nib will destroy the crispness of the pen strokes.

The pen can be wiped clean with a rag whenever necessary and if ink dries on the nib, clogging the reservoir or the slit, the pen can be rinsed out carefully with water. But it should be wiped and dried after washing, to avoid any deterioration of the metal which does tend to oxidize if left damp.

A beginner should start with a reasonably broad nib and a letter

Above This seventeenth-century illustration shows the correct way to hold a quill pen to produce the writing style then in vogue. The nib of the quill was cut to a fine point to produce the thin flourishes which decorated the writing.

height of about four or five nib widths. This is the clearest way of showing the action of the edged pen in forming the letters, and the medium weight will avoid any problems of trying to control a particularly fine or heavy stroke. The first thing to practise is the constant angle of the pen. It may be found useful to mark light pencil lines showing an angle of 30° at intervals on the writing line to provide a visual check on the angle of the nib. Since the position of the hand is most natural in writing slanted forms at this angle, it is the easiest way to gain confidence and familiarity with the motion of formal writing. To understand the pen angle and the thick to thin contrast of the stroke, the beginner may, at first, want to try out some simple pen strokes – vertical, curved, oblique. It is more valuable, however, to study the strokes used in a particular alphabet form and relate the pen practice immediately to the typical components of the letters. In addition, this breaks the habits of handwriting and implants familiarity with the number and order of strokes used in forming the different letters.

In keeping with the principle of allowing the pen to make smooth, unforced movements, each letter is composed of two or more strokes (except I and sometimes J). They are put together in accordance with general rules governing the direction of each stroke and its order in the sequence of construction. The logical sequence of strokes, and that most natural to the movement of the hand and pen, is to construct the letter from left to right and draw the strokes from top to bottom. Thus vertical and oblique strokes are described from the upper limit of the letter height down towards the writing line. This direction applies to all oblique strokes, whether they fall right or left of the vertical, or actually cross it diagonally.

Round letters are formed with arcs, again moving from top to bottom, starting at the narrowest upper point and finishing at the narrowest point at the base of the letter. It has already been described how the O can be thought of as two symmetrical curves moving in opposite directions. In letters with partial curves, the number and sequence of strokes must be assessed in relation to the quantity of the full circle or ellipse that is included in the curve and how it is placed in the graduation between thick and thin.

Usually, the vertical stem of a letter is the first stroke. An exception to this rule occurs in lower-case letters a d and q, which have a bowl to the left of the stem. Here the bowl is formed first, constructed from partial curves, and the stem is added to the bowl. Letters that have no vertical stroke are formed in sequence from left to right, the four strokes of M and W, for example. In H and N the verticals are made first and the bar of H and diagonal of N inserted to join the two. Horizontal cross-strokes are made in the order top, bottom and centre; thus in E and F the central horizontal is the final stroke and T is formed with the stem first and then the bar.

The number, order and direction of strokes follows a logical pattern,

bearing in mind the basic character of the letter and the pen angle used. Every alphabet should be studied carefully for signs of its basic construction before it is copied; in old manuscripts where the scribe has been working at speed, it is sometimes possible to see a broken connection between strokes, which indicates the point where the pen has been lifted.

It is difficult at first to feel quite natural about the frequent pen lifts made in formal calligraphy. There may be a tendency to break the stroke rather abruptly, leaving a ragged tip, or to draw out the stroke too far. One method to practise is lifting and turning the pen at the end of a narrowing curve; this can be done in one smooth movement where the nib is allowed to glide up and away from the paper, lifting the leading tip of the nib edge as it comes out of the stroke. Dexterity is an important part of calligraphy and, in time, the rhythm of different strokes should become instinctive, giving a natural continuity and coherence to the lettering.

For initial practice of strokes and letterforms, it is only necessary to rule horizontal lines on the paper, allowing plenty of space between the lines for the height of the letters and ascenders and descenders, if any. Capitals can be spaced the whole height of the letter apart, therefore the paper can be ruled evenly and every other line used for writing. For lower-case forms, the space needed between lines of writing is three times the height of the letter o. As ascenders and descenders are generally shorter than the body height of the letter, this measurement leaves some room for clearance between the lines. Allow extra space at first for italics with curving ascenders or flourished letterforms.

When starting to write words and full lines of writing, rule a left-hand margin on the page as well as horizontal guidelines and start each line at the vertical rule. A light pencil line is sufficient guide for placing the lettering. Spacing and layout are discussed in more detail in the following chapter.

Ideally, the writing line should be the only reference, as the calligrapher will gradually gain a proper instinct for the even height and correct relative proportions of letters. In practice, a beginner may prefer to rule a writing line, a line to mark the body height of the letters and, if necessary, lines to indicate the extension of ascenders and descenders above and below the writing line. But Johnston remarked that 'writing between ruled lines is like trying to dance in a room your own height' and it should be remembered that it is essentially the pen that creates the form, not any principles of geometry or arithmetic planning. This is where calligraphy gains its true vitality. For the same reason, any temptation to sketch letterforms in pencil and fill them out with the pen should be resisted. For tentative calligraphers, practice with twin-points or a carpenter's pencil may instil some early confidence, but experienced penmanship will only be attained through experience of using the pen.

Above *By writing with balsa wood instead of a pen, and on a fairly large sheet of paper, the beginner can become accustomed to making serifs and to producing confident strokes. While this is no substitute for work with a pen, such exercises can lead to increasing fluidity and dexterity; the scale helps to analyze mistakes.*

Serifs and finishing strokes

A frequently quoted axiom of calligraphy states that a practised scribe can construct a whole alphabet in a consistent style if given only the forms of O and I. It has already been shown how O demonstrates the model for the skeleton form, whether it is round or elliptical, and also how the angle of the pen governs where thick and thin graduations will occur within the curves. The feature of an alphabet characterized by I, which gives the scribe the clue to formation of straight stroke letters, is the way the vertical stroke of I is finished at head and foot.

Hooked serifs, which are characteristic of italic writing and the modified tenth-century hand, are made by pushing the pen upwards slightly before following down into a vertical or oblique stroke. A

Right *This manuscript, written in Latin on vellum, is the Book of Hours known as the Hours of Eleanora of Toledo, signed by the scribe Aloysius and dated 1540. A fine example of the* cancellaresca *or chancery script, developed and perfected in sixteenth-century Italy, it is decorated with borders, emblems, miniatures and other types of Renaissance ornamentation. This script was a cursive hand used for copying classical texts and for documents issuing from the Roman Chancery.*

Tule tupahan onni,
pysy siellä pyytämättä,

similar motion is made just before lifting the pen at the base of the stroke. This type of serif may serve merely to tip the main stroke of a letter or it may be noticeably hooked and possess its own direction. As a rule, these serifs come in from the left of the main stroke at the head of the letter and tail off to the right at the base. On a vertical stem this motion is made quite abruptly so the stem itself remains a true vertical; the serif should not curve into the main stroke but does literally form a hook on the head or foot. In general, the tails of letters that are fluid and oblique, as in K and R, are not hooked but follow a natural pen curve tapering to a hairline.

More formal serifs are constructed of two or three short pen strokes, creating a distinct shape to the head and foot of the letter and in the finishing cross-strokes. A horizontal or wedge-shaped serif is marked with a hairline at right-angles to the main stroke, and is then moulded into the form on a curve. This can be done in two ways. Either draw the horizontal hairline first and then, as a separate stroke, turn the pen to describe a fine curve into the stem; or make a curving stroke by first moving in from the horizontal and the right-hand edge and then sharpening this by laying in a short vertical stroke over the curve. In Roman capitals the serif is centred on the stem and curves in from left and right.

Some extra dexterity is required of the calligrapher when twisting the pen on a serifed form, to ensure that the width of the serif stroke is kept in line with the stem. Finely curved hairlines and flourishes also respond to this motion and it is occasionally desirable to modify the curve of a structural stroke in this way. To twist the stroke the pen can be gently rolled between the fingers, altering the angle of the nib or lifting one corner of the nib away from the surface. Alternatively, the pen angle can be kept constant and the hand turned slightly from the wrist in a quick, smooth movement. Only practice endows this sort of ability and if the calligrapher is sufficiently sensitive to the action of the pen, it will be possible to feel when the right kind of movement is achieved. This realization will be borne out by the visible results.

Elaborate serifs draw attention to a piece of writing. This is a particularly useful technique when designing selling or display material, such as this piece by the Finnish calligrapher, Erkki Ruuhinen (above). Flourished finishing strokes may also be used for signatures. The notable scribe George Bickham used controlled serifs to highlight this engraving he made of his signature (below). Bickham was particularly interested in developing a practical business hand, which was presentable but not fussy.

GBickham

The alphabets

When copying an alphabet look for its basic characteristics and try to distinguish its skeleton form and the pen-made modifications to that form. Study the proportion of letters in height and width, between the body of a letter and the rising and falling strokes, and the general shapes of curving letters, whether they are round or elliptical, tilted or vertically stressed. Identify the weight of the lettering, the pen angle, the relationship of thick and thin strokes and the sequence of construction within each letter. These are the elements that govern the family likenesses between letters in an alphabet. They are expressed in the nature of curved strokes, the internal spaces in the letters, the serifs and finishing strokes and the joining of strokes – such as the way arches and bowls are attached to the stem of the letter. Calligraphy is much more vital where these innate characteristics have been understood than where the calligrapher merely attempts to copy the letters by eye.

Roman capitals

The classical Roman capitals are not easy to construct as natural pen letters, because the forms were originally modified by stone-carvers and adapted to the action of the chisel. However, they were also written with the pen, which gives the strokes their thick and thin contrast, although the finest surviving examples of Roman capitals actually occur in monumental inscriptions in stone. Roman square capitals are of enormous interest to the calligrapher as the origin of other written forms, and also because they are regular and finely proportioned. There have been many modifications of the original Roman lettering, which exaggerate or modify the thick-thin contrast and the construction of serifs to simplify the calligrapher's task.

The skeleton Roman alphabet is based on strict geometric models, which are optically adjusted in pen lettering to maintain a balance within the letterforms themselves and in their relationships to one another. In simple terms, the majority of letters are based either on a square or on a rectangle, which is half of the square. The skeleton form of O is a perfect circle that fits exactly to the basic square. Q is also a circle, distinguished by its tail, which flows naturally from the base of the letter but does not cut the curve. M and W are based on the square, although the outer oblique strokes extend slightly beyond the boundaries, at the base of M and at the head of W. The curves of C G and D follow the circular O, but are cut to nine-tenths of the square in the open C, the vertical stem of D and the bar characteristic of G.

The narrow letters B E F I J K L P R S X Y all fit into the half-square. The remaining letters, H U N T A V Z are regularly proportioned within eight-tenths of the square. X and Y, like M and W, extend outside the rectangle in the oblique strokes, X at the base and Y at the head. Thus, there are four basic frames for the proportions of all Roman capitals. Each one is clearly distinguishable by the strong

Below *This modern Roman capitals alphabet shows the basic construction of the letterforms without the serifs which are so characteristic of the traditional Roman form. The essence of the alphabet is the combination of thick and thin strokes that complement the underlying geometry of the forms.*

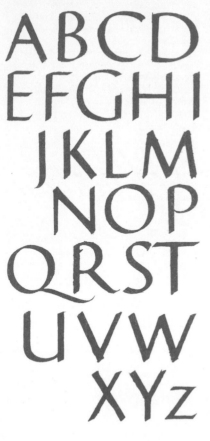

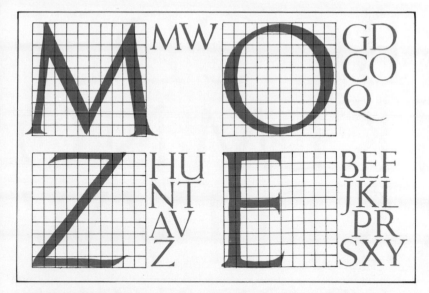

The Roman alphabet (left) is based on geometrical models, but subtle refinements and adjustments to individual letterforms prevent the letters from looking rigid or inelegant. The letter M is slightly wider than it is high. The second and third strokes curve slightly before they meet, making the form more open and less angular. The lower serif on the Z is curved outward slightly to draw the eye on. The O is based on a perfect circle and its curves are tilted at a slight angle. The E is half a square but the centre bar is slightly shorter than the other two and the bottom serif turns at an angle to lead the eye to the next letter. Similar accommodations can be seen on the other letters.

contrasts between straight and curved elements of the forms and the regular distribution of square, triangular and circular shapes.

Certain modifications have been made to the position of cross-strokes and the curve of bowed letters to establish proportions that are optically satisfying. In a basic skeleton form, for example, B can be, in effect, formed of two D shapes, one on top of the other. The two bowed sections would then be equal, coming together at the centre line between top and bottom. In practice, the lower bow of B is slightly enlarged and the two curving strokes meet above the centre line, otherwise the letter appears top heavy. The modification is subtle and it is a common mistake to exaggerate this difference, an over-compensation that should be avoided as it makes the letter inconsistent with the structure and proportion of other forms. Likewise, the lower bowl of S should not be allowed to overtake the scale of the upper section. The classical Roman S, as seen on the Trajan column inscription, tilts forward slightly. This is unfamiliar to modern readers who are accustomed to the typical typographic styles, where the upright form is weighted in the bottom curve.

The cross-strokes through the centre of E F and H are placed slightly above the centre line, so that the bottom edge of the pen stroke sits on the line. (Note that in both E and F the top arm and cross-stroke appear equal in length, but the middle arm is slightly shorter, while the base of E is slightly extended.) By contrast with the usual habit of fixing the optical centre of a letter just above the actual centre, the bowls of R and P drop below the centre line so the enclosed counter has a clean, open curve corresponding to the circular form of O. The cross-stroke of A is also lowered so that the enclosed triangular space is not cramped and disproportionate. The branching of Y crosses slightly below the centre

AABBCCDEF GHIJKLMNO PQRSTUVW XYZ

ABCDEKM
NOSVWZ

Above *The standard Roman capitals alphabet with serifs is written with the pen at an angle of 30°. Each stroke is 1/10 as thick as its height. The direction and order of strokes is shown* (right).
Below *A certain uniformity in proportion holds between different letterforms within the same alphabet. Thus, the letters CDG all occupy 9/10 of the square that contains the letter O.*

line whereas the oblique strokes of the X cross slightly above the centre, leaving the lower triangle fractionally larger than the upper.

The proportions and optical corrections are described to give the calligrapher an explanation of the relative constructions. However, in starting to practise Roman capitals with the pen it is not necessary to draw a complex grid and slavishly repeat the geometric proportions. It is better to study the models and try to achieve the strokes naturally, using the pen angle and weight of the lettering as guidelines.

The angle of the pen nib for Roman capitals is 30° from the horizontal writing line. This means that the thick-thin contrast in most of the letters is not extreme, since the oblique strokes do not directly correspond to the edge of the nib or to its full width. The height of the lettering is seven nib widths, but the thickness of the vertical stroke, because of the pen angle, is one-tenth of the height. Because of the width and angle of the pen, the narrowest sections on the curve of O become tilted. As previously described, the O is formed by two semi-circular pen strokes; first the left-hand curve, then the right, meeting at the narrowest point to the right at the base of the letter. Vertical and oblique strokes are drawn from top to bottom. The

FRAGT NICHT/
WAS EUER LAND
FÜR EUCH TUN WIRD
FRAGT/
WAS IHR FÜR EUER
LAND TUN KÖNNT
FRAGT/
WAS WIR GEMEINSAM
FÜR DIE FREIHEIT
DER MENSCHEN
TUN KÖNNEN

JOHN F. KENNEDY

cross-strokes of A E F H and T are the final strokes of these letters.

The serifs of Roman capitals correspond to the chiselled forms of incised lettering. However, they are more difficult to achieve with the pen because they are delicate and fit on a geometric curve into the stem, which is not automatically formed by continuing the stroke. The serifs finish with an edge at right-angles to the structural stroke; the curve attaching it to the stem is a perfect quarter-circle. To achieve this with the edged pen it is necessary to turn the nib angle and work at right-angles to the main stroke. The curves are made by drawing short strokes with the edge of the pen coming in from left and right and following into or out of the stem. The flat edge of the serif is then made regular with a fine hairstroke. Note that the serifs on vertical strokes extend on both sides of the stem, whereas in horizontal strokes they turn from the writing line or the top of the letter, except in the cross-strokes of E and F, where again they extend in both directions across the end of the stroke. It is interesting to compare these serifs with the finishing strokes of the modified tenth-century hand, which are entirely adapted to the consistent pen angle and the natural pen-made rhythm of the forms.

Above left *This quotation from a speech by John F. Kennedy was written in a modern version of Roman capitals by Werner Schneider, using India ink and a metal pen on handmade paper.*
Above *A feature of the lettering, originally intended for a poster, is the use of the inset E instead of the German accent umlaut. This device is correct grammatically but also helps to preserve the clarity of the line spacing.*

Uncials

Uncials followed the Roman square and Rustic capitals and were the result of the need to write in a formal style, but more quickly than is possible using the stately, deliberate capital forms. Uncials are bold, upright and rounded. They are natural pen letters, having simple constructions and finishing strokes, fluidly contained within the fixed angle of the pen and the direction of strokes.

The existence of two or three alternative constructions for more than half of the letters indicates that the uncial was an adaptable and highly practical hand. These variations all fit within the general family characteristics of uncials, but are an indication of how speed in writing tends to produce natural modifications of form.

Uncials were the standard book hand of scribes from the fifth to eighth centuries, later superseded by the half-uncials and the rapid development of minuscule scripts. They were somewhat neglected during the revival of formal calligraphy; although Edward Johnston commended them as typical pen-made letters and adapted them for his own use, they were not promoted as enthusiastically as other forms of lettering such as italic and Johnston's own Foundational hand based on tenth-century script. More recently, uncials have found favour as a highly decorative and vigorous alternative to straightforward capital and lower-case forms. Despite their association with some of the finest early Christian manuscripts, they seem to have a curiously modern

Above *A regular, even-height script such as uncials can be used to good effect in a repetitive pattern. Here, basic uncials give a textured, woven look in a design for florist's wrapping paper.*
Right *This quotation by Beethoven was written in uncials by Henri Friedlaender, using India ink and gouache with a pen on paper. The lettering was originally designed for a broadsheet, but was later reduced for use on an exhibition invitation.*

DE GEEST IS HET/
DIE DE EDELE EN
GOEDE MENSCHEN
SAMENHOUDT/ —

EN GEEN TIJD KAN
HEM VERNIETIGEN.

BEETHOVEN

flavour, which is well-suited to contemporary ideas of design.

Uncials are a straight-pen written form, where the pen is held with the edge of the nib parallel to the writing line. The thinnest strokes are precisely horizontal and the thickest vertical. Uncials are naturally quite heavily textured, although they are also pleasantly open as a result of their rounded constructions. The uncial O is a round character, but because there is a pronounced thickening of the curves on either side, the pen form extends across the circular skeleton. The inner space follows the curve of a circle more closely than does the outline of the form.

Serifs occur as natural extensions of the pen strokes; on a vertical stem, for example, the serif is formed by pulling the pen from a leftward direction to form a fine line flowing easily into the broad stem. It can be squared off at the right-hand edge by drawing the pen down vertically over the original curve. The rounded version of W has a serif extended both ways; this is made by a light stroke coming in from the left, crossed by a similar stroke from the right, which follows into the main curve. Since the edge of the pen is horizontal in forming these strokes, the evenness across the top of the serif is automatically established. In general, the curved and extended strokes of uncials have a naturally graceful finish owing to the rhythm of the pen's progress; tiny hairline 'tails' can be created by a quick twist of the nib before lifting the pen.

Above *There are two ways of making serifs in the uncial script. For serifs extending to left and right, a light stroke made from the left is crossed by a similar stroke from the right, which continues into the main curve. Otherwise, the pen can simply be pulled to the right to create a serif before continuing down into the main stroke, which is finished off in a similar way.*

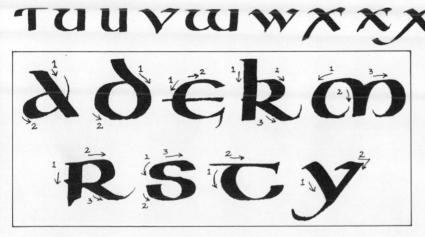

Above *The uncial alphabet (shown here with variations) is made with the pen held horizontally. This gives the marked contrast between thick and thin strokes; the verticals are always the broadest strokes and the letterforms have a squat appearance.*
Left *This example shows the sequence and direction in which the uncial strokes are made.*

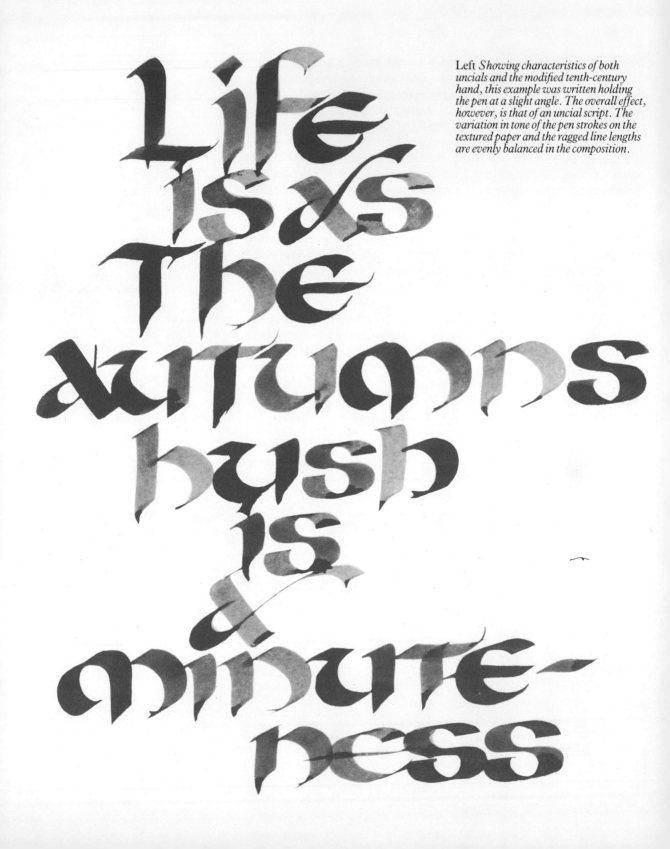

Life
is⁄s
The
autumns
hush
is
&
a
minute-
ness

Left *Showing characteristics of both uncials and the modified tenth-century hand, this example was written holding the pen at a slight angle. The overall effect, however, is that of an uncial script. The variation in tone of the pen strokes on the textured paper and the ragged line lengths are evenly balanced in the composition.*

Modified tenth-century hand

The modification of tenth-century minuscule script produces a rounded, vigorous letterform, naturally adapted to the movements of hand and pen in calligraphy. There is both invention and adaptation in this alphabet, as in the curving forms of V and W, and in the regular vertical emphasis of a and g in the minuscule form, which are sloping and more freely written in the earlier versions. In addition, the tenth-century manuscripts often show use of the long s, which to modern eyes appears to be f; in the modified hand the s conforms to the expected shape in relation to the other letterforms. The alphabet of capital letters has been systematically constructed to accompany the modified script and is not typical of tenth-century capitals, when versals and adapted uncials were commonly used and much variation and ornament.

Like the Roman capitals, this hand has a regular system of proportion and a subtle graduation of thick and thin strokes, but it is open,

Below and below left The lower-case and capital letter alphabets of the modified tenth-century hand are written with a pen angle of 30°; the weight is four nib widths to height. The order of strokes is shown for each letter in the lower-case alphabet. A rounded, almost cursive hand, designed for clarity and ease, the letterforms should be written fairly close together to emphasize the rhythm and coherence of the strokes.

ABCDEFGHIJKLMNO
PQRSTUVWXYZ &!?

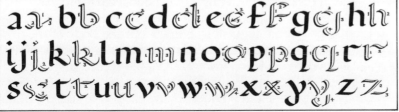

broad and less severe than the square capitals. The pen angle used is 30°, as with the Roman capitals, which gives the tilted, circular O. The lettering is quite sturdy and compact. The vertical and rounded forms are dominant, so in letters that have a vertical stem this is usually the first stroke written.

Serifs at the top of vertical strokes are simply formed by a slight curve starting the stroke from the left, and then overlaid with a vertical stroke to sharpen the right-hand edge. Less formally, in oblique strokes the fluid motion of the pen is allowed to begin and end the stroke in a logical manner – tails curve naturally with a tiny flourish as in the minuscule g k and y and the capitals K R and X. This script almost has the freedom of a cursive hand and the letters should be closely spaced so there is a lively horizontal linking between the forms, occurring easily through the characteristic rhythm and direction of the strokes.

Dignus es, Domine Deus noster, accipere gloriam, et honorem, et virtutem: quia tu creasti omnia, et propter voluntatem tuam erant, et creata sunt.

And I saw in the right hand of him that sat on the throne a book written within and on the back, close sealed with seven seals. And I saw a strong angel proclaiming with a great voice, Who is worthy to open the book, and to loose the seals thereof? And no one in the heaven, or on

Above This example written by Edward Johnston, demonstrates his Foundational hand, a modification of an English tenth-century hand that was a standard script for scribes. Johnston updated the old minuscule forms and the result is more upright letters accompanied by similarly modified capitals.

Is Gott für uns, wer mag wider uns sein? Welcher auch seines eigenen Sohnes nicht hat verschonet, sondern hat ihn für uns alle dahin gegeben, wie sollte er uns mit ihm nicht alles schenken? Wer will die Auserwählten Gottes beschuldigen? Gott ist hier, der da gerecht macht, wer will verdammen? Christus ist hier, der gestorben ist, ja viel mehr, der auch auferwecket ist, welcher ist zur Rechten Gottes und vertritt uns.

Above *This packaging design for cosmetics makes use of a modified version of Gothic script. The angularity of the writing makes it suitable for such graphic treatment.*

Above right *Rudolf Koch (1874-1934) was responsible for carrying on the traditions of Gothic Black Letter in Germany in the twentieth century. A calligrapher and type designer, Koch emphasized the relationship between both disciplines. This piece by Koch, written in 1933, demonstrates some slight modifications to the standard script, particularly in the use of hairline strokes as decorative spacing-filling devices.*

Gothic Black Letter

The compression of Black Letter writing, its angularity and rigidly vertical structure, was a development based on speed and economy in writing, which was also stylistically in keeping with other art forms of the period. This style of Gothic lettering is also known as *textura*, a Latin word meaning both 'texture' and, more specifically, 'a web'. Its rich, dense texture is considered picturesque and ornamental, if barely legible, and it evokes many associations with the highly decorative form of Gothic illuminated manuscripts.

At its most formal, Gothic Black Letter could be written as a series of evenly spaced verticals, which might then be adapted to form any letter by the addition of oblique joining strokes, abbreviated cross-strokes and extensions ascending or descending from the body of the text. When it is presented in this type of systematic patterning, it is almost illegible to modern readers. However, it would seem that the vertical stress of Gothic lettering was widely accepted by its contemporary readers, since it formed the model for the early type designs of the Gutenberg Press. It was in use for such a long period and in so many different places, that there are naturally a number of variations of Gothic letterforms which can be adapted to current use.

The pen angle for the Gothic forms is 30° to the writing line. The weight of the writing may vary; Black Letter is usually quite heavy, for example in a range of about three to five nib widths to height, and it is more difficult to control the evenness of patterning if the strokes are finely made. Serifs and joining strokes are formed in much the same way; the constructions should be carefully studied to see how these elements are differentiated. The lozenge-shaped serifs are not precisely centred on their vertical stems, but set slightly to one side. The Fraktur serifs consist of two spars branching from the stem, with more emphasis on the right-hand branch. The curious construction of X in this alphabet eliminates the usual crossing of two oblique strokes and subordinates the form to the consistency of vertical emphasis.

abcdefghij
klmnopqrs
tuvwxyz

The standard Gothic alphabet is written
with the pen held at an angle of 30°; there
are no set rules for the height of the writing
(above left). There is no fixed capital
alphabet in Gothic Black Letter; this is a
just one example (left). Capitals in Gothic
scripts exist in many forms, based on a
variety of earlier styles. The pattern of
writing was often further complicated by
the use of fine hairstrokes cutting through
the forms. Essentially, the script is heavily
stressed vertically, with oblique joining
strokes between the verticals making
individual letters (above).

ABCDE
FGHIJKL
MNOPQ
RST
UVWXYZ

A fine, flowing hand, italic is most often used in the lower-case form (below). The pen angle is 45°; the writing may be sloped slightly to the right. The weight is usually four nib widths to the body height, three each for ascenders and descenders, italic being a lighter script than other hands. Capitals are seven nib widths high and resemble a compressed, fluent form of Roman capitals (right).

ABCDE
FGHIJKL
MNOP
QRSTU
VWXYZ

abcde
fghijkl
mnop
orstu
vwxyz

Right *Italic is a fluid, cursive script, regular and easy to read without being overly formal. Although ascenders and descenders are often elaborate in this hand, it is just as effective to restrict extra flourishes to initial capitals.*

Then the whining schoolboy with his satchel
And shining morning face, creeping like snail
Unwillingly to school

As You Like It 11vii

Italic

Italic was the typical pen form of Renaissance Italy. It came into being in the interest of developing a greater writing speed while maintaining an elegant, finely proportioned form in pen script. The characteristics of italic are the elliptical O, on which model all the curved letters are constructed, the lateral compression and slight rightward slope of the writing, and the branching of arched strokes flowing rapidly out of the letter stems. Compressed, angular hands are naturally quicker than rounded forms and italic is the most easily adapted to informal, cursive handwriting. This was the main reason for its original development, but it was also refined and formalized.

Italic is by nature a lightweight form and is usually written with a nib width narrower than those used for the rounded forms of medieval book hands. There is less variation in the widths of italic letters, but they are elongated, with extended ascenders and descenders. For this reason, the height should be carefully controlled to keep the pen strokes firm and cleanly curved. In keeping with the flowing elegance of italic, the tails, ascenders and descenders are often elaborately flourished or looped. For practical purposes, a simple, basic form is easier for the beginner and as the movement of the script becomes familiar, further elaboration can be made.

Italic is most commonly written in the lower-case form, with capitals as appropriate; the capital alphabet is like a compressed version of Roman square capitals. The weight is most easily fixed at four nib widths to the height, a further three each for the ascenders and

and our aesthetic enjoyment in recognition of the pattern

descenders. The capitals are seven nib widths high, based firmly on the writing line, to align with the body height and ascenders of the lower-case forms.

The pen angle is 45°. The lettering may be upright or sloped, but never more than 5° from the vertical. A pronounced slant is unnatural and an unnecessary exaggeration. The direction and order of the pen strokes follow the usual guidelines. In arched letters such as h m and n the pen can be turned at a sharper angle in the branching from the stem and the finishing curve, to narrow the fine strokes. It takes time to learn control of varying the pen angle and for initial practice, the fixed angle of 45° products a logical and well-proportioned letter.

Above A detail of a design by Julian Waters, this script is an italicized minuscule showing characteristics of both styles of script. The arched letters such as m n and h are italic in the branching arches but the o is not elliptical. The elliptical o is the distinguishing feature of italic alphabets.

Ich habe felber ausprobiert, daß es recht nützlich ift, nachts im Bett in der Dunkelheit die Hauptlinien der Formen, die man ftudiert hat, oder andere bemerkenswerte Überlegungen in Gedanken nochmals durchzugehen; es zu tun ift empfehlenswert und geeignet, Dinge im Gedächtnis zu feftigen.

LEONARDO DA VINCI

Above This quotation from Leonardo da Vinci, written in italic by Werner Schneider, is a clear demonstration of the elegance of the italic script. Flourishes have been used in a restrained way, and always for a specific purpose: as decoration in the margin, to balance the design where space permits, and to emphasize the flow of the line.

The basic serif of the italic alphabet is a hook, formed by pushing the pen upwards briefly from left to right before following down into the stem. Loops and tails are finished on the natural curve of the pen stroke. It is common to see ascending strokes carried over on a curve to the right, following the general emphasis of the lettering. This is a convenient way of tailing off the ascenders, but it is a matter of preference whether this style or a simple, pen-made serif is used. Serifs on the capital forms are also natural pen hooks, following the main curve or using a pushed or slightly twisted stroke. There are many examples of elaborately flourished italic capitals; this is one of the most varied forms in terms of decorative modifications. Models for alternative forms can be found from studying Renaissance and modern manuscripts and copy-books.

Versals

Versal letters are large or small capitals that are used to denote the opening of a chapter, paragraph or verse (hence the name versals), and to mark important passages in the text. In early manuscripts versals were simple forms based on Roman capitals. In Italy, there later developed a more exaggerated, bulging form often referred to as Lombardic, after the region where this style was first introduced into hand-lettered manuscripts. These Lombardic versals had their roots

AABB CCDD
EEF GHIJKLMNOPQR
STUVWXYZ

Unlike calligraphic scripts, versals are built-up letters; their shape is not determined by a single pen stroke. Instead, inner and outer strokes are drawn and then the centre is flooded in a single stroke. This alphabet shows both the skeleton form and some filled letters (above). Versals were used in early manuscripts as initial letters highlighting the beginnings of passages or important places in the text. Gradually they became more decorative and elaborate; in some cases, like these ninth-century 'zoomorphic' letters (left), the basic form is only barely discernible. Less fanciful versals were still used elsewhere in the text but initial capitals were freely interpreted representations of animal and plant life, vividly drawn and boldly coloured.

in the rounded forms of uncial letters, which can be seen in the curving shapes of E H G and M. Versal letters were the basis of the compound forms in highly decorated medieval manuscripts, which were also often adorned with figures, animals and plant forms, and richly ornamented with gold and bright colours.

Versals differ from the alphabet styles so far discussed, because they are built-up letters. While still dependent upon the pen stroke for their basic character, it is not a single stroke that forms the shape and thick-thin contrast. The stems of versal letters are formed from two outer strokes which are quickly filled with a central stroke. They are drawn, rather than written. It is usual to make the outer, left-hand stroke first, then the inner and flood in the central stroke immediately.

Above *This versal alphabet is in the Lombardic style, a curved, more exaggerated form based on uncials. Cross-strokes and serifs in both types of versals are wedge-shaped; the Lombardic versals, in particular, are often finished or flourished with fine hairline strokes.*

However, when forming curved letters, for example O or the bowls of B or P, the inside is the first stroke to be formed.

There are a few practical points of technique to note in relation to versal letters. The board used as a support for the work should be lowered to a shallow angle. The width of nib used should be slightly narrower than that applied to the main body of the text. A quill is often used, with a slit lengthened to ½-¾ in (1.2-1.9 cm) long, which allows the paint, watercolour or gouache that has been diluted to a rich, milky consistency, to flow smoothly through the nib.

The quill is held perpendicular to the writing line as the main outline strokes are drawn and filled, but horizontally when applying cross-strokes, serifs and hairlines. The cross-strokes start at the width of the nib and are splayed in two flaring strokes at the end to produce the wedge shape. Hairline strokes form a clean right-angle to the main stroke and are not moulded into curves as in the classical Roman capitals. The curves of bowed versals are exaggerated slightly; the inner curve may be flattened and the outer curve made more pronounced. Once the outlines of a stem are drawn the centre should be flooded with the third stroke immediately, laying down enough paint to give the letter a delicately raised effect when dry.

Left *Versals lend themselves well to elaboration. Experimenting with scale, spacing and decorative elements will throw up interesting combinations as well as increasing the fluidity of the strokes.* **Below** *The illustration shows the number and direction of strokes for certain versal letters. While the outer stroke is usually drawn first in letters with vertical stems, for curved letters, the inner stroke is the first to be drawn.*

Versal letters should be built up quickly and spontaneously. Attempts to repair or modify the forms after they are fully written are likely to spoil the smooth curves and fluid, raised strokes. Exaggeration of bowed forms can be subtle or extreme, as preferred, but it is important to preserve clean interior shapes and to define the overall character of the letter distinctly. If versal letters are written very large, the proportions can be adjusted so that they are more elongated and refined as the height increases, otherwise the shapes become extremely bulky and will tend to overpower other writing on the page.

Versal letters in a body of text may be written in the margin, set into the text or positioned symmetrically on a line between the two. Traditionally, built-up letters are added after the general text is completed. If the versals are set within the text the necessary space must be calculated beforehand and the opening lines of text adjusted to accommodate them. Where versals fall in a vertical line down the margin, especially if they occur on every line or almost as frequently, they provide a more rational arrangement if they are centred on a vertical axis rather than aligned from one side or another. Otherwise the different widths of the letters can create a jumbled or apparently random design.

Layout & design

A single letter is a designed form: when two letters are put together they create a more complex motif. Each time the number of components in a design is increased, the interrelationships of the basic forms also multiply. There are many different strands to the process of designing that must be considered equally, however large or small the text. The aesthetics of calligraphy do not begin and end with the choice of elegant letterforms and the competence to repeat them with precision. It is no easy task, however, to cope simultaneously with the verbal significance of lettering and its abstract visual qualities. The calligrapher's special responsibility is to preserve the substance and meaning of a text while also transmitting the vitality of writing as a thing in itself.

In a highly literate society reading habits are conditioned by the printed word: the average reading rate of an adult is 250 to 300 words per minute. Research into the visual characteristics of letterforms and their relative legibility has been related mainly to typography, although legibility is also a prime consideration of calligraphy. When printing was first invented it was the forms of the scribes that provided models for type design. Since that time the two skills have tended to part company. But although the calligrapher's intentions are different from those of the typographer and are addressed to a different audience, they still have much in common. The context of calligraphy has changed and it is useful for modern calligraphers to observe the methods and results of contemporary lettering artists, as well as studying the precedents set by the early scribes.

poem — E.E.Cummings

nite
thatthis
crou
ched
moandgrowl-&thin
a stirs M
id a
live whats wh
umich cur
ling s
y are mi idenl
drite also conce
als 2 ph
antoms clutch
ed in
a writhe who room)as
how's of
whi
ne
climbser
AM
e
xploding aRea t

Above *The design of a piece of calligraphy is often suggested by the nature of the text. The poetry of e.e. cummings is particularly idiosyncratic in style and this example, written out by Miriam Stribley, reflects cummings' disregard of grammatical rules. The spiky script tends toward italic, although it is not a standard form. Broken words and ragged line lengths are linked by looped and curving flourishes.*

The context of design

Research into the effectiveness of visual communications focuses on the proposed audience for the work and the impact it is supposed to convey. There are different levels of literacy, knowledge and attention span required from the potential audience for an advertising poster and that for a science textbook, for example. In calligraphy this appreciation of the function and context of the work is economically expressed in Johnston's proposal of three questions, which every calligrapher should address when starting a work: '*What* is the thing? *How* is it done? *Why* should it be done?'. This provides reasonable guidelines for the quality of thought needed before the design itself may begin. Redirected, the question might be phrased: 'What is added to the value of the content by the style and design of the writing?' This applies whether the calligrapher is working for pleasure or if the work is specially commissioned or intended for public exhibition. In addition, Johnston's questions suggest that the nature of the text itself often indicates the style of presentation.

Text may take a number of different forms. It could be two or three letters only, as in a logo or monogram; a title or heading of a single word or very few words; a phrase or short text; a formal arrangement such as a roll of honour; an independently structured item such as a poem, calendar or verse; or a continuous running text of many lines or even several pages. The characteristic form of the text, therefore, has a broader context according to the style of form and presentation. A flat sheet may be held in the hands or mounted and displayed in a frame; a book, for practical purposes, is relatively limited in size, unless it is required as a highly formal record for display rather than a personal possession to be handled. Calligraphy that is intended for reproduction in print does not need to be made to size – it can be scaled down mechanically, for a letterhead or book jacket for example, or blown up proportionately, as for a poster. Calligraphy designed for transfer to another medium, such as stone-carving, television graphics or silk-screen processing, poses additional problems, because some modifications to the original design may have to be anticipated. These aspects will be discussed more fully in the following chapter on the special applications of calligraphy (pages 144-55). To discuss the basic precepts of design, it is convenient to consider it as self-contained, aiming for the production of a unique, well-crafted, single work.

There are various conventions relating to the design of calligraphy that have developed in practice and are sound basic guidelines. In many respects, there are exact parallels between calligraphic and typographic conventions. In so far as these represent knowledge acquired by lettering designers of all disciplines and provide information on the advantages and drawbacks of different methods, they are valuable signposts for effective design. But all design rests to some extent on optical modifications and visual judgements that cannot be

subject to measuring systems or reduced to infallible codes. No one device will apply to every situation, nor will it perform the same function in different contexts. The dual purpose of design in calligraphy is to make something interesting and pleasing to the viewer and by doing so, demonstrate a synthesis of visual and verbal qualities. The calligrapher will only learn through individual experiment and discovery. Good design is a matter of informed decision making, but it can also result from having the courage to break all the rules.

Spacing

Texture

The movement of the pen creates both the actual letterforms and the spaces in and around them. Black and white are of equal value in their contribution to the texture of a word, line or text. In writing, as in drawing, it is easy to focus so attentively on making the marks that the shapes surrounding them can seem to be a secondary factor, a product of instinct or accident. There is no such thing as correct spacing of letterforms, because this is relative to the weight of the letters and the overall density of the text. There are a few rules of thumb that provide basic reference points for spacing, but in a complex arrangement the calligrapher must make continual optical adjustments. Spacing is judged by eye, not by a system of mathematical proportion. The best equipment a calligrapher can bring to a design is a full consciousness of

Many design features seen in early manuscripts have become standard traditions for written and printed texts. In an astrological map of the tenth century the device was used of weaving the lines of writing through the drawn figure, as seen here in Saggitarius (above left). The drawing is bold but fairly crude, the script a miniscule typical of the period. An interesting demonstration of calligraphic style has been used by Ann Hechle to create her own business card (above). The heavily flourished title is echoed in the single, smaller line of italic; these lines are alternated with other information written in a modern version of Rustic capitals. The design is centred on the card to rationalize the different line lengths and combination of styles.

the positive importance of space.

The consistency of alphabet forms and the family relationships of shape and proportion ensure a rhythmical pattern in writing. This rhythm is enhanced by variations made by the touch of the scribe. Consistency is not the same thing as uniformity, which can have a deadening effect. Type *en masse* is necessarily both consistent and uniform; it need not be dull for this reason, but in general its function is to assist the reader unobtrusively, not to draw attention to itself. In this respect, the formal conventions of typography are relatively restricted. In calligraphy, on the contrary, the slight modifications of form that naturally occur are signs of life. There are distinct variations that could be applied to the appearance of a single letter, which correspond to logical design principles. This will be discussed later in the chapter. In a coherent text, however, a slight degree of variance is enlivening, but a random inconsistency is puzzling.

The texture of writing depends upon the basic weight and character of the alphabet, the number of words or lines in the text and the overall arrangement on the page. Johnston differentiated between fine writing and massed writing. The properties of fine writing he described as open letterforms distributed within a generous space, in straight or

The rich textures and patterns of freely written forms are fully exploited in these examples of work by modern scribes. In commissioned work, such as the title of a newspaper article (above right) by Miriam Stribley and a poster (right) by Gunnlaugur SE Briem, legibility is important so the words are written vigorously but quite distinctly. Each item has a particular focal point, distinguished in visual terms from the surrounding text; the fine capitals of the word ETCHINGS in the poster and the large capital C linking the different-sized scripts in the newspaper heading. A change of scale or form is an effective way of drawing the viewer's attention. Both designs are arranged with the emphasis slightly off centre to enliven the overall layout. A perfectly regular text tends to have a more static quality. The movement of the pen is given free rein in a trial layout for a cursive alphabet design (far right). This work employs a columnar structure and a pronounced variation of thick and thin strokes. The letters are fitted together in an instinctive visual rhythm. The action of the broad pen fluidly describes the modified letterforms and joining strokes.

Gunnlaugur SE Briem presents
Einar
Hákonarson
ETCHINGS
21 Nov-2 Dec
Monday to Friday, 9:30 to 16:30
Paperpoint, Wiggins Teape plc
130 Long Acre, London WC2

The greatest scandal in Christendom

by Arthur Koestler

slanted hands and only lightly ornamented. Massed writing he defined as having a dense, closely woven texture, consisting of a great concentration of text within a relatively restricted space. He cited Gothic and italic forms or particularly heavy lettering, and remarked that contrasts of weight and colour might be advisable to help to relieve the density of texture.

The design of a written page takes into account the spaces within and between the letters, between words and lines and the width and evenness of margins. Further considerations might include the contrasts between different letterforms, or between letters and decorative forms, and also the balance of tone (black and white) and colour. Space and texture do not exist in a fixed relation that depends upon the weight of the basic letterform. All the components of the design are mutually affective and create visual sequences that may be modified or rearranged as required.

This process is a combination of instinct, acquired knowledge and anticipation. Such knowledge is not acquired only through practice or in isolation. While Johnston advised careful, self-critical analysis, his own principles of calligraphy were derived from intense study of the practice of others. To this can be added the value of inquisitive analysis of any kind of two-dimensional design. The more abstract qualities of a good design can often, if clearly identified, be translated from one medium to another. There are, of course, practical values that are specific to the materials and methods of different artistic disciplines and should be kept for these individual art forms.

Working drawings show the evolution of a design: the changes may be radical or quite subtle as the work progresses. A working drawing by Eric Gill (above right), made for Count Kessler of the Cranach Press in Germany, shows a typically elegant arrangement of capital letters. In a book cover by John Woodcock (above and below) the letterforms became gradually heavier and more elaborate.

The texture of writing, whether heavy or light, is consistent to the degree that the same letterform is used throughout. Devices that cut into this even texture naturally stimulate attention. The clearest illustration of this principle can be seen daily in the visual organization of newspaper pages. Hierarchical values, shown in size and weight of type, are applied to headlines, sub-headings, by-lines, quotes and solid text. In books the same principle applies, as headings are usually presented in a large, bold or compressed type compared to the body of the text; paragraphs are indented or opened with a line of capitals; quotes in the text might be set in a smaller type size or perhaps in italics contrasting with Roman type in the body of the text; long passages of type are broken into columns. Such decisions are made on the basis of more substantial logic than merely the aesthetic preferences of the designer. Newspaper editor Harold Evans has pointed out: 'Design is not decoration, it is communication'.

In the design of newspapers, speed is of the essence and the technology of the printing method is a significant arbiter of visual style. In addition, the product is intended for a short life, its prime function is as a vehicle of communication, not as a thing of beauty to be cherished. In these respects, the basic determinants of mass commmunication are very different from those of calligraphy. In simple terms of design, however, these conventions, which enliven the texture of a printed page, apply equally to calligraphy. In fact, most of the techniques are present in manuscripts produced before the age of printing. Roman capitals and versal letters are the forerunners of newspaper headlines, and it is via the precedents set in handwritten texts that the principles of

typography have been developed. They have continued to develop, however, in a sophisticated and scientifically researched context and, to this extent, have left their origins in calligraphy behind. This point is stressed to suggest that a calligrapher can learn as much about basic design principles from a daily newspaper as from the Book of Kells, although this says nothing about the comparative pleasure to be gained from either source. There are other specific aspects of the design and function of calligraphy that should be gained from a careful study of handwritten forms, ancient and modern.

Legibility

Spacing is a prime determinant of legibility in a text. Some early manuscripts have no spacing between words; examples of this solid linear arrangement can be seen in manuscripts of square and Rustic capitals. In later examples the words are differentiated not by spaces, but by a small dot or stroke between letters, indicating the end of one word and the beginning of the next. By the tenth century distinct separation of words was standard form. Modern reading habits have been determined by a number of these inherited conventions, which have developed over hundreds of years.

Text run together or divided by positive strokes rather than spaces is not illegible to modern readers, although it is unnecessarily tiring. Lines written vertically or in the *boustrophedon* form, however, are far more difficult. Although the technique of reading is merely a matter of habit, it is habit confirmed by centuries of use. A great deal of research has been conducted into the way we read and the factors that govern the relative legibility of a text. This has been specifically geared to typographic forms, but it has produced many instructive basic facts, which are of interest to calligraphers or any designer concerned with the form of words. It clearly demonstrates the mutual dependence of written forms and reading mechanisms.

How and why a word, phrase or text remains legible, when it can be written in such a variety of ways, is a question that has exercised scribes, typographers and lettering designers for many years. The concerns of the medieval scribes were, to some extent, simplified by the small size of their literate audience, which meant that many of their texts were already known by heart to anyone capable of reading them. Legibility is not a simple matter of familiarity, however, either in writing style or text content. A letterform may be legible without being necessarily easy or pleasant to read. A script can be decipherable without being strictly legible.

To a literate person, reading seems a smooth and easy process, but it is actually performed in a series of jumps and pauses. The pauses occupy a high proportion of reading time and provide a period for the reader to recognize and absorb the words; the jumps propel the eye through the text. In machine printing, the mechanisms work on a

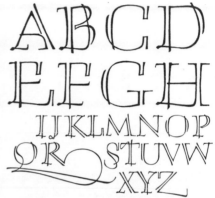

Above *An alphabet design by Gunnlaugur SE Briem refers to the thick and thin contrast of forms written with a broad-edged pen, but this is suggested only by the subtly broken outlines. Because the letterforms have no solid weight the shapes are modified, but each letter retains the essential characteristics of construction that make it clearly recognizable.*

Right *Legibility is not a prime concern in this freely written alphabet, one of a series by Terry Paul. The main interest is the calligraphic properties of the forms in abstract terms, as a combination of line and mass. Careful attention has been paid to the balance of internal spaces and the extension of flourished strokes into the surrounding white space. This kind of experimental work, interesting in its own right, is also good preparation for more formal writing since it accustoms the calligrapher to considering the overall layout of the lettering as well as its verbal message and individual details.*

letter-by-letter basis, but humans read by recognizing the shape of words. Each person acquires a memory bank of words that are understood at a glance. A wrong or missing letter may be remarked, but it rarely interferes with the reading of the word. Recognition does depend upon a familiar order of the pattern, however, which is why words written vertically or back to front are more difficult to identify. In addition, the recognition of words is linked to experience of the object, image or feeling the word represents. When a deciphering process is needed to deal with an unfamiliar word, it draws on a range of visual and aural references since it is also connected to knowledge of the sounds in speech.

Letterforms combining curved and vertical strokes are easier to

identify than those which are all vertical or all curved; they are more distinctive. Vertical stresses are a particular stumbling block. The letters most frequently misread in lower-case type are i l t f j. A predominance of any of these in one word may confuse the overall pattern for the reader.

This problem is graphically represented by the insistent vertical patterning of Gothic letterforms. The lack of variety in form and texture impairs legibility. In Germany Gothic Black Letter is not uncommon in printing and writing, whereas in most western countries the more familiar rounded Roman forms are considered much easier to read. However, the weight and dense texture of Black Letter is appreciated for its decorative value and the associations it invokes.

A text written in capitals is more tiring to read than one in lower-case. This is partly because of the increased number of verticals, but also because of size. There is a focal point of vision beyond which a certain number of letters remain peripherally clear. Since capitals are larger than lower-case letters, fewer can be absorbed in one reading pause and this may disrupt the pattern of word recognition. The appropriateness of lettering is also relative to the conditions in which it will be read and there is a simple factor of distance that gives large letters the advantage. It is still the designer's choice whether to use capitals or a lower-case form on any scale.

Lower-case lettering has a more complex texture than capitals and it is apparent that ascenders and descenders aid legibility by giving more clues in the overall pattern. Curiously, it has also been proved that if a word is split in half horizontally, it is more easily identifiable in the top half alone than in the bottom. This does not mean that descenders are relatively dispensable in a whole text, but it does seem that letters with ascenders contribute more crucially to the shape of a word. Consonants are more essential to a word's visual character than vowels (longhand forms of notation at speed use this principle), although vowels are used as the clue to the number of syllables in a word. Just as internal spaces are crucial to the individual character of a letter, so they are vital to the recognition pattern of a word. A word printed in solid black with the counters filled in is not easily recognizable even though its silhouette is intact; it is the internal spaces that relieve any possibility of confusion.

Many variations of standard and ornamental types are used in everyday communication, but there has been some investigation into whether a strictly plain form, without serifs or variation of stroke, would be easiest to read. In fact, this form is generally considered monotonous when seen in quantity. Serifs are not merely ornamental or a simple relic of the past; by forming horizontal links between letters and words, they emphasize the grouping, encouraging the eyes to move through the text. Exaggerated serifs are unnecessary, sometimes obstructive. Flourishes and hairlines are purely decorative and are

Below *The convention of fitting one or more following letters inside a large versal letter is seen in many early manuscripts. It is a convenient device for two reasons, one being the practical effect of saving space and enabling the scribe to adjust the length of a heading or line of words. It also has a visual advantage in that it breaks up the texture of a word or phrase and introduces an abstract quality to the design without destroying legibility.*

elegant in moderation, but they too can interfere with legibility. The eye appreciates some variation of texture in a written page, but is distracted by too much.

Nevertheless, legibility is relative. Calligraphers can take liberties which typographers cannot; context also plays an important role. Both on an intellectual and a visual level, the reader can decide what a doubtful word means. Complete illegibility is uncommon, and, because it is difficult to accommodate the entire range of viewer response, we should be cautious of imposing too many restrictions.

Practical guidelines

An instinct for clean and visually accurate relationships between letters can only be acquired through practice, although a few simple standards have been proposed. There is a certain consistency in the relative proportions of letters, but it is impossible to apply a fixed, mathematical relationship to the spaces between. It might seem simple, for example, to imagine each letter as encased within a rectangle, and lay them down with a fixed amount of space between these imaginary boxes. Although the different widths of letterforms are accommodated in this way, their distinctive differences in shape are not. Using the example of capital letters, the strong vertical stresses of an M and N placed side by side will apparently narrow the space between them. The opposing vertical slants of A and V will create a disproportionate amount of space. The I is a constant problem, because it is such a narrow letter. It may seem to float disconnectedly between the forms on either side, especially if not flanked by vertical letters. There are too many variables to fit happily into a geometric grid.

The simple guidelines on letter spacing proposed by Johnston are that two vertical strokes require the most space between them, a medium amount is allowable between a curved and a vertical stroke, while two curved forms can be drawn up close. Even so, this is merely a starting point for optical adjustment. It is further affected by the basic character of the alphabet. The spacing appropriate to capitals is not equally applicable to uncials or a minuscule form. An upright hand requires different treatment from that applied to a sloping hand and the existence and character of serifs in any letterform will directly influence the interrelationships of letters.

The term most frequently applied to good letter spacing is evenness, but it must be remembered that this refers to a visual, not mathematical, quality. It means that there will be roughly the same area of space between the letters in a word, allowing that each space will have a different shape according to the character of the flanking letterforms. A useful way of checking this evenness visually is to write out a word and then hatch in the spaces between letters using a coloured pencil or felt tip. It is often easier to assess the areas of spacing when they are given identifiable tone, than by trying to compare white shapes.

Below A simple standard for spacing between words written in a lower-case form is the width of the letter n. For capitals the equivalent guide is the width of O.

Below Spaces between letters are adjusted according to whether the form is wide or narrow, and mainly constructed from vertical, oblique or curved strokes. The evenness of letter spacing is judged by eye and can be more easily identified if a trial layout is filled with lightly hatched strokes.

Exaggerated errors of letter spacing are easily identifiable. Unless for intentional effect, letters should not be joined between two curves. Letters that are too widely spaced are difficult to read as words; a space much larger than any other will seem to break the word, as it will correspond too closely to word spacing.

Word spacing has more formal guidelines. The space between capitals, as in the Trajan column inscription, is based roughly on the width of the letter O. Johnston qualified this for a general standard by recommending a slight narrowing of the width. Closer spacing may take the letter n as the distance between words, for example in lower-case forms. In modern writing and printing the requirement of distinct spacing between words is generally invariable. Computer typesetting methods can quickly adjust spaces to fit a number of whole words to a regulated line length. Incorrect spacing is noticeable when typesetting produces a strung-out or tight arrangement of words.

Lines of writing may be spaced closely or clearly separated by a deep space. Again, there are a few basic rules that propose some standard arrangements. For lines of capitals the interlinear spacing can be as much as the full height of the letter. For a closer arrangement, a space measuring half of the letter height or slightly less retains legibility. Letters with ascenders and descenders present a more complicated problem since they form a secondary pattern between the body of the text on the writing lines. A space equal to one and half times the height of the body of the letters leaves just enough room for ascenders and descenders to stay unentangled between following lines. The more crowded arrangement, described by Johnston as massed writing, requires some abbreviation of rising and falling pen strokes.

Line spacing is basically governed by the same primary factor that is the principle of letter and word spacing: the pattern of reading is disrupted by too much space or too little. The design of a text should assist the horizontal emphasis necessary for our system of reading and writing. Vertical connections between words or lines interfere with legibility. The eyes should be encouraged to travel smoothly from one line to the next. However, there is a slight hiatus when using the standard left to right reading arrangement; the eyes are required to travel back along the width of the line quickly without doing any work of recognition, to pick up the following line. It is difficult to pass easily down the page if lines are so densely packed that one sits on top of another, or if they are so far apart that there is an apparent break between them. Such imbalances may cause the eyes to skip a line or return to the beginning of the line that has just been read.

Here again, the only measure is optical. To a large extent, if it looks right, it is right. After trial and error, variations in spacing depend upon the experienced judgement of the calligrapher. There is one other important connection between word and line spacing. This refers to the positive action of space in the texture of writing. Exaggerated

Gothic script in a thirteenth-century English manuscript is dense and evenly spaced, with heavy ornaments filling the ragged lines (below). A page from a book of italic scripts (bottom), written by Francesco Moro in the sixteenth century, is more generously spaced to show off the decorative written forms and the curling linear ornaments.

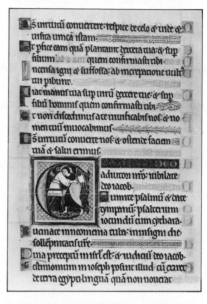

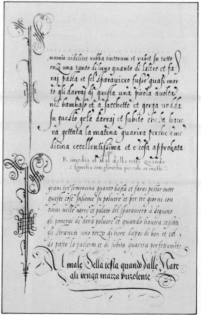

Below A double-page spread can be arranged in a number of suitable forms. A page divided into two columns (1) aligned at either side is useful in newspapers or magazines where small pictures may be inserted into the width of one column. Alternatively, two columns of text may be arranged around a central piece of ornamental writing or illustration (2), for example. The standard double-page layout is placed with each outside margin equal to the central space between the blocks of text (3).

word spaces can induce a vertical link between lines as much as exaggerated letterforms can. It occasionally happens that word spaces fall in exactly the same place on following lines and create the effect of a vertical break in the text, known as a river. This should not occur frequently as it is usually automatically adjusted by variations in the length of words and the number of words per line. When planning out a text, however, it is advisable to check for this effect in the rough copy and make minor adjustments to spacing, by closing up or extending letter or word spaces, for example, to eliminate the effect.

Page layout

The arrangement of writing on a page takes account of a number of variables in design. The proportions of white space to text, most simply represented in the widths of top, side and bottom margins, are assessed in terms of both aesthetic preference and the function of the work. Work that is presented flat, whether or not it is framed, may have any size of margin from minimal to extremely broad. Usually, the lower margin is the deepest and the side margins are equal. On book pages, the custom is to leave a wider margin at the outer edge of the page, called the foredge, than at the inner fold. However, depending upon the binding method, it may be necessary to allow extra space at the centre when ruling book pages on a flat sheet, to accommodate glueing or stitching at the fold. Conventional measurements in typography reduce the text area to about one half of the page. Jan Tschichold's analysis of late Gothic manuscript books identified a proportional system that reduced the written area to one-third of the page; the height and width set by the page size were repeated, for example a rectangular page would hold a proportionate rectangle of text.

Margins serve more than one purpose. In purely practical terms, it is necessary to leave some clear space in a book, so that when it is held in the hands the fingers do not obscure the writing. A margin also protects the text from physical damage. With regard to general presentation, it is thought that wide margins help to contain the text and create a barrier that discourages the eyes from picking up peripheral distractions or from sliding off the page at the end of a line. In practice, typographical research has not identified any significant advantage to the reader from margins that are wide or disadvantage where type falls close to the outside edge of the page.

Calligraphers may then apply aesthetic preferences for one page arrangement compared to another. A freely written, flamboyant word or phrase may seem more expansive and rhythmic if generously surrounded by white space, whereas small, fine writing in an open letterform may gain cohesiveness if allowed to create a mass of text that is both broad and deep across the page area. Alignment is an important factor. A long piece of continuous writing may be arranged horizontally across the page or in columns; a list of names, dates or achievements

in a formal presentation requires careful tabulation. It is convenient here to discuss alignment by reference to a page of running text, from which it is possible to extract principles that can be transferred or adapted to more structured forms.

It has been noted that as western writing runs along horizontal lines from left to right, this conditions the basic conventions of page layout. Text may be perfectly aligned at the margins down both sides of the page. This is a primary feature of computer typesetting where spacing can be rapidly adjusted to achieve this effect. It is less easily organized in handwritten text, requiring innumerable adjustments of rough layouts before even line lengths can be predicted accurately. Ragged text, that is where the lines are not of equal length, is the simplest way of accommodating a text, in which the number of letters per word and words per line are constantly variable. The left to right emphasis

This hand-lettered poster (below left) has a most unorthodox layout, since there is virtually no vertical alignment of the successive lines. The smaller version (below) has been arranged to show how it would look if centred on a vertical axis. In the original there is no such anchor; each line is shifted to left or right of the centre, giving a more spacious and lively arrangement, which works effectively because a standard letterform is used throughout and the proportions and letter spaces are extremely well balanced.

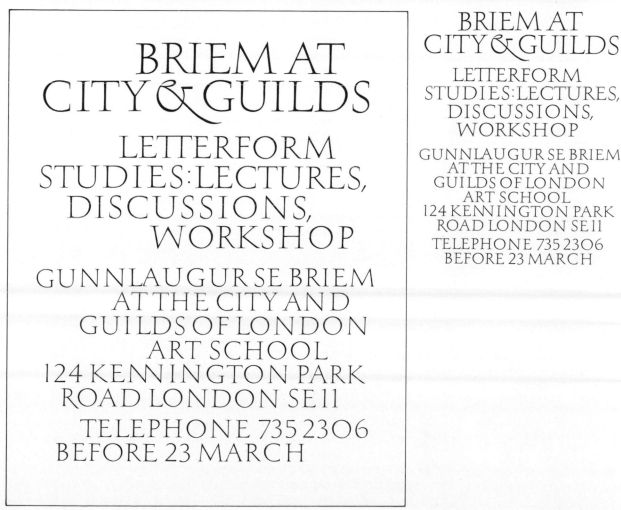

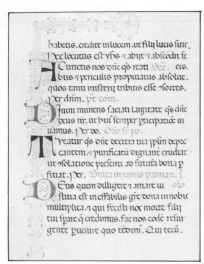

A decorated Italian fourteenth-century missal (above) shows a typical use of versal letters, set half in the text, half in the margin, marking each new paragraph on the page. By contrast, the form of a ninth-century page of minuscule script (below) is a plain and evenly spaced block of text, introduced by a large but undecorated versal B.

dictates text that is aligned on the left and ragged at the right. It would be very unusual to see the opposite arrangement. It is not unusual, however, to see text ragged at both sides but centred on the page. This requires a simple preparation by the calligrapher involving a rough copy of the text.

A convenient device for making minor adjustments to line length is to break words between syllables with a hyphen and move the last section of the word to the beginning of the following line. Word breaks are not particularly noticeable in printed text. A paperback novel opened at any page will probably display a few word breaks that are not registered by a reader concentrating on narrative flow. They do become obtrusive, however, if used too frequently or if the broken syllables seem to form new words. In handwritten text, word breaks are more obvious; in formal calligraphy there are generally fewer words per line than in print and the reader is consciously assessing the form of the writing itself, as well as absorbing the content. It is not generally advised, therefore, to rely on word breaks as a means of evening up the lines. Johnston noted that it was better, if possible, to make adjustments to letterforms and spacing, compressing the writing slightly if need be, to fit in the whole word. In fact, unless there is a yawning space at the end of a line, which seems exaggerated by the line lengths above and below, ragged text is more pleasing than inconsistent efforts to repair the symmetry.

To produce a text aligned at left is a simple matter of fixing the depth of the writing lines and the width of the margin at left. The subsequent arrangement of words is up to the good judgement of the calligrapher. A centred text requires a preparatory stage to produce an accurate arrangement of the relative line lengths. The text is written out in the style of the final work, line by line on a sheet of rough paper. Each line is then cut out separately and folded to align the first and last letters, giving a sharp crease at the centre of the paper strip. The strips are then reassembled on a clean sheet of paper, matching the centre folds to a line ruled vertically down the centre of the sheet. From this rough version a grid can be taken and transferred to the proper writing surface, showing the point at which each line should begin and end. This method is particularly useful for writing out poetry, when the line lengths are fixed non-arbitrarily, but there is no reason why prose should not also be presented as centred text.

Between eight and twelve words per line are easily read. The number of words accommodated obviously depends upon the style and size of the letterforms, and whether the text is fully horizontal or arranged in columns. Five or six words per column width is a reasonable adjustment. If there are fewer words in a line the text starts to seem jumpy, and a line longer than 12 words is tiring. A column width of two or three words, probably requiring plentiful word breaks, is enough to irritate the most willing reader and is unlikely to have a

persuasive visual presence. The space between vertical columns can be judged in the same way as that between lines: too much space will make blocks of writing seem disconnected, whereas too little will tempt the reader to break into the adjacent column at the end of a line.

Paragraphs may be differentiated by extra line spacing between them or, as in typographic convention, by indention of two or three letter widths at the opening of the paragraph. Calligraphic traditions include different ways of marking paragraphs, correspondingly echoed in printed forms, such as the use of paragraph marks and ornamental letters for the first letter or phrase in the opening line.

Poetry usually has a deliberate linear structure, which dictates certain of the calligrapher's decisions. A poem broken into verses naturally requires that this separation be preserved. Following lines in a poem may be intentionally constructed to widely varied lengths. This presents a puzzle to the calligrapher, on how to balance the texture of the writing over the whole page and how to accommodate extra length.

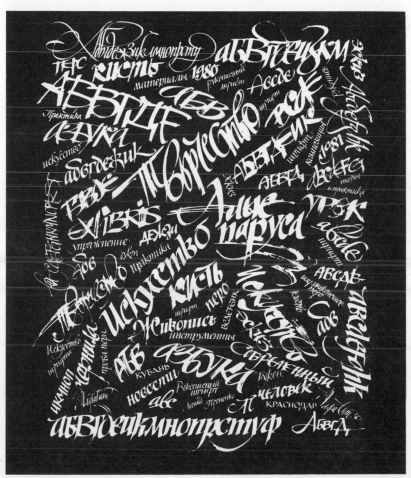

Ann Hechle's rendering of a quotation from The Land, *by Victoria Sackville-West (below), inventively fits together letters, words and lines like pieces of a jigsaw. The apparent randomness of a vigorous design by Leonid Pronenko (left) is deceptive, since this arrangement is also carefully organized to create an interesting visual balance.*

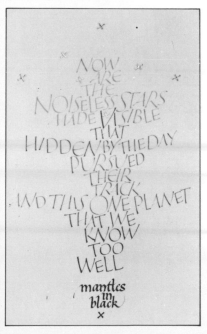

When the structure is informal the calligrapher is relatively free to interpret the basic rhythm. A formal arrangement of line, metre and verse in poetry is a prime example of those times when the calligrapher becomes the caretaker of another person's words and is not licensed to reinvent the form.

Colour in lettering and decoration

The richness of decoration in old manuscripts derives from relatively few colours compared with the range of modern paints and pigments, and the most luxurious were highly expensive and frequently scarce in supply. The two basic ways of using colour in calligraphy – to write in colour by feeding liquid paint into the pen or to add drawn and painted decoration – are both well represented historically by both simple and highly complex forms of ornamentation. The use of burnished gold provided the richest keynote, but for medieval books, under the wealthy patronage of the church, no expense was spared. For the modern scribe gold is still a luxury and the laying of gold is a skill requiring patient practice to develop a level of competence and economy. Gold is not strictly regarded as a colour and is considered a separate element, additional to an overall scheme of colour. It is used, as it was before, in specially prestigious work, in capital letters and particular ornamental forms and sometimes also for whole lines or even blocks of text.

Modern calligraphers' use of colour has tended to follow earlier traditions and their restricted palette of bold colours. Recent developments have included more expressionistic forms of lettering written in variegated or combined colours; although some have rainbow hues, in written designs where the colours spread throughout the page, it is common to find them slightly muted or restrained.

Black and red is a simple, traditional colour scheme in calligraphy. The term 'red letter days' derives from the practice of marking saints' days and special feasts in red on medieval calendars, but the inclusion of red lettering dates back to some of the oldest surviving manuscripts, including Egyptian papyri and early works on vellum. Johnston described this convention as a 'connecting link between plain writing and illumination proper'.

It is not precisely known how the convention arose, but it makes sense in visual terms. Red is a clear, strong colour that forms a striking contrast to black, while being sufficiently dense to sustain its presence in the overall balance of tones. Its early use is probably also connected with availability of materials. Red ochre is an earth pigment found in natural deposits. Vermilion, on the other hand, was a purer but more costly pigment, the use of which, to some extent, indicated the value placed on the work.

Most simply, red is used for capital letters against a black text, instantly identifying the start of paragraphs, important names or other

אבגדהו
זחטיכרל
ממננזסעפף
צצקרשת

Left These Hebrew letterforms are cut in wood blocks to form a typeface for printing. They are the work of Henri Friedlaender, who printed the design in two colours, originally black and red, in such a way that the black letters taken together spell Jerusalem.
Below *An unusual alphabet system was devised by Geoffroy Tory in his work of 1529,* Champ Fleury. *He related the structure of Roman capitals to the proportions of the human face and body. The work is full of reference to allegory and classical myth and he also endowed certain letters with special associations, such as the O, which contains the names of the seven liberal arts.*

items needing a special mark. The first sentence of a paragraph or text may be written in red, hence the term rubric (*rubrica* is Latin for 'red ochre'), which now has a more general application in designating the opening passage or prologue to a text. Not surprisingly, the convention has also been extended to the closing part of a text so the black is contained, as it were, between the red sections. Red was used for ruling staves in music, on which the notes were marked in black. The contrast was also introduced to the words of songs written between the staves, and early forms of both written and printed music have a highly decorative effect.

In basic terms, a line or mass of red letterforms is a definite contrast to black, but red is tiring if used for a heavy block of continuous text. Capital letters in red distributed sparsely over a page may lose their impact or seem to float in the page area. If red capitals appear in the body of a text, they are more firmly anchored by one or more large versal letters at the margin. Such arrangements can be systematic to a degree where they function most effectively without being so rigidly disciplined that they appear boring.

The mutual strengthening of decorated letters through linked colours is the rationale for limiting the number of colours used in a single page or book. This is a long-standing tradition in calligraphy and is still common in modern work. The favoured colours of ornament and illumination are red, blue and green – all strong, dense tones. The use of colour must be judged as appropriate to the context. In modern works such as calendars, herbals and poems, colour is often used with vigour. A riotous rainbow effect would hardly be in place in a formal document or memorial inscription, however.

Ornament and illustration

As Edward Johnston proceeded with his research and practice of calligraphy, he laid more and more stress on the idea that the simplest design is often the best. This encourages the calligrapher to exercise a useful self-discipline in questioning the value of decoration for its own sake. The medieval period is generally considered to be the peak of western calligraphy, partly because it was the final period before printing superseded handwritten forms, but also because of the undeniably sumptuous character of the richly illuminated pages. Earlier manuscripts, however, especially the fresh, distinctive forms of Rustic capitals or uncials, prove how striking simplicity of design can be. The *Codex Siniaticus*, housed in the British Museum, is a masterpiece of elegance and restraint.

A stylized plant form was a typical decoration for capital letters in handwritten manuscripts (above). This example was devised by Edward Johnston to show how the stems were sometimes woven through the body of the letter, as if the form was cut through. The vine pattern, characteristic of Italian decorative style, was adapted to letterforms created for printing (far left and centre). Human faces or figures and animal forms were also commonly used and often became the form of the letter itself, rather than additional ornament, as in this example from fifteenth-century France (left). Below Marie Angel's decorated capitals follow a long tradition of calligraphic design but, as in this pen-drawn letter, they have a distinctively modern style. The combination of illustration and letterform is skilfully achieved – both elements are cleanly described but neatly interlocked as a single unit.

In the matter of colour and decoration, study of illuminated manuscripts quickly demonstrates the freedom felt by the scribes and their confidence in their own skills and the materials to hand. There are examples of ornamental lettering and design that closely relate to the style of the edged pen, others which display a free hand in drawing and the extension of pen-lettered forms.

Ornamental devices in manuscripts consist of geometric or organic forms and emblems, which seem to be a synthesis of the two. These may be linear or blocked, patterned or coloured. In fourteenth-century manuscripts common forms of decoration are the Italian white vine and the French ivy-leaf patterns, which are curling inventions of stylized plant forms that often fill the whole margin space. Woven patterns, plant-like or abstract knots, are typically used in border designs and as background to versal letters. Small abstract devices or sections of a border are neat ways of tidying the texture and alignment of writing; they are frequently employed as line-fillers, inserted in the spaces of a ragged text. As long as the calligrapher is aware of the dangers of excessive ornamentation, these decorative forms may be used as available options in the tradition of calligraphic design.

Miniature paintings and figurative illustrations included in medieval manuscripts can be quite uninhibited in concept and execution: a delightful example is the curious activity of a number of 'humanized' animals working their way across the lower margins of the Stowe manuscript, housed in the British Museum. Such illustrations are

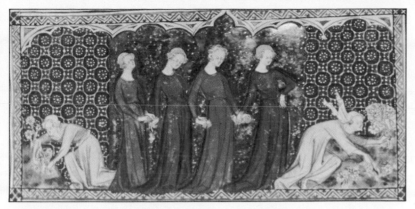

highly typical of their times – they show day-to-day activities, the impact of the changing seasons on rural life, the symbolic conventions of warfare. In specially commissioned works, such as the delicate Books of Hours common in France, the illustrations were related to the life of the patron; in religious works they add to the story-telling power of the Bible and represent the figure-heads in religious life and thought.

As engaging as these tiny pictures are, they are contrived only in terms of design; in content and style they demonstrate the relatively unsophisticated visual perception of a pre-Renaissance age – they often lack any sense of scale or perspective, for example – and deal with the common preoccupations of all classes of people. For this reason, modern interpretations of medieval illustration can look quite bizarre, because the forms are not natural to the experience of modern designers. Where such models are used, it must be with the conscious acknowledgement of borrowed conventions and with a reasonable sense of their suitability to the work in hand. Conversely, contemporary equivalents of such illustrations, dealing with the everyday images of our own time, will not necessarily look sensible among medieval letterforms, unless some parallel modifications are made.

There are some basic ideas of design contained in early works that can be usefully extracted for a contemporary context. The habit of developing decoration in reference to plant forms, animals and human figures, for example, is not incongruous in itself. It is a precept open to current influences in art and design and has, in fact, been continually updated in drawing and print. Many styles of lettering design have been developed in the twentieth century in relation to advertising and display, which attempt to invoke particular associations with real objects or with an intended mood and feeling. In ornamental lettering, where the calligrapher can adapt forms to suit the pen stroke or moves beyond the basic pen stroke to the intricacies of built-up letters, there are many clues on colour, form and texture to be gained from the contemporary standards of all types of graphic design, as well as from the traditional excellence and sheer vitality of earlier forms.

Above Word and image are fully integrated in the free calligraphic style of these designs for a cocktail menu. The cocktail glass, reduced to a simple two-dimensional symbol, forms a broad base for the weight of the lettering above. Above left The fourteenth-century Queen Mary Psalter is famous for its illumination. Scenes are taken from both the Old and New Testaments.

Letters are symbols which turn matter into Spirit Alphonse de 18 Lamartine 65

Above *An alphabet page by the modern scribe Sheila Waters makes use of a number of different styles of lettering to weave an open linear pattern, suggested by the quotation written on the left of the design. The large capitals form the basic structure of the column and the uncial, minuscule and italic forms are so placed as to link the capitals and develop the textural effect.*

The abstract properties of letterforms

It would be fair to say that calligraphy has shown some reluctance to move forward, following the first, overwhelming enthusiasm for pen lettering invoked by the scribes of the early twentieth century. Experimental work is going on, particularly in the United States, where the influence of ancient Mediterranean and European traditions is less strongly felt, and in Japan, where calligraphy has always had a secure and decisive role to play among the visual arts. In Germany, in line with a major contribution to modern design represented by the Bauhaus school and a history of expressionist forms in painting and the graphic arts, lettering and typography have had a particularly important and vigorous impact.

For beginners in calligraphy, it may seem difficult enough to grasp the structure of basic letterforms and learn to execute them cleanly and with confidence. For many calligraphers, the major appeal of pen lettering lies in the archaic nature of forms and traditions still in use. However, these traditional pleasures of formal penmanship may also be extended to include some modern alternatives and extensions to basic ideas of design.

As computers are developed as the new tools of recording and communicating information, so the efficiency of language and the basic alphabet forms have been reviewed. New languages and systems are being invented especially for computers. These issues concern whether or not we need 26 letters in the alphabet; how forms can be abbreviated or identified phonetically; modifications in visual structure that will retain legibility for both people and machines; the relationship of visual form to sound – problems with words that look the same but sound different or that sound the same but are spelled differently and mean different things. Many of these items are long established preoccupations that are continually reviewed within new contexts.

This is not to suggest that there is an immediate link between calligraphy and information technology. But it is true that language is the common tool and any further developments that take place in the structure of visible language are the proper concern of calligraphers. But also, there are precedents in the past that can be re-explored and within which a broad interest in design can be pursued with particular relevance to calligraphy.

Edward Johnston's Foundational hand was a modification of tenth-century Winchester script. The compressed and italic hands were, likewise, developments arising from his studies of traditional forms. They are now taught as standard calligraphic alphabets, but any systematic revision, modification or invention of forms has been minimal since Johnston's time. Expert calligraphers such as Eric Gill, Berthold Wolpe and Jan Tschichold designed lettering systems that have become standard typographic alphabets. The way is open for any

Above *Although far from a calligraphic image, wood block letters by Hans Schmidt demonstrate an interesting interpretation of the essential form of an alphabet. Each letter is fitted to a square module, curves are represented by a shaving of the squared outlines and the narrow black bars provide one further clue in each case as to the identity of the letter. The abstract pattern spells out the words* ICH BIN.

Right *A very different treatment of the abstract properties of lettering is seen in an illustrated poem by Margaret Tam. Although there is a marked contrast between the solid black shapes and the finely written Arabic letters, there is a consistently disturbing quality to the spidery forms, repeated in the jagged outline of the overall spread of the design.*

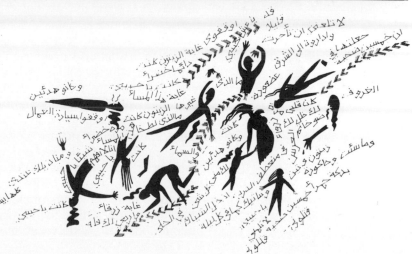

calligrapher to follow Johnston's example in updating letterforms through study of established scripts.

There are early systems of writing that have been abandoned in practical terms, but which present interesting visual problems – pictograms and ideograms are, after all, the ancestors of modern alphabets. The *boustrophedon* form has long become obsolete in western script, but it is fascinating to consider how a line reading right to left can best be constructed from signs and symbols designed for reading left to right. An element of accidental design has crept into many old manuscripts when additions, translations or marginal notes have been added at later dates and in different hands. These have often become integrated with the old text through age, and create variations of colour and texture that are highly pleasing.

It has been mentioned that consistency of family relationships between letters is an important element of legibility. In general, there is a standard form of each letter within an alphabet style that remains obvious, despite the examples of notable variations in single letter-forms that are identifiable in many manuscripts. There is another way of regulating forms consistently and that is by attending to the sound the letterform makes within the spoken word. Consider, for example, the different vowel sounds represented by the letter A in the words bat, ball, castle, spade, many. It is not beyond the wit of a calligrapher to invent regular modifications of the written appearance of an A to fit these five different speech sounds. In addition, there are the combined vowel forms of ai, ae, ao, au, which could be symbolically represented by a single character. These are merely examples and can be applied to other vowels, syllables and details of pronunciation.

The objection to this line of enquiry is that the Roman alphabet derives from the evolution of forms over many years towards the simplest and most basic form that can be made to represent all these various sounds. Compare the 26 letters of this alphabet to the thousands of signs and symbols used in Chinese writing. But remember also that the Romans did not use as many as 26 letters. This suggests that there is no law against breaking with traditions or inventing new letterforms or even whole languages. In addition, there is no reason why the calligrapher should not set a puzzle for the reader, provided there is a certain deliberation in its construction and a reasonable number of consistent clues. Calligraphy is not, after all, concerned with the speed and efficiency required of everyday communications such as memos, news bulletins or even a shopping list. It can afford, perhaps, to reclaim some of the freedom that has been appropriated by other forms of visual art.

This touches more broadly on the question of how far calligraphy can go in destroying the immediate legibility of written text. Here it must be assumed that the audience for calligraphy is prepared to accommodate the difference between reading and deciphering and

Below *This working drawing shows a circular design of Greek letters for decoration on the rim of a plate. The scribe has made additional notes in pencil within the drawing, relating to the commission itself and the development of the design. Rough sheets often become a comprehensive record of the progress through different aspects of the work.*

will find visual interest to compensate for difficulty in verbal recognition. There is a branch of calligraphic art, concerned primarily with the abstract qualities of letterforms, which is not constrained by legibility. This might be in decorative or freely written alphabets, when the character of a letter may be mainly discernible from its place in the sequence. It is concerned with designs that consist of line, shape and texture based loosely on letter constructions. A rich, abstract pattern of layered and overlaid letters is as satisfying in its own terms as a beautifully written poem.

Below *These sketches are part of a student project, the brief being to work out the design of a logo for sportswear sponsored by Steve Ovett. The basic form of capital O, a tilted circular shape, is treated with different arrangements of tone and linear detail. All types of two-dimensional design evolve through this sort of process and this example shows how the initial idea can be built on a calligraphic form and elaborated within the conventions of printed lettering and graphic design used in advertising.*

An interesting parallel to formal calligraphy, and as ancient in origin, is the art of making calligrams, writing that in some way creates, or is interwoven with, a pictorial image. In simple terms, this may be a silhouetted shape of a recognizable object filled with a written texture, as in the tenth-century interpretation of the *Phaenomena*, originally written by Aratus of Soli (b 260BC). Islamic calligrams often consist of an animal or flower drawn in outline by the path of the line of writing. There is a looser approach in which the writing becomes marks in a drawing, as in the landscape titled *Allegorical Essay for Albert Wigand*, by the German artist Calfriedrich Claus. In this last category the writing can become indecipherable, perhaps with a symbolic message almost lost in terms of verbal identity.

At the last, also, the modern calligrapher has an extraordinary freedom to use colour, whether in a descriptive, symbolic or purely abstract function, simply because of the excellent range of materials available. There is an infinite variety of marks a pen can make; in addition, contemporary calligraphers have experimented with sticks and rudimentary brushes as did their most ancient forbears. A final word of caution: the basis of good design is considered judgement and respect for the inherent qualities of the materials and techniques of a craft. By simple laws of chance, anyone who continues long enough to play at random with alphabet forms is likely to produce something presentable. To be able to design a work deliberately and know why it has succeeded or failed is another matter. Order and logic are central tools of the designer's trade, but they do not exclude the value of instinctive visual sense.

Special applications

A unique work of calligraphy reveals the act of writing; the movement of the pen or brush and the manual skill of the calligrapher are directly on display. Ideally, the shape and texture of the writing are fully illustrative of the materials and tools chosen for a specific task. In any art or craft, the underlying principles of design must be the expression of the essential qualities available from a particular medium; this can be represented in broad terms, in that writing is essentially different from painting for example, and more specifically within the territory of a particular skill, that writing with a pen is characteristically different from writing with a brush.

There are three basic categories within the applications of calligraphy, which demonstrate a gradual displacement of the direct representation of calligraphic skill. The first is the production of a unique item that stands in its own right, whether it is intended to be decorative or functional. The second is calligraphy designed for reproduction, which, however faithfully reproduced, loses some essential quality of form or texture. The third category is the application of principles of calligraphy to lettering created directly in a medium that requires the instinctive rhythm of written forms to be modified. This might be by virtue of the characteristic qualities of the medium itself, as in stone-carving, or related to the scale and function of the work, for example in sign-writing.

Calligraphy is often required for presentation pieces. Whenever a new certificate is introduced to replace a previous version (top), an appointed scribe will have to experiment with various layouts before an acceptable form is selected. This is the redesigned certificate for the Royal Academy of Arts (above), which was produced by the English calligrapher John Woodcock.

The art of the scribe

Every work of calligraphy is unique, so that commissions to scribes are often intended for once-in-a-lifetime events or, at least, record information that is considered valuable. There are still many occasions when a single document is required, which must be individual and is not suited to a printed form for various reasons. In Britain, for example, many of the formal commissions for manuscripts arise from events connected with the monarchy and the long-established parliamentary system of government. Patents of nobility, granted to persons assuming a seat in the House of Lords, are handwritten and illuminated. Any civic body may commission a loyal address to The Queen tc mark an occasion such as a royal visit or marriage.

These items are specific to a particular historical tradition, but there are comparable conventions in other countries relating to government and formal diplomacy. There are many other forms of institutional documents that are uniquely hand-crafted – university charters and graduation diplomas, rolls of honour, memorial inscriptions, citations and dedications. These works range from large to small, from plain, simple records to ceremonial, highly decorative panels and manuscript books. A practised scribe engaged on such work may need a comprehensive knowledge of painting and gilding methods, of the forms of medieval decoration and heraldry, and an appreciation of traditional standards of design and modern adaptations.

Such work is, relatively speaking, the preoccupation of a privileged few. A far greater amount of calligraphy produced by both professional and amateur scribes is, by comparison, informal, often experimental and essentially constructed for the pleasure of the craft and the satisfaction of skilled practice. Private commissions are made for single works to give personal enjoyment, arising from their decorative value and display of skill and well-developed aesthetic qualities. Individual projects include texts, poetry, alphabets and sample writing, decorative panels such as a hand-drawn map, a song-sheet, calendar or family tree. Work may be produced for sale, exhibition, as a gift or purely for the calligrapher's own interest. There is endless scope for experimentation with all aspects of design, from the basic forms of lettering to more ambitious combinations of colour, shape and texture.

Calligraphy in print

The original rules of the English Society of Scribes and Illuminators, at its inception in 1921, contained a clause that sought to preserve the integrity of the craft by advising that it should be practised for its own sake alone, without thought to commercial advantage or financial gain. This rule no longer exists and it was not strictly intended to prohibit scribes from practising professionally; however, the spirit of its content has proved somewhat inhibiting on the possible broader influence of calligraphy, whereas in Germany and the United States, handwritten

The map shows St. Felix School with the following labels: Entrance, Ruth's Field, Sanatorium, Bronte House, Fawcett House, Hard Playing Space, ST. FELIX SCHOOL, Exit this way, Dining Halls, Workshop, Tennis Courts, Clough House, St. George's House, Chapel, CAR PARK, Bursar's Office, Caretaker's Cottage, Music School, Art & Science, Cloisters, Swimming Pool, Gymnasium, Hall Library, Craignyle House, School House, Gardiner House, Somerville House, Hard Tennis Courts, Miss Colman's Shelter, SOUTHWOLD, Sheila's Garden, The Sunk Garden, To Tweddle Observatory, SHEPHERD'S LANE, CM

Above *Calligraphy may be put to cartographic use. It is most successful in this context where legibility is a prime consideration. Dorothy Mahoney has managed to produce this clarity in her drawing locating St Felix School. The writing does not dominate, but is a definite addition to the work. Different weights and letterforms help to pin-point places of importance. Maps gain character and individuality if calligraphic writing is used.*

lettering has had a greater role to play in mainstream developments in graphic design during this century.

Before describing the translation of calligraphy directly into printed forms, it is interesting briefly to consider the relationship of calligraphy to typography and book production from the beginning of the modern revival of the craft. Several pupils of Johnston's original lettering classes were significant contributors to improving standards of book design. T. J. Cobden Sanderson, owner of the Doves Press, involved Johnston in the design of hand-drawn letters, initials and headings for a proposed new printed version of *Paradise Lost*.

Anna Simons carried out similar work in Germany, writing decorative letters for combination with type in books printed at the Bremer Press. In an article on lettering in book production she referred to the principles espoused by Johnston and Cobden Sanderson, particularly Johnston's crisp and modest statement that the task-in-hand was 'to make good letters and to arrange them well'. She pointed out that it was of little use to copy the old forms of manuscript design into modern production methods; rather that they could be studied and analyzed so that new forms would be allowed to emerge 'in consonance with the spirit of our own time'.

The forms of modern typography have been crucially influenced by the expertise of craftsmen who were skilled scribes as well as designers of mechanical lettering. Standard typefaces still in use include Eric

Gill's Perpetua and Gill Sans, Frederic Goudy's Old Style and Modern, Jan Tschichold's Sabon, Berthold Wolpe's Albertus, Pegasus and Hyperion, to name but a few. Johnston himself designed the standard sans-serif lettering used exclusively by London Transport, which was influential on Gill's own sans-serif alphabet. There are many modifications and regulations made to the construction of a typeface, however the basic form is initially conceived; designs have also been dependent upon the advice and instruction of skilled technicians, conversant with the intricacies of cutting a typeface. There are mathematical principles involved in lettering design, which override the inherent forms of pen- and brush-made letters so the link between the handwritten and mechanical letterforms is, at best, indirect. Nevertheless, it is true that many of the best and most widely repeated mechanical letterforms have been produced by artists with an extremely broad-based understanding of the different expressions of form in lettering through various media and techniques.

The headings, titles and cover designs of books and magazines have often been calligraphic, or a combination of calligraphy and type, particularly in the United States where it reached a peak as a preferred style during the 1950s and early 1960s. A related item of calligraphy in print was the fashion for hand-lettered and hand-drawn bookplates. Both these categories have their origins in early techniques of printing, when engraved lettering and illustration were combined with metal type. Both were temporarily eclipsed by a preference for wholly typographic forms of design, but have since come back into fashion.

With the highly sophisticated modern methods of photographic reproduction, it is possible to reproduce much of the detail of hand-drawn and handwritten work with remarkable precision. The uniformity of surface in a reproduction tends to smooth out the tiny irregularities and accidental qualities that can give a particular liveliness to the work, although if it is to be combined with the uniformity of typographic elements in a coherent design, this may be ultimately an advantage. It is also possible to cheat quite blatantly: in a black and white design, for example, the reproduction camera picks up only the black and any mistakes or infelicities of form can be simply wiped out with white paint or an opaque correction fluid. On the other hand, there is also the welcome capacity to reproduce exactly the fine linear qualities of even the most complex specimen of calligraphy. The writing may be plainly displayed, superimposed on photography or inventively combined with such elements in the original design.

There are innumerable uses for calligraphy in print. The fashion for handwritten book titles often reflected some traditional quality in the content of the book, for example in works of history, although calligraphy has also been used for all kinds of writing with an essentially modern flavour. Magazine graphics and advertising have frequently made a feature of calligraphic letterforms to promote a particular image

Above *The traditional form of the Gothic Black Letter has been used here in a modern context, a map of the centre of the city of Basel. It is given weight by the heavy form and central position of the writing, which immediately attracts the eye. The lateral balance of the spacing has been perfectly complemented by the fluid joining of both the letters and the lines. The serifs and finishing strokes have been connected unobtrusively; the h of* harz, *for example, is cleverly joined to the a of* Mart, *and the z, with its straight-line finishing stroke, is unexpectedly connected to the s of* Basel. *The buildings around the edge of the writing provide an original border.*

or identity, so the style and the name of the product become inseparable in the viewer's mind. Calligraphy is used in designing logos and letterheads for large and small businesses; it is often thought to be appropriate when invoking association with other forms of craftsmanship. It also seems aptly applied to professions associated with scholarship – publishing or the law, for example. However, publicity is big business and many large firms prefer standard type designs, because they are readily available in various forms that may be needed – photocomposition, instant rub-down lettering, moulded plastic and so on – and a new style of presentation can thus be relatively quickly and cheaply assembled without losing stylistic identification.

Some forms of calligraphy that are commonly developed as unique products are also adapted to print – texts of all kinds, maps, booklets, decorative wall-charts and calendars. There are more ephemeral, but

A calendar is a practical use of calligraphy. Johnston designed this 'perpetual calendar' (below) for his wife in 1932. The Latin motto is written in lower-case lettering, the days in capitals and the numbers are constructed in the style of these two. Johnston was particularly proud of these numbers. More modern adaptations of calligraphy include titles for television programmes. These are some samples for a programme heading, designed by Miriam Stribley (below right).

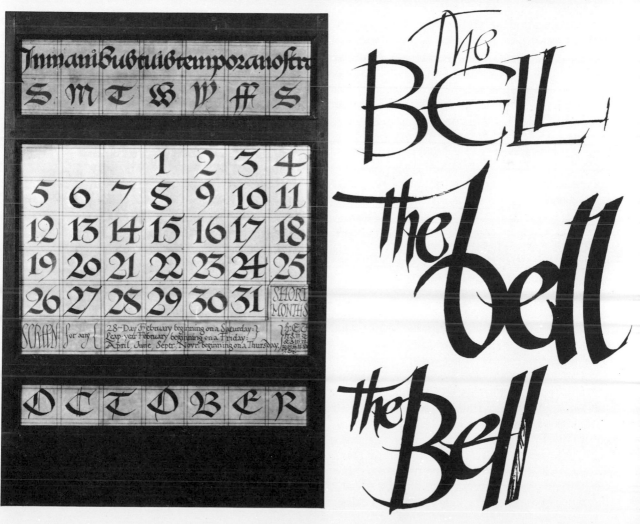

also more personal items – greetings cards and invitations. Posters for local or temporary events may be hand-lettered singly or, for large quantities, it is possible to have an original design printed quickly by photosilkscreen or photolithography.

Calligraphy has recently been used more widely in graphic design for film and television, particularly when an elegant handwritten script seems appropriate to the setting of an opera, classical play or historical film. On film, which is a straightforward photographic medium, calligraphy is reproduced as clearly as it is originally written, especially if titles and credits are shown against a plain background. In television there is a more complex problem, since the transmission of the image is made in the form of a moving line of light. The system of projection breaks up definition of the image. Fine hairlines do not register and the letterforms generally lose their clarity. The writing must be precise and extra spacing allowed between letters and words to counteract distortion. Televization has a fattening effect on form, causing a thickening of the letters, which must either be anticipated in the original design or rectified when the effect has been seen, by overpainting the outlines of the letters where necessary. In addition, although the original calligraphy is usually done in black on white, the lettering is frequently reversed into white for projection, and superimposed over opening photography or live action at the start of a broadcast.

Calligraphic design

Broadly speaking, all the items referred to so far have originally consisted of pen or brush lettering on a flat surface and on a relatively small scale. When a three-dimensional element is added, it is necessary to make some modifications to the letterforms, whether they are for decoration or display of information. There are a number of ways in which basically calligraphic forms are used for different purposes and in different media. They are modified both in relation to the scale and situation of the object to which they are applied and, most crucially, in respect of the inherent qualities of the medium and technique of the particular craft.

In a sense, this section brings the story of calligraphy in a full circle – scratched, carved and painted inscriptions on stone, wood and clay have their precedents in the earliest products of human civilization. Such techniques involve an attitude to communication and design that is apparently both instinctive and highly practical. Unfortunately, modern crafts are frequently considered anachronistic, and the individual standards of a skilled craftsperson are not only uneconomic in competition with mass production, they are often inconvenient to potential clients, who require an instant response. Fortunately, there are always a few people who survive the hardships of making a business from their craft and continue to offer an alternative to the broad influence of more commercialized forms of design.

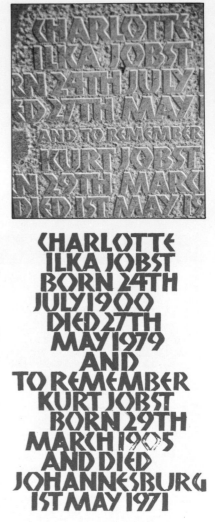

Memorial stones are a suitable outlet for calligraphic design. Alec Peever designed and carved this piece (top) on Purbeck stone. A brush-drawn rough is made on paper initially to decide on the design (above). Here a direct and immediate visual response was required, which is achieved through the weight and simplicity of the forms. The design is then transferred to the stone by first using a chisel-edged brush to outline the basic shapes. This is important in raised lettering for calculating spacing and correct letterforms. A hammer and chisel may then be used confidently to produce the finished carving.

Modern examples of architectural lettering are rarely calligraphic, but as Jock Kinneir has pointed out in in his book, *Words and Buildings*, 'written styles have always had a pervasive influence on other forms of lettering'. Much public display lettering utilizes standard forms that are matched to typographic alphabets. However, details of architectural and monumental forms are often calligraphic in design – nameplates, plaques, memorial stones and headstones, for example. The general standards of stonemasonry tend to rely on a fixed range of style and the most rapid and convenient method of execution. A stone-carver interested in translating calligraphy into stone operates more slowly and with attention to every detail of the design. From start to finish the particular requirements of the commission will be taken into account, such as the technique and material to be used and the precise location of the completed form.

Architectural letters can be chiselled into brick, like this Roman R, produced by Richard Kindersley (above). The nature of this material is generally more suited to simple letterforms. These numbers (below), however, typical of the art nouveau style, are also carved in a hard medium: stone; in this case, a more intricate form has been worked. Richard Kindersley has carved this sign in slate (left), using his freely constructed capital letters.

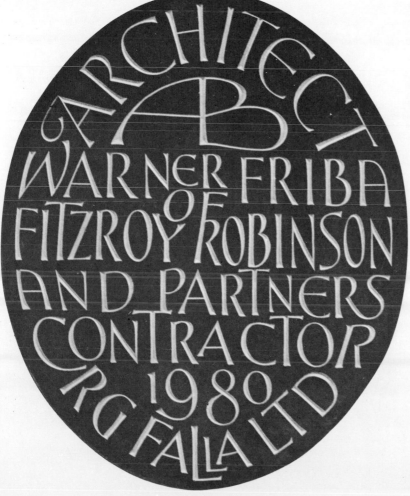

The original design for a plaque or headstone, for example, may be written with a pen, brush or double pencils, in a rough version and eventually in a full-scale, detailed drawing. In carrying out incised work on stone, however, it is important to allow the chisel to be the final arbiter of the letterforms. The nature of the material is also decisive, whether it is a hard stone such as marble, or a softer texture such as Portland stone, or if it has a peculiar quality when worked, like slate, which exists in a range of rich, natural colours, but on which incised forms appear characteristically pale in tone.

A design may be pounced on stone from a tracing, or drawn up directly with a soft watercolour pencil or similar drawing tool. Fre-

Individual labels have always provided scope for the calligrapher. Alec Peever designed this house nameplate in raised lettering on Portland stone (below) and the incised one in Westmoreland green slate (bottom left). The lettering in Stowe Maries *has moved away from the influence of the pen, whereas* White's Farm *has exploited a calligraphic style. Medicine pots also require some form of distinguishing tag. This sixteenth-century drug pot for aqua-bugalossa is glazed in an Italian tin glaze,* majolica. *(bottom right).*

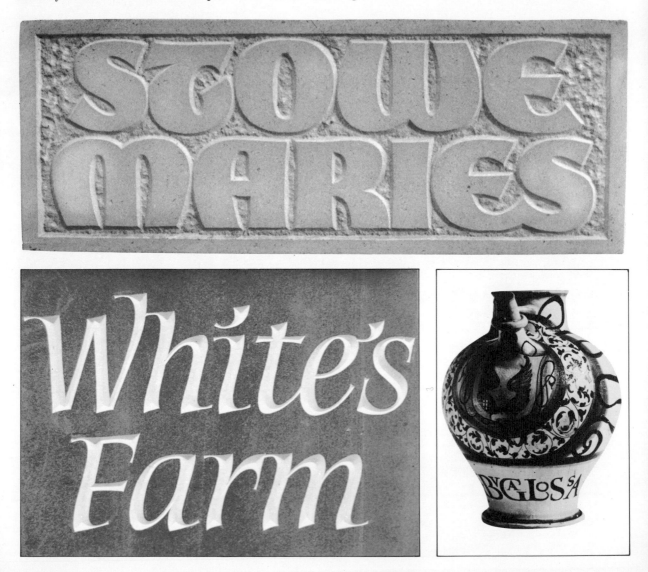

quently, however detailed the master drawing, the design is transferred only roughly to the stone and the carver then sets to work, allowing the chisel to dictate the forms directly. There may be modifications in the early stages – in certain materials the thinning of a curved letter will be invisible when it is cut so the design of the curve is shallowed and thickened slightly to compensate. A fine chisel is used to cut the centre line of the letter strokes and the cut gradually widened to produce the V-shaped incision. This basic explanation is intended to illustrate certain aspects of the craft – the stone-carver responds directly to the demands of each individual project, ultimately concerned with expressing the vitality of the material and letterforms.

Glass engraving was popular in the Victorian era. This sign (below) was constructed with built-up letterforms; the tails and serifs were gradually added to the letters. Alec Peever and Fiona Winkler produced this engraved decanter (bottom). The modern lower-case letters are plainly described, in contrast to the elaborate Victorian style.

Stone, wood and glass can also be shaped by sand-blasting. This involves cutting a stencil in adhesive, resistant, masking material; the stencil is applied to the surface and the exposed parts of the material are forcibly abraded. The design itself can be raised or recessed, depending on how the stencil is cut, and the degree of blasting may produce a lightly textured contrast in the smooth plane of the material or a noticeable effect of sculptured relief.

This technique can be used for decorating glass panels or whole windows; finer forms of glass engraving are done by hand using a drill, commonly a dentist's drill. The design may be drawn up beforehand and transferred to the glass (a waterproof marker is suitable for drawing on the smooth surface), but here again, the tool itself and the skill of the engraver makes the actual form of the lettering. Designs on glass take into account that the medium is a transparent material: a window panel or roundel, for example, has an image behind the glass as well as surrounding features of architecture and decoration. In a small item such as a drinking glass, rounded and fully transparent, a design which encircles the form is self-affecting from every angle.

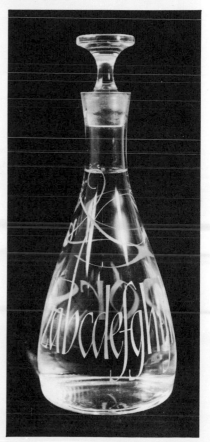

There is a certain grandeur and formality attached to stone-carved inscriptions, but lettering is a traditional form of decoration for ceramic objects and has been applied to design in many different crafts. Ceramic ware can be painted with coloured glazes or incised. Painted decoration and fine incision correspond more closely to the familiar processes of handwriting and brush lettering, but lettering designed for a curved or dished object may need modification to correct distortion on the curves. Enamelling, the fusion of powdered, coloured glass to a surface under the action of intense heat, produces a

Writing on metal may be produced in several different ways. Scratching the surface of the metal, as on these decanter labels for example (right), is one method. The scratches may be produced with strokes hatched in one direction (far right) or following each line of the letters (near right). Letters can be cast in metal, demonstrated in this plaque for a statue (below). An alternative process involves hammering out the lettering from the underside, as in this inn sign (bottom).

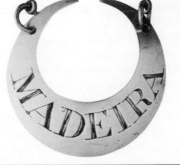

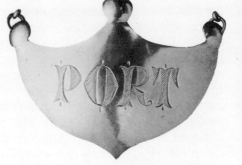

characteristic colour intensity and texture in a design, but it is difficult to control the forms precisely. Various experiments have been made in adapting calligraphic lettering to work in metal.

Sign-writing was once an art closely associated with calligraphy – the skill of direct brush lettering and inventive design was a matter of pride to individual artists, who passed on such skills to their apprentices. In general, however, as typographic forms became standard they were widely adopted by sign-writers; speed and convenience became principal requirements of the trade. In sign-writing on a large scale, it is difficult to avoid the necessity of working with built-up letterforms, rather than displaying writing shaped by the natural movements of the brush. This is perhaps inevitable, but it is still possible to develop composite forms by reference to calligraphic standards, and not in relation to mechanical lettering. There is something of a revival in the traditional concerns of sign-writing, particularly related to inn and café signs where, despite the modern corporate image favoured by some suppliers, there is room for individual peculiarities and preferences.

Loosely related to sign-writing is the practice of decorating the fascia of shops and city buildings with neon signs. The way that neon is shaped and bent into letterforms has lent itself to the development of some quirky, cursive styles of lettering design, although few could claim to be based on traditional calligraphic alphabets.

Below *This sign was designed and produced by Alec Peever for a brick company. It was mainly constructed as an experiment in a new medium. Petrarch is the material that has been used, which is resin-bonded, reconstituted slate. It is a substance similar to plastic and has been sand-blasted to produce the letterforms.*

GLOSSARY

Arch The part of a LOWER-CASE letter formed by a curve springing from the STEM of the letter, as in h, m, n.

Ascender The rising stroke of a LOWER-CASE letter.

Base line Also called the writing line, this is the level on which a line of writing rests, giving a fixed reference for the relative heights of letters and the drop of the DESCENDERS.

Black letter The term for the dense, angular writing of the GOTHIC period.

Body height The height of the basic form of a LOWER-CASE letter, not including the extra length of ASCENDERS or DESCENDERS.

Book hand Any style of alphabet commonly used in book production before the age of printing.

Boustrophedon An arrangement of lines of writing, used by the Greeks, in which alternate lines run in opposite directions.

Bowl The part of a letter formed by curved strokes attaching to the main STEM and enclosing a COUNTER, as in R, P, a, b.

Broadsheet A design in calligraphy contained on a single sheet of paper, vellum or parchment.

Built-up letters Letters formed by drawing rather than writing, or having modifications to the basic form of the structural pen strokes.

Calligram Words or lines of writing, or massed areas of text, arranged to construct a picture or design.

Carolingian script The first standard MINUSCULE script, devised by Alcuin of York under the direction of the Emperor Charlemagne at the end of the eighth century.

Chancery cursive A form of ITALIC script used by the scribes of the papal Chancery in Renaissance Italy, also known as *cancellaresca*.

Character A typographic term to describe any letter, punctuation mark or symbol commonly used in typesetting.

Codex A book made up of folded and/or bound leaves forming successive pages.

Colophon An inscription at the end of a handwritten book giving details of the date, place, scribe's name or other such relevant information.

Counter The space within a letter wholly or partially enclosed by the lines of the letterform, within the BOWL of P, for example.

Cross-stroke A horizontal stroke essential to the SKELETON form of a letter, as in E, F, T.

Cuneiform The earliest systematic form of writing, taking its name from the wedge-shaped strokes made when inscribing on soft clay. *Cuneus* is a Latin word meaning 'wedge'.

Cursive The description of a handwriting form that is rapid and informal, where letters are fluidly formed and joined, without pen lifts.

Demotic script The informal SCRIPT of the Egyptians, following on from HIEROGLYPHS and HIERATIC SCRIPT.

Descender The tail of a LOWER-CASE letter that drops below the BASE LINE.

Diacritical sign An accent or mark that indicates particular pronunciation of a letter or syllable.

Ductus The order of strokes followed in constructing a pen letter.

Face abb **Typeface** The general term for an alphabet designed for typographic use.

Flourish An extended pen stroke or linear decoration used to embellish a basic letterform.

Gesso A smooth mixture of plaster and white lead bound in gum, which can be reduced to a liquid medium for writing or painting. It dries hard for use in creating a raised letter for GILDING.

Gilding Applying gold leaf to an adhesive base to decorate a letter or ORNAMENT.

Gothic script A broad term embracing a number of different styles of writing, characteristically angular and heavy, of the late medieval period.

Hand An alternative term for handwriting or SCRIPT, meaning lettering written by hand.

Hairline The finest stroke of a pen, often used to create SERIFS and other finishing strokes, or decoration of a basic letterform.

Heiratic script The formal SCRIPT of the ancient Egyptians.

Hieroglyphs The earliest form of writing used by the ancient Egyptians, in which words were represented by pictorial symbols.

Ideogram A written symbol representing a concept or abstract idea rather than an actual object.

Illumination The decoration of a MANUSCRIPT with gold leaf burnished to a high shine; the term is also used more broadly to describe decoration in gold and colours.

Indent To leave space additional to the usual margin when beginning a line of writing, as in the opening of a paragraph.

Ionic script The standard form of writing developed by the Greeks.

Italic Slanted forms of writing with curving letters based on an elliptical rather than circular model.

Layout The basic plan of a two-dimensional design, showing spacing, organization of text, illustration and so on.

Logo A word or combination of letters designed as a single unit, sometimes combined with a decorative or illustrative element; it may be used as a trademark, emblem or symbol.

Lower-case Typographic term for 'small' letters as distinct from capitals, which are known in typography as upper-case.

Majuscule A capital letter.

Manuscript A term used specifically for a book or document written by hand rather then printed.

Massed text Text written in a heavy or compressed SCRIPT and with narrow spacing between words and lines.

Minuscule A 'small' or LOWER-CASE letter.

Ornament A device or pattern used to decorate a handwritten or printed text.

Paleography The study of written forms, including the general development of alphabets and particulars of handwritten manuscripts, such as date, provenance and so on.

Palimpsest A MANUSCRIPT from which a text has been erased and the writing surface used again.

Papyrus The earliest form oí paper, a coarse material made by hammering together strips of fibre from the stem of the papyrus plant.

Parchment Writing material prepared from the inner layer of a split sheepskin.

Phonogram A written symbol representing a sound in speech.

Pictogram A pictorial symbol representing a particular object or image.

Ragged text A page or column of writing with lines of different lengths, which are aligned at neither side.

River The appearance of a vertical rift in a page of text, caused by an accidental, but consistent, alignment of word spaces on following lines.

Roman capitals The formal alphabet of capital letters, devised by the Romans, which was the basis of most modern, western alphabet systems.

Rubricate To contrast or emphasize part or parts of a text by writing in red; for example, headings, a prologue, a quotation.

Rustic capitals An informal alphabet of capital letters used by the Romans, with letters elongated and rounded compared to the standard square ROMAN CAPITALS.

Sans-serif A term denoting letters without SERIFS or finishing strokes.

Script Another term for writing by hand, often used to imply a CURSIVE style of writing.

Scriptorium A writing room, particularly that of a medieval monastery in which formal manuscripts were produced.

Serif An abbreviated pen stroke or device used to finish the main stroke of a letterform, a hairline or hook, for example.

Skeleton letter The most basic form of a letter demonstrating its essential distinguishing characteristics.

Stem The main vertical stroke in a letterform.

Textura A term for particular forms of GOTHIC SCRIPT that were so dense and regular as to appear to have a woven texture. *Textura* is a Latin word, meaning 'woven'.

Transitional script A letterform marking a change in style between one standard SCRIPT and the development of a new form.

Uncial A BOOK HAND used by the Romans and early Christians, typified by the heavy, squat form of the rounded O.

Vellum Writing material prepared from the skin of a calf, having a particularly smooth, velvety texture.

Versal A large, decorative letter used to mark the opening of a line, paragraph or verse in a MANUSCRIPT.

Weight A measurement of the relative size and thickness of a pen letter, expressed by the relationship of nib width to height.

Word break The device of hyphenating a word between syllables so it can be split into two sections to regulate line length in a text.

x-height Typographic term for BODY HEIGHT.

INDEX

ACKNOWLEDGEMENTS

The pictures on these pages were reproduced by kind courtesy of the following: **7-8** Terry Paul; **9** Suzuki Seiyo; **10** Berthold Wolpe; **12** Heather Child; **13** V & A Photographic Library; **14** Julian Waters; **15**(t) Ann Hechle; (bl, br) V & A; **16** Jovica Veljovic; **17** Michael Holford; **18**(t) Alex Arthur; (b) Paul Arthur; **19** Ronald Sheridan's Photo-Library; **20**(t, bl) Ronald Sheridan's Photo-Library; (br) British Library; **21-22**(tl, tr) Ronald Sheridan's Photo-Library; **22**(b)-**23** British Library; **24**(l) Ronald Sheridan's Photo-Library; (r) British Library; **25** Michael Holford; **26** Ronald Sheridan's Photo-Library; **27**(tl) Koyoma Tenshu; (tr) Suzuki Seiyo; (b) Ronald Sheridan's Photo-Library; **28** Herman Zapf; **29**(t) Hella Basu; (bl) Karlgeorg Hoefer; (br) Imre Reiner; **30**(t) Alec Peever; (b) Quill; **31**(l) Gunnlaugur SE Briem; (t) Robert Boyajiam; (bl) Peter Thompson; **32** Donald Jackson; **33** Ronald Sheridan's Photo-Library; **36** Quill; **37** Ronald Sheridan's Photo-Library; **38** British Library; **39** Quill; **40**(l) Quill; (r) Ronald Sheridan's Photo-Library; **41** Lettering Archive, Central School of Art; **42**(t) Quill; **43**(t) Paul Arthur; **43**(b)-**44** Lettering Archive, Central School of Art; **46** Miriam Stribley; **47** British Library; **48**(t) Miriam Stribley; **48**(b)-**49** British Library; **50**(t) Miriam Stribley; (b) British Library; **51** Mary Evans; **52-53** Fotomas; **54** V & A; **55, 58-59** Mary Evans; **60-61** Quill; **62** Mary Evans; **63**(t) Quill; (b) Heather Child; **64-68** Quill; **69**(l) Photo: Heather Child/Permission: Dorothy Mahoney; (r) Miriam Stribley; **70** Arthur Baker; **71**(l) Alan Wong; (r) Quill; **74-75** Miriam Stribley; **76** Quill; **77** Miriam Stribley; **78-81** Quill; **82** Michael Holford; **83** Ann Hechle; **84-85** Quill; **88** Lettering Archive, Central School of Art; **89** Heather Child; **90-91** Miriam Stribley; **92** Werner Schneider; **93** Quill; **94-96** Miriam Stribley; **97** Peter Thompson; **98** Quill; **99** Mary Evans; **101** Miriam Stribley; **102** V & A; **103**(t) Erkki Ruuhinen; (b) V & A; **104-106** Miriam Stribley; **107** Werner Schneider; **108**(l) Sally Giles; (r) Henri R. Friedlaender; **109** Miriam Stribley; **110** Carol Thomas; **111** Miriam Stribley; **112**(l) Jagjeet Chaggar; (r) Heather Child; **113-114** Miriam Stribley; **115** Julian Waters; **116** Werner Schneider; **117**(t)-**122** Miriam Stribley; **123**(l) Ronald Sheridan's Photo-Library; (r) Ann Hechle; 124 Gunnlaugur SE Briem; **125**(t) Miriam Stribley; (b) Terry Paul; **126**(l) John Woodcock; (r) St Bride's Library; **127** Gunnlaugur SE Briem; **128** Terry Paul; **129** Miriam Stribley; **130** Quill; **131**(t) British Library; (b) V & A; **132** Quill; **133** Gunnlaugur SE Briem; **134** British Library; **135**(l) Leonid Pronenko; (r) Ann Hechle; **137**(l) Henri Friedlaender; **138**(l) Dover Publications Ltd; (b) Marie Angel; **139**(l) British Library; (r) Rachel Yallop; **140** Sheila Waters; **141**(t) Hans Schmidt; (b) Margaret Tam; **142** Miriam Stribley; **143** Neil Svenson; **146** John Woodcock; **147** Dorothy Mahoney; **148** E. Spitteler; **149**(l) Heather Child; (r) Miriam Stribley; **150** Alec Peever; **151**(l, tr) Richard Kindersley; (br) Nicolete Gray; **152**(t, bl) Alec Peever; **152**(r)-**153**(t) Lettering Archive, Central School of Art; **153**(b) Alec Peever; **154** Lettering Archive, Central School of Art; **155** Alec Peever.

KEY: (b) below; (l) left; (r) right; (t) top.